Mythical Flesh
Alexandru Rădvan

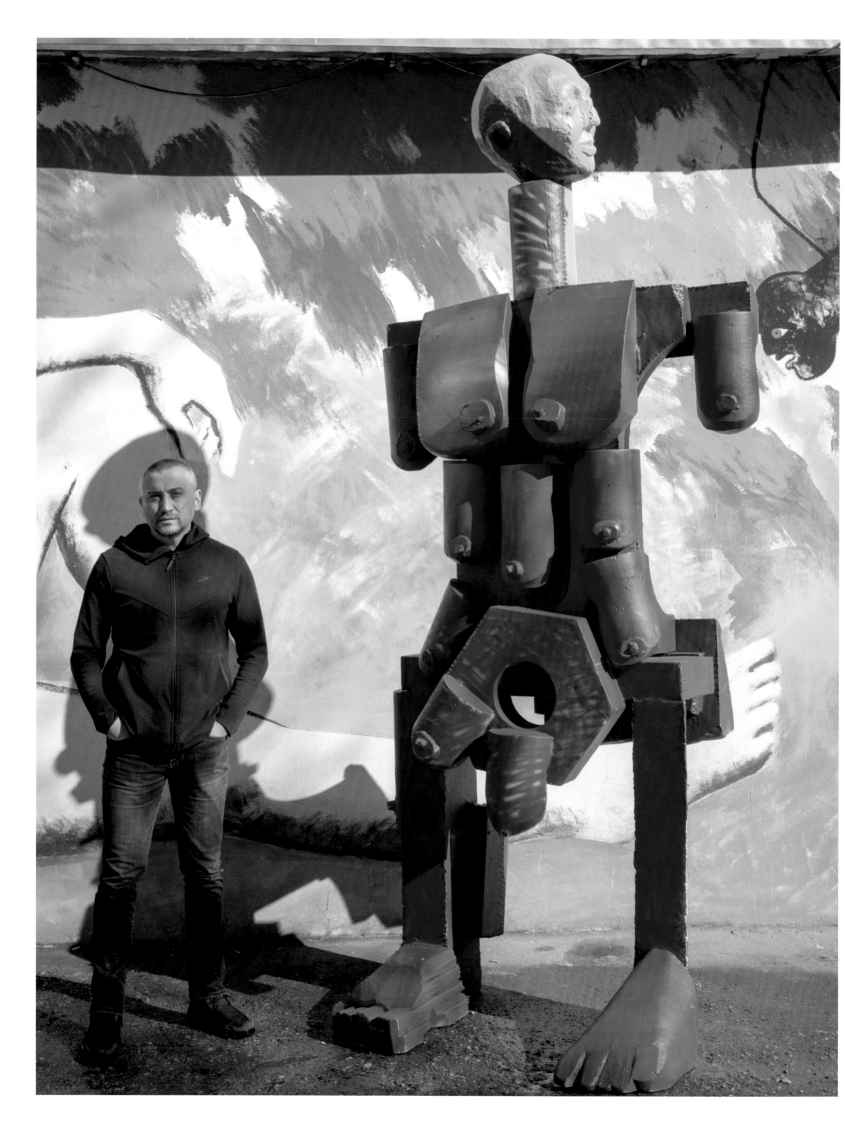

Mythical Flesh
Alexandru Rădvan

Essays by

Mark Gisbourne

Diana Dochia

Anaid Art Gallery

Berlin, DE

KERBER ART anaid art gallery

STIFTUNGKUNSTFONDS

NEU
START
KULTUR

Foreword and Acknowledgements

Alexandru Rădvan is among the most intriguing artists of the Eastern European art space. Born in Bucharest, Romania in 1977, he started his career at the end of the 1990s, after finishing his studies at the Bucharest University of the Arts. An institution that has given the art world some now illustrious modern and contemporary international artists such as Constantin Brâncuşi, Max Hermann Maxy, Victor Brauner, Peter Jacobi, Paul Neagu and Florin Mitroi. In fact, during his university years, Rădvan followed Florin Mitroi's painting classes, an artist with a particular way of drawing and painting. As a result, at the end of his studies, Rădvan became Mitroi's painting department assistant, he is currently a lecturer at the University of Art in Bucharest.

Since that time the artist has produced an extensive body of work across many media, from drawing on paper and various textiles, to oversized paintings on canvas and large two to three–dimensional sculptures made from metal or resin, to sculptural objects made from distrained sometimes found materials in open spaces. His subject matter and general themes consist mainly of an understanding of the ancient myths and mythologies, usually of a Mediterranean origin, recast in the current context, he revivifies them for a contemporary audience today. Ancient narratives that still carry forward into contemporary society a form of symbolic meaning and knowledge. The aim of this catalogue is to provide an extended opportunity to art lovers, collectors, specialists and the general public as a whole, to discover the creative expressive potential of Rădvan's work that goes beyond that of mere narrative spectacle.

From the beginning of his career, Alexandru Rădvan thinks through subject themes that have as a starting point those fascinating mythological characters such as Hercules, Prometheus, Narcissus or from narrative myths such as Daphne and Apollo or Pygmalion and Galatea. The extended groups of works created in the last years 2014-2021, each represent defined series, each with a distinctive title, that collectively provides a panorama of his wider artistic concept. This catalogue 'Mythical Flesh' is a second monograph on the artist and is mainly devoted to an extensive presentation of works on paper, collages and decoupage, paintings and sculptures. The creative artistic approach has grouped together seven thematic chapters that are central to Rădvan's general

oeuvre: entitled specifically 'On Rituals and Sun', 'Meridional', 'Pygmalion', 'Strange Women', 'Apollo & Daphne', 'Hercules', 'Self-portrait'. These chapters allow the viewer to trace the artistic path of Rădvan combining, both popular elements integral to the myths with investigative acknowledgements within the covered topics. The artworks of these series are sometimes intentionally provocative using oversized paintings and sculptures that integrate motifs drawn from art history alongside ancient myths. In this series, Rădvan re-oriented his search toward forms of expression that are not only engage with but also enrich our understanding of notional archetypes as they are experienced today.

Our special thanks and gratitude goes to the remarkable people who supported our endeavours through these years. We want to express our special appreciation towards our collectors who believe and are committed to the art of Alexandru Rădvan. Further special thanks go to the art historians that have written the texts of this catalogue. We want to thank all the people who worked on this catalogue – photographers, layout designer, translators and editor. Also of course we want to express our thanks to the publishing house that has produced and distributed the book. We wish a special pleasure to the future readers of this publication.

<div align="right">Mihai Ziman</div>

Vorwort und Danksagung

Alexandru Rădvan gehört zu den faszinierendsten Künstlern des osteuropäischen Kunstraums. Er wurde 1977 in Bukarest, Rumänien, geboren und begann seine Karriere Ende der neunzigerjahre, nachdem er sein Studium an der Bukarester Universität der Künste abgeschlossen hatte. Eine Institution, die der Kunstwelt einige heute berühmte moderne und zeitgenössische internationale Künstler wie Constantin Brâncuşi, Max Hermann Maxy, Victor Brauner, Peter Jacobi, Paul Neagu und Florin Mitroi beschert hat. Tatsächlich besuchte Rădvan während seiner Studienzeit den Malunterricht bei Florin Mitroi, einem Künstler mit einer besonderen Art zu zeichnen und zu malen. Am Ende seines Studiums wurde Rădvan Mitrois Assistent der Malabteilung. Derzeit ist er Dozent an der Kunstuniversität in Bukarest.

Seit dieser Zeit hat der Künstler ein umfangreiches Werk in vielen Medien geschaffen, von Zeichnungen auf Papier und verschiedenen Textilien über übergroße Gemälde auf Leinwand und große zwei- bis dreidimensionale Skulpturen aus Metall oder Harz bis hin zu skulpturalen Objekten aus manchmal gefundenen Materialien in offenen Räumen. Seine Fachkenntnise und seine allgemeinen Themen bestehen hauptsächlich aus einem Verständnis der alten Mythen und Mythologien, die normalerweise mediterranen Ursprungs sind und im aktuellen Kontext neu gefasst wurden. Er belebt sie heute für ein zeitgenössisches Publikum wieder. Alte Erzählungen, die immer noch eine Form symbolischer Bedeutung und Wissens in die heutige Gesellschaft tragen. Ziel dieses Katalogs ist es, Kunstliebhabern, Sammlern, Fachleuten und der Öffentlichkeit eine erweiterte Gelegenheit zu bieten, das kreative Ausdruckspotenzial von Rădvans Werk zu entdecken, das über das bloße narrative Spektakel hinausgeht.

Alexandru Rădvan denkt von Beginn seiner Karriere an über Themen nach, die faszinierende mythologische Charaktere wie Herkules, Prometheus, Narziss oder narrative Mythen wie Daphne und Apollo oder Pygmalion und Galatea als Ausgangspunkt haben. Die erweiterten Werkgruppen, die in den letzten Jahren, 2014–2021, entstanden sind, repräsentieren jeweils definierte Serien mit jeweils einem eigenen Titel, der zusammen ein Panorama seines breiteren künstlerischen Konzepts bietet. Dieser Katalog „*Mythical Flesh*" ist eine zweite Monografie des Künstlers und widmet sich hauptsächlich einer um-

fangreichen Präsentation von Arbeiten auf Papier, Collagen und Decoupage, Gemälden und Skulpturen. Der kreative künstlerische Ansatz hat sieben thematische Kapitel zusammengefasst, die für Rădvans Gesamtwerk von zentraler Bedeutung sind: mit dem Titel „Über Rituale und Sonne", „Meridional", „Pygmalion", „Seltsame Frauen", „Apollo & Daphne", „Herkules", „Selbstbildnis". Diese Kapitel ermöglichen es dem Betrachter, den künstlerischen Weg zu verfolgen, indem er sowohl die populären Elemente der Mythen als auch die hohen Anerkennungen der behandelten Themen kombiniert. Die Kunstwerke dieser Serie sind manchmal absichtlich provokativ, indem sie übergroße Gemälde und Skulpturen verwenden, die neben alten Mythen auch kunsthistorische Motive integrieren. In dieser Reihe richtete Rădvan seine Suche auf Ausdrucksformen aus, die sich nicht nur mit unseren heutigen fiktiven Archetypen beschäftigen, sondern auch unser Verständnis bereichern.

Unser besonderer Dank und unsere Dankbarkeit gelten den bemerkenswerten Menschen, die unsere Bemühungen in diesen Jahren unterstützt haben. Wir möchten unseren Sammlern unsere besondere Wertschätzung aussprechen, die an die Kunst von Alexandru Rădvan glauben und sich ihr verpflichtet fühlen. Ein weiterer besonderer Dank geht an die Kunsthistoriker, die die Texte in diesem Katalog verfasst haben. Wir möchten uns bei allen bedanken, die an diesem Katalog gearbeitet haben – Fotografen, Layouter, Übersetzer und Redakteure. Natürlich möchten wir uns auch bei dem Verlag bedanken, der das Buch produziert und vertrieben hat. Wir wünschen den zukünftigen Lesern dieser Publikation ein besonderes Vergnügen.

Mihai Ziman

MYTH AS SIGN AND SUBSTANCE
THE ART OF ALEXANDRU RĂDVAN

A magical paradox exists at the heart of figurative painting; it first signifies what it is not, yet at the same time confirms what it is in the form of an open sign.[1] Unlike the semantic use of language where the signifier is conventionally the indicative sound, image, thought, or name word, the signified is the idea or thought that is pointed to, and the sign combines the two into an interpreted relationship.[2] In contradistinction a painted image in the first instance signifies its material status as a figurative painting, followed by a signified as alluded-to subject matter, but whose status of thought image as signage is never fixed and remains open to displacement. This may also be the reason why there is great emotive power attached to the nature of myths and to the mythical, and why they have long been associated with painted subject matter in figurative painting. For myths are allegorical indicatives; they signify, yet are subject to coded interpretations that continue to operate through difference over the passage of time.[3] If the original narrative content (as 'archetype') is unchanged, the transmuted specificities as to time and place ('kunstwollen') remain in continual flux.[4] Hence figurative painting is pictorially doubled as representative illusion and allusion—as the there and the not there.

In this context the paintings and sculptures of Alexandru Rădvan have an apposite use of mythical signification with subtle associative systems of his own making. His symbolic or indexical use of myth, taken from Classical, Byzantine, and Mediterranean cultural history, remain as creative factors that have always permeated his painting and sculptural production. However, the artist's adoption and use of narrative myth is not one of mere repetition and recitation, recycled storytelling; rather its use seeks to embody the ideas anew as a form of re-perception of the familiar and known. To speak of material and subject matter, the mythical sources chosen are a form of intended re-embodiment, since the title of this publication as 'mythical flesh' points again to the sense of visual doubling previously cited. Flesh is substance that as expressive myth is insubstantial, material and immaterial, a figurative illusion that carries forth a mythical allusion. Yet the concept of flesh is understood less as that of mere carnal matter or corporeal entity, so much as a state of encompassed being embedded between the individual and the idea intended. The philosopher Merleau-Ponty determines it in phenomenal-ontological

terms as a process of self-interrogation, the 'there is', added meaning that expresses the perceiving self and perceived sense of other—capturing the lines of force in the world.

...my perception of the world feels it has an exterior; I feel at the surface of my visible world that my volubility dies away, that I become flesh, and that at the extremity of this inertia that was me there is something else, or rather an other who is not a thing.....he is everywhere around me with the ubiquity of oneiric or mythical beings... [5]

When directly citing painting Merleau-Ponty refers to a painter lending his body to the world, not as a subdued entity or mish-mash of mere physical body functions, but rather as an active invigorated force 'that body that is an intertwining of vision and movement'. [6] To Rădvan his body, or the body-self enacted as psychical other, is embedded in his personal allegorical viewpoint within his paintings. It is an approach to the pictorial that becomes essential to the developmental painting practices of the artist, who draws upon famous archetypal myths and the mythical as living tropes filtered through art history, derived oral narration, modern uses in film, and sources in music. This said it is to be noted a priori that the artist comes from a Latin culture; the Romanians are not Slavs, and this in turn affords a different and added emphasis to Greek and Roman Classical associations.[7] Rădvan's practice is therefore (as said) an embodied painting process in which the figure forms and subject matter interpenetrate as a flow of internal -external imagining consciousness, in a manner not unrelated to the Surrealist idea of cognitive communicating vessels.[8] A certain feeling of Pre-Socratic transmutation is also evident in the paintings, where Archaic Greek-Classical, Roman to Italian art and film sources have fragmented into states of tension between the mutable-immutable.[9]

The artist was twelve when Ceauşescu and Romanian Communism ended in 1989, and against a background of itinerant childhood—his family moved five times—his immediate and precocious engagement with art began at this time. The artist recalls an early fascination with art-historical encyclopaedias and imported Neckermann catalogues; each, in different ways, grounded the young Rădvan's interest in both history and images of Western popular culture. Significantly, in the years following the post-Communist period alongside his studies (1996-2000), the artist undertook series of travels and, sometimes spending several days at a time, became familiar with many of the major historical art collections across Europe. But while the artist freely confesses that there

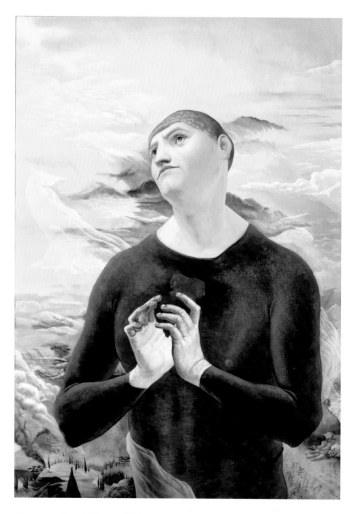

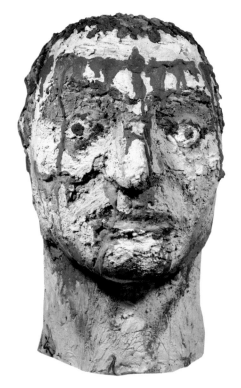

Constantin. Fides, 2006
Acrylic on canvas / Acryl auf Leinwand
170 H x 120 W cm
(66 59/64 H x 47 1/4 W inches)

Morbus, 2006
Concrete/Beton
66 H x 40 W x 50 D cm
(25 63/64 H x 15 3/4 W x 19 11/16 D inches)

are many subsequent visual influences on his art and practice, it is quite clear that Italian painting sources were from the outset among his most immediate of assimilations. It is clearly evident in the years following Alexandru's completed studies as in the paired half-portrait paintings *Constantin.Fides* and *Aurea Aetas* (Golden Age, 2006), that show the reverent pose and upwards glance, alongside the gestural emphasis and depiction of hands reminiscent of Perugino and his early workshop assistant Raphael.[10] The concrete heads called *Morbus* and *Pagan Christian* (2006-07) also evoke archaic Roman appearances, and the latter in concrete and glass considers the material innovations of Roman culture.[11] While the concrete and copper decollation *Spolia Optima* (2006-07) poses questions as to further notional uses and adaption of period materials.[12] The relative proximity of Orthodox Romania to the former Constantinople (now Istanbul) shows natural affinities with Early Christian and Byzantine subject matter (with specific references to crucifixions and biblical sources), but at an historical moment facing the

transiting moment of pagan to Christian culture. The mythic Minotaur, athletes, heroes, and battles, are often interwoven with biblical sources as a form of synthesis, an overlapping compendium of Graeco-Judeo and Christian schemata. A whole series of pastel-on-paper monotypes, *Athletes* (2012) and *Ulysses* (2011), are other examples of the interconnecting materials means and mythical narrative. The Sandro Chia-like figures of Athletes also suggest another more contemporary Italian influence, namely that of the Transavantguardia, and earler still, perhaps, interwar Italian masters such as Giorgio De Chirico and his brother Alberto Savinio come to mind.[13] The artist openly acknowledges an assimilation and absorption of Chia, Clemente, and Paladino art works. [14]

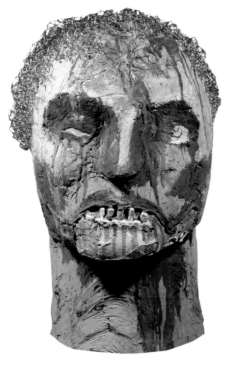

Spolia Optima, 2006–2007
Concrete/Beton
66 H x 40 W x 50 D cm
(25 63/64 H x 15 3/4 W x 19 11/16 D inches)

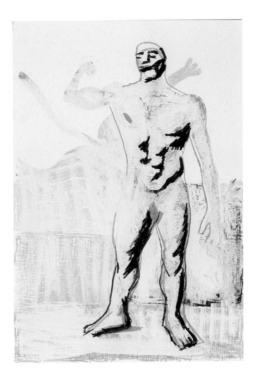

Athletics Series (XI)
Oil pastel on paper / Ölpastell auf Papier
72 H x 51 W cm
(28 11/32 H x 20 5/64 W inches)

Though not primarily the subject of this current essay, the main focus of which is on recent years of Alexandru Rădvan's production, the aforementioned early paintings and sculptures indicate the in depth knowledge of iconography and visual literacy and sources mastered and incorporated into his art over the last twenty years. In the early transition of the last decade (2008-2013) an increased emphasis was placed on images of violent transgressions of the body and its presentation. The artist created a series of charcoal

drawings addressing *Crusader* atrocities, depictions of the violent deaths of martyred female saints, and a series of works (drawings and paintings) that were a perverse homage to the imagined humanity of Judas. The Messianic narrative use of violence is focused on the human experiences of Jesus, rather than on the hypostatic union. Whereas in paintings of the Virgin Mary, shown naked, either squatting or supine, there is an assertion of the uterine or carnal rather than spiritual aspects of human birth. In fact a persistent tension between Greek dualism of *eros* (erotic) and *agape* (spiritual) desire remains a motivational characteristic consistently at work in Rădvan's representational practice. The artist shares a sense of expressive feelings taken forward from intuitive affinities to the Baroque Age. The expression of narrative pictorial violence, seen in earlier masters such as Caravaggio and the Carracci family, founders of the Italian Baroque, is yet another influence absorbed and recast in this artist's creative oeuvre.[15]

The Hero

I referred earlier to the embodied, to self in the other, a transference and preponderance of self-identification through the practice of allegorical personification.[16] The mythical Ulysses (Homeric 'Odysseus') is just such a personification for Rădvan, among the first he engaged with as a personal allegorical identity. For Ulysses is a mythological character that personifies the everyman, the dogged and persistent hero who embodies many aspects of life and its fraught journey.[17] In the case of generic mythologies there is always an existential motif that leads to the journey of the hero, a search and/or pursuit, with various tasks or trials that must be enacted and realised along the way. In fact it is the first archetypal and universal monomyth of human storytelling, found in almost every culture and mythological narrative, and thought as essential to an eventual personal and cultural transformation.[18] The hero is seen in the series of works devoted to Hercules that the artist has worked on sporadically between 2014-2021. Hercules is an exemplary hybrid, half divine (son of Zeus or Jupiter) and half human (the mortal woman Alcmene), a pagan if muscular simile of the dyophysite Christ who also possessed the dual natures of god and man—though little related otherwise. The prescriptive tasks of Hercules (the twelve labours) are selectively depicted in fragmented narratives of allusion, they reflect a gravitation in Rădvan's practice from the use of earlier modulated painting towards a more immediate use of graphic directness. Executed in acrylic on canvas in the larger paintings or as tempera on paper works, we might note again the artist's expanded use

material innovation. A section within the Hercules series is entitled *Hercules after Carracci* (2014), and for the most part makes allusive reference to the first of the hero's labours, the slaying of the Nemean Lion, denoted by pictorial attributes within the images. The artist's inspired choice of Hercules no doubt comes from the famous Carracci frescoes and paintings commissioned by Alessandro Farnese for his late 16th century palace in Rome.[19] This said visually there is a marked shift towards the idea of painted collages and cut outs, which appear as silhouetted decoupage transferred and expressed as painting. Yet the Carracci sources are radically re-translated into the expressive vivacity of a very different modern idiom, the colours are brightly painted and flat, whereas configured contours have been minimalized.

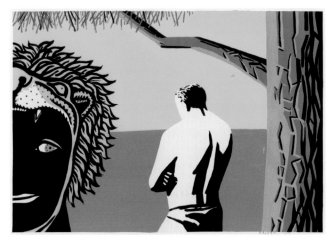

Hercules after Carracci I, 2014
Tempera on paper / Tempera auf Papier
70 H x 100 W cm (27 9/16 H x 39 3/8 W inches)

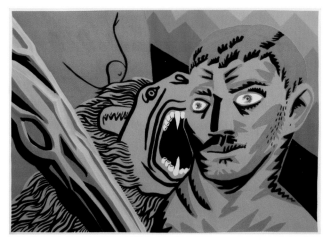

Hercules after Carracci II, 2014
Tempera on paper / Tempera auf Papier
70 H x 100 W cm (27 9/16 H x 39 3/8 W inches)
Private collection / Private Sammlung

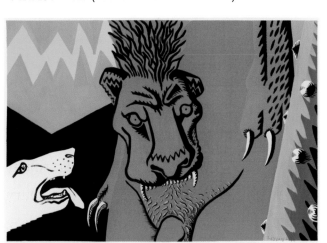

Hercules after Carracci III, 2014
Tempera on paper / Tempera auf Papier
70 H x 100 W cm (27 9/16 H x 39 3/8 W inches)

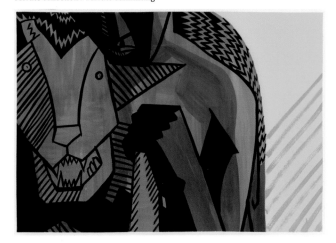

Hercules after Carracci IV, 2014
Tempera on paper / Tempera auf Papier
70 H x 100 W cm (27 9/16 H x 39 3/8 W inches)

In the *Small Hercules* paintings of the same date (2014), depictions are often shown as a fragmented part image, in which only the attributes of the lion skin or the hero's club are left to identify the subject matter. Some mid-size paintings follow the diptych or triptych

format, where notionally the three-headed hound Cerberus (guardian to the Gates to the Underworld) intervenes as a fragmented and marginally ferocious beast. The artist's use of part-object depictions connotes the intention of creating a displaced yet open narrative, which is to say that the paintings should not be read as a literal descriptive narration of the origin myth as a subject.[20] Hence the paintings are not to be understood from a conventional linear or denotative approach to storytelling, but rather as embedded projected and associative personifications determined by the artist. When Rădvan returned to the subject in recent works *Hercules in Halkidiki* or *Hercules in Vineyard* (2019) the tone has been altered to **ut pictura poesis** representing a visual Mediterranean idyll.[21] Less the epic hero, and more the reflective and introspective poses of the hero turned lyric poet.[22] However, what is remarkable is another material innovation, as the colourfully intense paintings are executed on a black canvas fabric, and when exhibited take the form less of conventional paintings but of material wall hangings. The emergence of abstract semi-geometric asymmetry, flat cut out delineated shapes, are also reminiscent of his earlier horizontal mid-size *Meridional* landscape series that the artist began in 2013, they both share in the sense of a sultry heat, with the umbrella pines, cicadas and the metamorphic butterflies, the tone is that of lethargy and lassitude expressed under a cloudless aestival sky.[23]

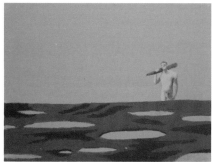 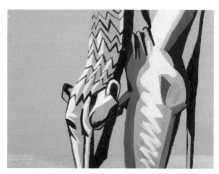 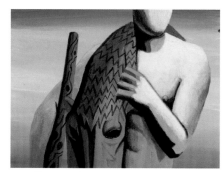

Small Hercules I, 2014
Acrylic on canvas board /
Acryl auf Malkarton
18 H x 24 W cm
(7 3/32 H x 9 29/64 W inches)

Small Hercules II, 2014
Acrylic on canvas board /
Acryl auf Malkarton
18 H x 24 W cm
(7 3/32 H x 9 29/64 W inches)

Small Hercules III, 2014
Acrylic on canvas board /
Acryl auf Malkarton
18 H x 24 W cm
(7 3/32 H x 9 29/64 W inches)

The Hercules theme is also embodied in several works of three dimensions, in the vividly painted polystyrene sculpture of the fourth labour *Hercules and the Erymanthian Boar* and the painting-relief *Hercules' Victory Dance* (2019). The latter in particular has an attached and padded Hercules figure wrestling the lion breaking free of the picture plane into the foreground space. A second larger scale and recently completed work entitled *Fragmentary Hercules at the Oracle* (2019) carries this idea even further using again the

idea of canvas or tent-like fabric constructed as an open lattice frame that is placed directly onto the wall. Whereas affixed to the right is a fabric-padded Hercules mounted on a white goat (most often a suborned beast of common pagan myth and Christian impediment), and to the left is the attached torso of the oracle, whose large breasts and vaginal opening acts as a point of bi-focal engagement. In both instances installed with straps as wall hangings and soft sculpture relief, they mediate the space between the two, a simile to painting—echoing relief examples of Transavantgarde and Neo-Expressionist artists of the 1980s.

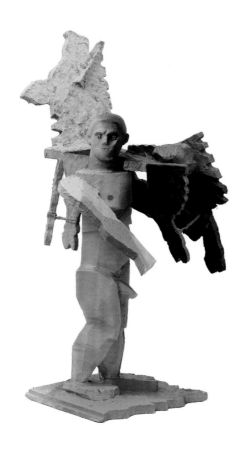

Hercules and the Erymanthian Boar, 2019
Polystyrene, acrylic resin, oakum, hemp /
Polystyrol, Acrylharz, Werg, Hanf
120 H x 45 W x 70 D cm
(47 1/4 H x 17 23/32 W x 27 9/16 D inches)

Eros and Thanatos

That Alexandru Rădvan investigates his self-identification through various archaic and mythical allegorical personifications can no longer be in doubt. His recent series of narrow vertical self-portraits makes this abundantly clear, where he depicts himself as a naked man and standing figure personifying the beginning of history.[24] Or, alternatively, in a self-portrait referring to the beginning of time as a naked woman, or a self-depiction as a fertility goddess, or the flayed satyr Marsyas who dared to challenge the god of the arts Apollo to a music contest, and finally as a questioning *Self-portrait as a Cautious Hero* (2019).[25] This latter

painting is particularly interesting since it appears visually to draw upon certain Christian archaic and primitive local paintings traditions in rural Romania. It shows an imagined Taras Bulba-type Trans-Asian figure whose body is covered with open eyes, while modestly covering his naked private parts.[26] It might remind the reader of matters as yet not discussed, namely the vital and necessary role that film sources have played as an influence on Rădvan's artistic development and to which I will return.[27] The human tendencies towards desire and destruction, the sexual life instinct and death drive, were expressed and seen as co-dependent in antiquity through the linked personifications of Eros (profane love) and Thanatos (death). Though this was, perhaps, without the same psychologically motivated interdependence and libidinal pre-determinations given to them by Freud.[28] While mythology is frequently a multi-narrative, with several different versions of a given myth, Rădvan favours the Ovidian Roman narratives over those of the Hesiodic and Orphic theogonies of Greece.[29] So it is with the famous myth of Apollo and Daphne, a story that expresses an erotic tale of pursuit, and the futility that results from its libidinal failure.[30] Yet again the artist has focused on iconic Baroque subject matter, recalling Bernini's famous sculpture in the Galleria Borghese in Rome (1622-25).[31] In a series of works 2017-18, the mythical idea is developed concerning the cruel and contradictory nature of the human pursuit of erotic desire. The origin myth narrates the thwarting transformation imposed by the God of profane love Eros (or "Cupid") as a punishment of Apollo for his lack of due reverence. Eros shoots, a golden tipped arrow with the power of love infatuation and intense sexual desire that pierces the God Apollo (under his synonym of Phoebus). The second lead tipped arrow carrying the fear of sexual love and male contact pierces the naiad Daphne. Rădvan paints a sequential series that touches upon different elements of this mythical and alchemical narrative—gold and lead represent the bound polarities of the alchemical metal table.[32] In several large vertical paintings beginning with *Eros Cruel God*, he has imagined the winged God Eros holding his bow resting against the waters of Peneus (named after Daphne's father the king) flowing from lower left to upper right, while reaffirming the fact that Daphne is a naiad or nymph of woodland and stream devoted to Diana (Artemis) the twin sister of Apollo. Whereas in *Daphne...almost...* the God Apollo is shown in frenetic and electrified pursuit, that is as Daphne begins her petition to the gods pleading for her transformation. And in *The God, The Nymph* the artist shows the moment of contact, in compositional terms, perhaps, the nearest to the Bernini source of depiction. It is followed by a painting *Untouchable Love* showing Apollo as he kisses

18

the now transformed laurel bush, and where the title is written on lower left field of the painting.[33] In the final part of this linear narrative as pagan colloquy *Apollo the Sad, Daphne the Poor*, the God Apollo, as the Parnassian god of poetry and music, is shown as a three quarter torso stroking a lyre in an encomium to his lost love. The symbolic significances that are attached to the myth are numerous, since laurels are associated with intellectual achievements in poetry and many other cultural and social accomplishments. Each painting surface is executed as applied coloured patches, onto which the pictorial events are transcribed in a graphic style and with contoured depiction. Yes the heightened nature of eroticism is also evident in the large (galvanised sheet and semi-precious stones) sculpture *After Ovid-Apollo and Daphne*, where the fleeing nymph and the trailing metal strands of her hair encompass a torso that has been transformed into a configuration of a thrusting phallus.

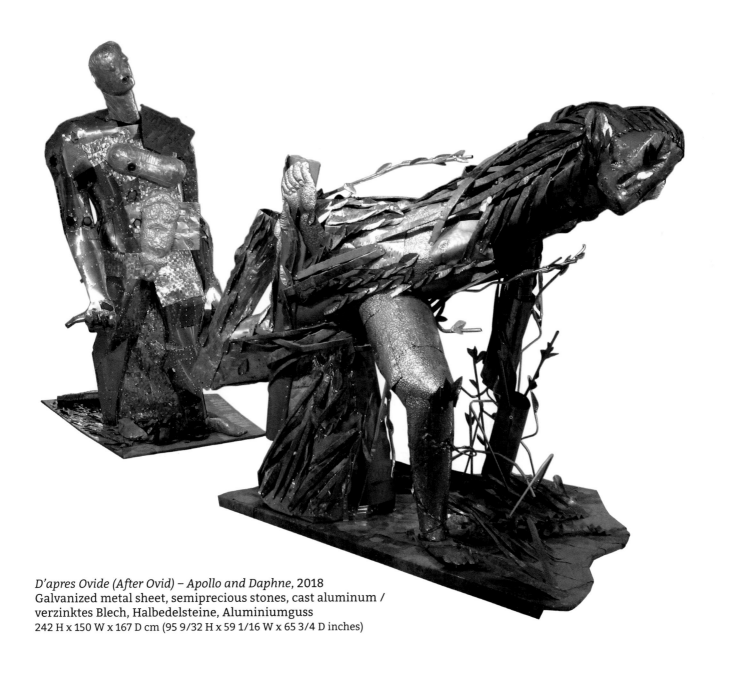

D'apres Ovide (After Ovid) – Apollo and Daphne, 2018
Galvanized metal sheet, semiprecious stones, cast aluminum /
verzinktes Blech, Halbedelsteine, Aluminiumguss
242 H x 150 W x 167 D cm (95 9/32 H x 59 1/16 W x 65 3/4 D inches)

The series of paintings and the earlier series of collage on cardboard, and acrylic marker on cardboard works (2015-17), might be seen therefore as an expression of the anxiety of conviction, that is to say the inevitable lacuna that exists (something common to all creative artists) between what the mind conceives and the expressive hand realises. For the Apollo and Daphne collages are often accompanied with painted text in the form of an allusive **poiesis**, as *The Sad Story of Daphne the Naiad and Apollo the God,* or as in the collage work called simply ...*almost* (2017).[34]

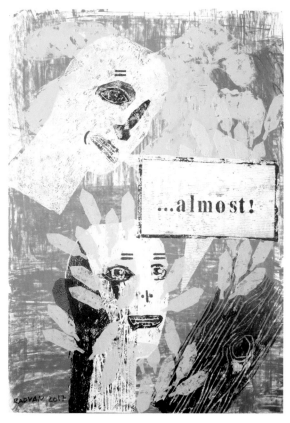

...almost!, 2017
Acrylic on cardboard /
Acryl auf Karton
100 H x 70 W cm (39 3/8 H x 27 9/16 W inches)

Daphne, 2017
Acrylic, acrylic marker on cardboard /
Acryl, Acrylmarker auf Karton
102 H x 72 W cm (40 5/32 H x 28 11/32 W inches)

The heads are adumbrated personifications of Apollo and the artist we can assume. They emphasise the erotic aspects of the female body, and the fact that each Apollo head is detached from a body poses ideas of detachment and voyeuristic provocation. An idea much in evidence in the series called *Strange Women* that the artist completed earlier in 2015, and in which a series of female torsos in distorted figure forms and sexual poses are represented. The artist mentions 'meeting' Umberto Eco, and travelling to an unnamed island, which he later paints as the *Island for Umberto* (2014), and where he first saw these women he later re-imagined. While not in any sense portraits so much as flesh made into sculptural forms, all are naked and presented with an intense focus placed on breasts and

vulvae. The paintings are visualised as large coloured contrasted graphics in appearance, yet again evoking the artist's favourite recitative fascination with Mediterranean themes and subject matter. Rădvan often speaks of his love of heat, of islands and the Mediterranean sea, and recalls as a young man a personal fascination with the films of the famous underwater mariner-explorer Jacques Cousteau, and that he once wanted to become a diver. Yet if the subject seems to echo chauvinist erotica, the paintings might better be read in relation to an internal personification, to the allegorical presentation of desire, and to chthonic forms of nature. These wanton dryads with earthly impulses are cults of fertility, archaic female deities—servants of Thanatos.[35]

Personification as Transfiguration

The narrative power of film as image, its iconic ability to frame a moment has always fascinated this artist. Though there were limited opportunities to travel to see international exhibitions and collections during the communist years, art cinema was more accessible particularly in the post-communist years immediately after 1990. The films of Pasolini and Fellini were particularly important when dealing with ideas of history and myth, since they visually embodied for the young artist narrative signs open to new interpretation, they increasingly became for the artist enacted forms of mythical flesh—the paradox of an insubstantial substance. For Rădvan saw films like Pasolini's 'Oedipus Rex', 'The Decameron' and 'The Canterbury Tales' as historical-mythical narratives leading to the possibility of reaching aesthetic truth by a different route.[36] With the exception of the Chaucer's 'Canterbury Tales', the film first seen by the artist, most contents of his art work have dealt with the cultures and myths of the Sun and the South, for in the artist's development there his been little interest given to Norse or Teutonic or other mythologies, reaffirming the case that Rădvan is determinedly Latin and Greek subject-oriented artist. It is the chthonic and pantheistic sylvan Earth as mother and nurture that informs many of the works called simply 'Mythologies' or 'Rituals and the Sun'. Large installation sculptures *The Sleeping Centaur,* to *Narcissus* (a recurrent theme), and *Prometheus*, he who stole the fire of the gods and gave it to mankind, are three-dimensional accounts that reaffirm a narrative existence in any number of relatable collages and paintings. A large green (verdant) sculpture *Mother of All Things* (2019) expresses this again, seemingly through his/her hermaphrodite presence a pathway to life.

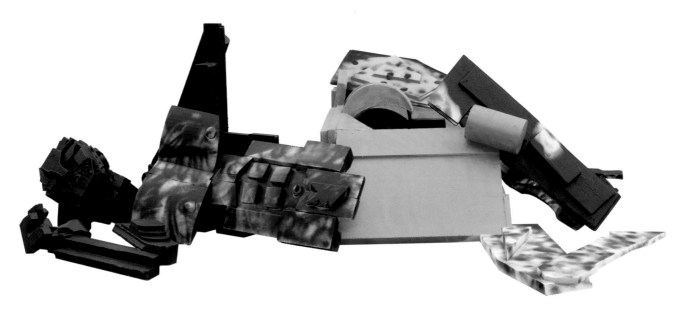

Sleeping Centaur, 2019
Polystyrene, polyurea resin, spray /
Polystyrol, Polyharnstoffharz, Spray
126 H x 400 W x 400 D cm
(49 39/64 H x 157 31/64 W x 157 31/64 D inches)

The investigation of archaic rituals and the myths of transformation are often focused on the female, since it is only through female incarnation that the beginnings of human transfiguration take place. And to use the verb 'to transfigure' is also to directly intimate the idea of to transform into something more beautiful and elevated.[37] The female sex is the site of emergence and human appearance in the world, and in the large canvases *Rite of Spring* and *Rite of Spring 2*, and the collage on cardboard *Le Sacre du Printemps* the issue of rituals are foregrounded. Many material means of innovation are related to the category of works he calls *Mythologies* and those that invoke his beloved Mare Nostrum as subject matter. Apart from the frequent use of vertical diptychs and variable triptychs, there are configured oval and rectangular compendium pieces, and wooden boxes with composed and inserted elements as *Holiday* (2015), or *Archaic Couple*, and *Meridian* (2016).

This latter innovation intentionally links the artist's ideas to that of staging and theatre, which of course for the Western Civilisation begins with Greek Drama. Images of coitus sometimes appear, as in *(Blems) Mythologies IV-VI*, though they carry no sense of erotic immediacy, but derive from engravings and woodcuts of ancient or archaic stories of headless men (acephale) that appear in Medieval manuscripts and bestiary images.[38] There are allusions to music as in the large painting *Prokofiev* (2014) cast in the form of the Narcissus myth, as well as the aforementioned *Le Sacre du Printemps* as a ritual of

initiation.[39] What is most effective is the extraordinary diversity of mark making we find in these canvas and collage works. The artist uses formal line drawing, various forms of hatching, delightfully abstracted leaves and stylised natural forms, symmetry and asymmetry, patches of colour, splodges of paint colour applied with the head of the brush, the use of displaced lines as in *Mythological (Faun)*, or patterning in *Mythological III (Bacchus)*, that uses counter directional all over slanted hatching, a visual technique redolent of its similar use by the American master Jasper Johns in the 1970s.[40]

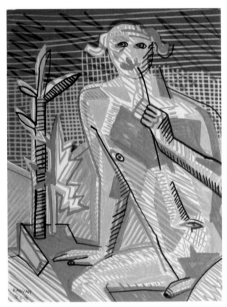 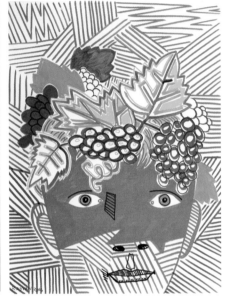

Mythological I (Faun), 2016
Acrylic marker on canvas /
Acrylmarker auf Leinwand
60 H x 45 W cm
(23 5/8 H x 17 23/32 W inches)

Mythological II (Faun), 2016
Acrylic marker on canvas /
Acrylmarker auf Leinwand
60 H x 45 W cm
(23 5/8 H x 17 23/32 W inches)

Mythological III (Bacchus), 2016
Acrylic marker on canvas /
Acrylmarker auf Leinwand
60 H x 45 W cm
(23 5/8 H x 17 23/32 W inches)

The artist's persistent mutation of various signifying personifications of identity within the open sign is no better illustrated than in Rădvan's use of the myth of 'Pygmalion'. Taken from Ovid the mythical story is polemical, no myth of self-expression (the making of self through the projection of other) has been so subjected to psychological and/or aesthetical debate as that of the sculptor Pygmalion. With plays and films, music, novels and numerous relatable texts, the story of Pygmalion has permeated all levels of serious and popular culture.[41] The story is a simple one where the subsequent complexity lies in its interpretation of the narrated myth. Pygmalion is an artisan sculptor and bachelor, who due to loneliness '...with marvellous artistry, he skilfully carved a snowy ivory statue. He made it lovelier than any woman born, and fell in love with his own creation. The statue had all the appearance of a real girl...'[42] Pygmalion treats the statue as if she were a real maid, dresses and adorns her, kisses and embraces her, and imagines real kisses in

return, places her in staged and provocative positions, gives her gifts, in fact what we might imagine today is that he makes a personal fetish of the statue. However, following an offering and prayerful petition at the annual Festival of Venus in Cyprus, the goddess intervenes and upon his return home finds the statue come to life, thence he marries her and nine months later she bears him a son. If in one respect it is a homage and testament to faith and hope, we cannot imagine the women's movements of today are happy with this outcome. It also draws comparison with the creation narrative of Adam and Eve, a woman generated from the rib of Adam due to a male god's intervention. But for Rădvan the power of the narrative myth is that of the artisan, the creative power of the artist to remake themselves and world around them. To personify through an artistic practice the ability to embody the sense and feeling of an immediate age and create altered perceptions of life. In *Sculptor. Pygmalion (triptych)* (2014) we are presented with the world of sculptor -artist. In the acrylic on paper collages *Pygmalion I-III* (2015) the sculptor is presented at work creating large breasted biomorphic sculptures. In *Pygmalion—The Artist and the Model* (2015)—there is also a large painting in 2017—it is important to state that the collage works are intended as autonomous. They are not specifically intended as preparatory sketches or models for the paintings that are produced, though at time different acceptable crossovers may and do take place.

Sculptor. Pygmalion (triptych / Triptychon), 2014
Acrylic marker on paper /
Acrylmarker auf Papier
72 H x 153 W cm (je 72 H x 51 W cm)
(28 11/32 H x 60 15/64 W inches
(each 28 11/32 H x 20 5/64 W inches))

Pygmalion – The Artist and the Model, 2015
Acrylic, acrylic marker, collage on cardboard /
Acryl, Acrylmarker, Collage auf Karton
70 H x 100 W cm
(27 9/16 H x 39 3/8 W inches)

We are invited into a painting of a large red sculpture-filled studio space (*pace* Matisse) *Sculptor Studio, with the Endless Column* (2016). It seems Brancusi is never far from a Romanian sculptor's consciousness. In a very recent painting *Remembering a Great Love* (2019) we find a painting full of fire and colourful heat, the artist sits in intimate relations

with his sculpted creation. As the artist chooses to express it 'I inseminate all the myths of the world and let them live in my flesh.' This is what is fully intended by an allegorical embodiment of mythical flesh that is at work in his art. If this is an overly Romantic viewpoint, Alexandru Rădvan is frank and as such would never seek to deny it.

©Mark Gisbourne

Endnotes

1 A painting is both a 'thing image' and 'thought image', as a representational 'thing' it has resemblance ('being alike') and points to a a given thought or idea, whereas 'thought image' is one of similitude (a state of being similar to something) that is a likeness subject to an open variability and interpretation as a sign. See Michel Foucault, 'Non-Affirmative Painting', in: *This is not a Pipe*, Eng. trans., James Harkness, Berkeley and London, University of California Press, 1982, pp. 53-54 (the discussion focuses on Magritte's painting La Trahision des Images 'Ceci n'est pas une pipe' 1929).

2 For the distinction between Saussure semiotics and Charles S. Pierce semiology, see Robert E. Innis (ed. and intro.), *Semiotics: An Introductory Anthology*, Bloomington and London, Indiana University Press, 1985.

3 Allegory and its functioning process 'allegoresis' from 'allos' or 'other', is the polysemy inherent in a pictorial image. It suggests what we know about figurative painting is that it is an illusion ('visual lie'), revealed through allusion that is interpreted or 'allegorized' into telling the truth, Jeremy Tambling, *Allegory*, London, Routledge, 2010, pp. 26, 46. Also see Maureen Quilligan, *The Language of Allegory: Defining the Genre*, Ithaca and London, Cornell University Press, 1979.

4 While subject to continuous scholarly discussion the term kunstwollen is a teleological 'will to art', a concept first formulated Heinrich Brunn (1856), and given its substantive understanding in the writings of Alois Riegl, and the Viennese School of Art History. See Andrea Reichenberger:, *Riegls 'Kunstwollen'*: Versuch einer Neubetrachtung, Academia Verlag, Sankt Augustin 2003. The concept undermined traditional notions of style in Classical Art History, that there were high points ('heyday') or low points ('decay') in the history of art and its production, tying art practices to a specific moment in time as subject matter. See Margaret Iversen, *Alois Riegl: Art History and Theory*, Cambridge, MA, and London MIT Press, 2003.

5 Maurice Merleau-Ponty, 'Interrogation and Dialectic' in: *The Visible and the Invisible*, Eng. trans., Alphonso Lingis, Evanston, Northwestern University Press, 1968, p. 61 Merleau-Ponty framed the investigation with a description of 'perceptual faith', that is our pre-reflective conviction that perception presents us with the world as it actually is, even though all perceptions are mediated, for each of us, by our bodily senses.

6 Maurice Merleau-Ponty, 'Eye and Mind', in: *The Primacy of Perception*, Evanston, Northwestern University Press, 1964, (pp. 162-190) p. 162 (Fr. L'Oeil et l'esprit, 1961, the essay was the last published prior to his death in the same year).

7 The early populations were Greeks Celts and Dacians, the Romans called the Province Dacia. See Vlad Georgescu, *The Romanians: A History*, Columbus, Ohio State University Press, 1991.

8 The belief in an immediate creative flow between cognitive dream and consciousness, between myth and reality, was a central characteristic of Surrealist aesthetics, see *André Breton, Les Vases Communicants*, Paris, 1932 (Eng. trans., Mary Ann Caws, *Communicating Vessels*, Lincoln, University of Nebraska Press, 1997).

9 In Pre-Socratic philosophy, before Platonic idealism and Aristotelian materialism, the mutable or elemental, materialist and atomic (Heraclitus, Democritus et al), were opposed to philosophers of appearance and their ideas of eternal immutability (Parmenides and the Eleatic School) See D. W. Graham (ed.), *The Texts of Early Greek Philosophy: The Complete Fragments and Selected Testimonies of the Major Presocratics*, 2 vols., Cambridge, Cambridge University Press, 2010.

10 The painting recalls figures from Raphael's Mond Crucifixion (Crocifissione Gavari,1502-03) in the National Gallery in London, an altarpiece work much influenced by Perugino and which Alexandru was very familiar with, due to a three week visit to London when 19 years of age, and where he spent much time in the collections. (c. 1996), See A. Roy, M. Spring, and C, Plazzotta, 'Raphael's Early Work in the National Gallery: Paintings before Rome', *National Gallery Technical Bulletin* Vol 25, pp 4–35.

11 Concrete was an invention of the Romans, and glass, while it had it origins in Mesopotamia and Egypt (imported from Alexandria), was fully mastered in terms of goods of mass production (much as plastic is today) by the Romans. It is no coincidence that the artist used these materials in his early work. See D. F. Grose, 'Early Imperial Roman cast glass: The translucent coloured and colourless fine wares', in: *Roman Glass: two centuries of art and invention*, London, Society of Antiquaries of London, 1991.

12 Alexandru Rădvan ©*Memoriile lui Constantin/Memories of Constantine*, Anaid Art Gallery, Bucharest, 2006.

13 Achille Bonito Oliva, *The Italian Trans-Avantgarde/Transavangurdia Italiano*, Milan, Politi Editore, 1978.

14 The Greek theme of the 'universal athlete' is of course classically derived, see the series reproduced in Rădvan Alexandru, Anaid Art Gallery, Bucharest, 2012.

15 Ruxandra Demetrescu, Diana Dochia, and Roxana Rădvan, *For Tomorrow: Investigating new Materials in the works of Alexandru Rădvan*, Bucharest, Archetype Publications/National University of the Arts, 2014.

16 Personification is defined as 'a specific form of allegory in which an abstract idea is represented by the creation of a fictional figure.' That is to say it is a mask of an unseen or absent or abstract or dead quality, so that it appears to have an autonomous identity. See 'Medieval and Renaissance Personification', Tambling, op cit., pp. 40-61 (glossary definition, p. 176).

17 The concept of the life journey is seen in the oldest known example of world literature, 'The Epic of Gilgamesh' (c. 1800 BC), Maureen Kovacs Gallery, translation with introduction, *The Epic of Gilgamesh*, Stanford, California, Stanford University Press, 1985.

18 For an anthropological and philosophical analysis of the monomyth of the hero, Joseph Campbell, *The Hero With a Thousand Faces*, Princeton, Princeton University Press, 1968 (First published in Bollingen Series, Pantheon Books, 1949) re-edited in *The Collected Works*, New World Library, Novato, Calif., 2008.

19 The Bolognese workshop of the Carracci and their frescoes and paintings for the Farnese Palace (c. 1595) are seen by art historians as the establishing of the Italian Baroque style, John Rupert Martin, The Farnese Gallery, Princeton, Princeton University Press, 1965. For recent analysis on the Carracci, see also Stefano Colonna, *La Galleria dei Carracci in Palazzo Farnese a Roma*, Rome, Gangerni Editore, 2016.

20 The 'part object' ('objet petit a') is the unattainable object of desire, in other words phantasy, the object of desire sought in the other. See Jacques Lacan's *Seminar Les formations de l'inconscient* (1957). For a glossary entry see Alan Sheridan, 'Translator's Note', Jacques Lacan, in: *The Four Fundamental Concepts of Psycho-analysis* London 1992, p. 282: and for Classical exegesis Oliver Harris, *Lacan's Return to Antiquity: Between Nature and the Gods*, London, Routledge, 2017.

21 The term 'ut pictura poesis' is from the *Ars Poetica of Horace* (65-8BC) meaning 'as in painting so in poetry.' (19BC).

22 The 'idyll' is a type of pastoral lyric poetry first attributed to Theocritus (300-260BC), Richard L, Hunter, *Theocritus and the Archaeology of Greek Poetry*, Cambridge, Cambridge University Press, 1996.

23 Alexandru Rădvan, *Torrid Geometry*, Anaid Art Gallery, Berlin Art Week (13-18 September), Berlin, 2016.

24 The 'self-portraits' were exhibited along with sculptures at a solo show, *The Oldest Day*, ARCUB—Bucharest Cultural Centre (14 May-23 June), Bucharest, 2019.

25 The painting *Self-Portrait as a Super Ancient Goddess* (2019) among others was shown in the exhibition entitled *Partner for the Abyss*, Bazis Contemporary (May 7—June 15), Cluj, 2019.

26 Taras Bulba is an eponymous hero of Nikolai Gogol's famous novella (1835), a story that has been filmed many times, but perhaps, best known through the Hollywood version (starring Yul Brynner and Tony Curtis, 1962). The artist's image is similar to Brynner's shaved head and pigtail version of the hero.

27 The artist has an intimate knowledge of the films of Pier Paolo Pasolini, *Salo: 120 Days of Sodom* (1975), and *Oedipus Rex* (1967) and Federico Fellini's Satyricon (1969), are among others that deal with myth and antique themes. An installation (primarily sculpture) by the artist in homage to Pasolini, called *Romantic Tomb for Pasolini*, took place at Kube Musette, Bucharest, 2015.

28 In Freudian psychoanalysis Eros and Thanatos represent the life and the death instincts, see Sigmund Freud, *Beyond the Pleasure Principle* (1922). German original text Jenseits des Lustprinzips, 1920.

29 Publius Ovidius Naso (43BC-AD 17) was initially a love poet (writing Amores, the Heroides, love letters by deserted women to the former lovers, and a handbook on love Amatoria). Yet his greater fame comes from the mythological narratives published in 8 AD, called Metamorphoses (Book of Transformations), Eng. trans., Mary Innes (1955), London Harmondworth, 1982.

30 ibid lines 453-568, pp. 41-44.

31 The subject matter was first visualised within in the Lorenzo di Medici and the Neo-Platonist circle in Florence in the 1470s-80s. See Piero and Antonio del Pollaiuolo 'Apollo and Daphne' at the time of her transformation in the laurel bush, and it was this pictorial moment of the narrative that subsequently became an archetypal representation. The painting is in the National Gallery in London, and for context, see Alison Wright, *The Pollaiuolo Brothers: The Arts of Florence and Rome*, Newhaven and London, Yale University Press, 2005.

32 The alchemical principle of the 'Philosopher's Stone' was to turn lead or mercury (base metals) into gold, see C.J.S Thompson, chap. IX 'The Philosopher's Stone and the Elixir of Life', in: *Alchemy and Alchemists* (1932), Mineola, New York, Dover Publications, 2002.

33 Diana Dochia, *Alexandru Rădvan: Untouchable Love*, Anaid Art Gallery (April 27-May 26), Berlin, 2018.

34 In the Symposium, Diotima speaks of 'poiesis' as how mortals pursue striving for immortality, Plato's famous dialogue defines this in three ways, through sexual procreation (offspring), in the urban space by heroic fame (celebrity), and the soul in the pursuit of virtue and knowledge. See Robert Cavalier, 'The Nature of Eros', http://caae.phil.cmu.edu/Cavalier/80250/Plato/Symposium/Sym2.html

35 The myth of spilled seed (semen) is a thread in Homeric and Hesiodic literature, and continues until today, Rachel Hills, *The Sex Myth: The Gap Between Our Fantasies and Reality*, New York, Simon & Schuster, 2015, p. 60 Hence the myth of Erichthonius is seen as an ancient explanation of 'premature ejaculation.'

36 *Oedipus Rex*, by Sophicles (c. 429 BC), *The Decameron* by Giovanni Boccaccio (completed 1453), and *The Canterbury Tales* by Geoffrey Chaucer (1387-1400).

37 See Elinor Gadon, *The Once and Future Goddess: A Symbol of Our Time*, San Francisco and London, 1989.

38 The 'Blemmyes' (coined by 1st cent. geographer Strabo) with references also to two-headed persons, single eye Cyclops, human-animal headed creatures appear in the 'Histories' by Herodotus (5th century BC). They appear again many times medieval manuscripts and bestiaries, and prints, for which there is a large literature. Rădvan may have taken the idea from Umberto Eco, who refers to them in his novel '*Baudolino*' (Bompiani, 2000) set in Constantinople in the 12th century Christian era.

39 Claimed to be an ancient pagan festival in Russia, it is known primarily from Sergei Diaghilev's 'Ballet Russes' staging of Igor Stravinsky's ballet, with Vaslav Nijinsky, and Nicholas Roerich's stage and costumes designs (1913), and who later argued it as a 'Restaging of Antiquity.' See Peter Hill, *Stravinsky: The Rite of Spring*, Cambridge, Cambridge University Press, 2000.

40 For an extensive overview of Jasper Johns, see Kirk Varnadoe (ed,), *Jasper Johns: A Retrospective*, Museum of Modern Art, New York, 1996.

41 Sigmund Freud in psychoanalysis, and George Bernard Shaw's play *Pygmalion* (1913). It became the basis for the musical (1956) and famous film '*My Fair Lady*' (1964). The Pygmalion myth was also important to the early protagonists of Surrealist Movement in France (1924-59).

42 Publius Ovidius Naso, op cit., lines 248-50, p. 231.

DER MYTHOS ALS ZEICHEN UND SUBSTANZ
DIE KUNST VON ALEXANDRU RĂDVAN

Im Kern der gegenständlichen Malerei begegnen wir einem wundersamen Paradoxon: Sie bezeichnet zuerst, was sie nicht ist, bekräftigt aber zugleich, und zwar in Form eines offenen Zeichens, was sie ist.[1] Im semantischen Gebrauch von Sprache ist der Signifikant zumeist Bedeutung stiftender Klang, bildhafter Ausdruck, Vorstellung oder Name, während das Signifikat für den Gedanken steht, auf den verwiesen wird, und das Zeichen beide in einen Deutungsbezug zueinander bringt.[2] Davon abweichend bezeichnet eine gegenständliche Malerei zunächst einmal ihre Materialität und ihren Stellenwert als gemaltes Abbild, sodann und insoweit eine andeutende Bezugnahme auf Inhalte stattfindet, ein Signifikat, dessen Status als Gedankenbild jedoch nie festgelegt, sondern fortwährenden Verschiebungen ausgesetzt ist. Hierin begründet sich vielleicht auch, warum den Mythen eine derart große Macht über unsere Gefühle eingeräumt wird, und warum das Mythische eine so lange und enge Verbindung mit den Themen und Inhalten der gegenständlichen Malerei eingegangen ist. Mythen sind allegorische Verweise, sie benennen einerseits und sind andererseits selbst codierten Deutungen unterworfen, die sich im Lauf der Zeit als Spiel der Differenz entfalten.[3] Der ursprüngliche Erzählinhalt (als „Archetyp") mag dabei unverändert bleiben; im Wandel der zeit- und ortspezifischen Ausprägungen des „Kunstwollens" bleibt er dennoch im Fluss.[4] Daher ist jede gegenständliche Malerei eigentlich ein doppeltes Bild – illusionäre Darstellung und Verweis auf nicht Sichtbares, das, was da ist und nicht da ist zugleich.

Vor diesem Hintergrund erschließt sich auch der Gebrauch von Mythenzeichen in Verbindung mit einem Repertoire hintergründiger, aufeinander abgestimmter Assoziationen in den Gemälden und Plastiken von Alexandru Rădvan. Rădvans symbolisches beziehungsweise indexikalisches Aufgreifen und Verarbeiten von Mythenerzählungen aus der griechischen und römischen Antike, aus dem Byzantinischen Reich und dem Mittelmeerraum prägte von Beginn an seine Malerei und Bildhauerei. Es begnügt sich nicht mit deren bloßer Wiederholung und Nacherzählung, sondern will den zugrundeliegenden Vorstellungen in einem Akt des Wieder-Sehens von allzu Bekanntem und Vertrautem lebendige Gestalt verleihen. Was Bildinhalte und Sujets angeht, zielt das vom Künstler ausgewählte Mythenmaterial auf eine Art Wieder-Verkörperung, und in genau diesem Sinn bezeichnet auch das „Fleisch der Mythen" im

Titel dieser Publikation den angesprochenen Doppelcharakter des Bildes als da seiend und nicht da seiend zugleich. Als Substanz ist dieses „Fleisch" Ausdrucksmythos und daher eigentlich substanzlos, stofflich und nicht stofflich, gegenständliche Illusion als Träger mythischer Allusion. Es versteht sich hier nicht im unmittelbar körperlichen Sinn als Muskelmasse, sondern leiblich als ein Zustand des allumfassenden, zwischen Einzelmensch und Idee eingebetteten Seins. In phänomenologisch-ontologischen Begriffen bestimmt es der Philosoph Merlau-Ponty als den Vorgang einer Selbstbefragung, als ein „Da ist" und eine überschießende Bedeutung, die dem wahrnehmenden Selbst und dem wahrgenommenen Anderen zum Ausdruck verhilft – und darin den Kraftlinien der Welt folgt:

... [M]eine Wahrnehmung der Welt empfindet sich als ein Außen; ich spüre auf der Oberfläche meines sichtbaren Seins, daß meine Beweglichkeit schwächer wird, daß ich Fleisch werde und daß es am Ende dieser Trägheit, die ich war, etwas Anderes gibt, oder besser: einen Anderen, der nicht ein Ding ist. (...) er ist überall um mich herum mit der Allgegenwart oneirischer oder mythischer Wesen... [5]

Wo Merleau-Ponty sich unmittelbar auf die Malerei bezieht, spricht er vom Maler, der „der Welt seinen Leib leiht". Er meint mit diesem Leib keine geknechtete Physis, kein „Stück des Raums, Bündel von Funktionen", sondern eine tätige, von Regungen erfüllte Kraft – „ein Geflecht aus Sehen und Bewegung".[6] Auch bei Rădvan zeigt sich der eigene Körper oder das als seelischer Anderer ins Spiel gebrachte Leib-Selbst verwoben mit einem je eigenen, in der Malerei eingenommenen, allegorischen Standpunkt. Diese Art des Herangehens an die Malerei, das Sicheinlassen auf den Entstehungsprozess eines Bildes, ist ein Wesensmerkmal dieses Künstlers, der dabei auf allseits bekannte Ur-mythen sowie auf das Mythische insgesamt als lebendige, durch die Kunstgeschichte – etwa in Form mündlicher Weitererzählungen, moderner Verfilmungen, Inszenierungen und Vertonungen – gesickerte Topoi zurückgreift. Wichtig zu wissen in diesem Zusammenhang ist, dass Rădvan als Rumäne nicht aus einer slawischen, sondern aus einer überwiegend romanischen Kultur stammt. Dementsprechend ausgeprägt ist sein Näheverhältnis zur griechischen und römischen Antike.[7] Er praktiziert, wie schon gesagt, ein verkörpertes, allmähliches Malen, im Zuge dessen Figuren und Motive einander in einem Bewusstseinsstrom innerer wie äußerer Imaginationen und nicht unähnlich der surrealistischen Vorstellung von kommunizierenden Röhren zwischen Traumwelt und Wachsein durchdringen.[8] Auch ein gewisses Grundgefühl

des vorsokratischen, elementhaften Wandels geht von diesen Bildern aus, indem darin archaische und antike griechische, römische und italienische Motive aus Kunst und Film in Spannungsmomente zwischen den Polen von Wandelbarkeit und Unwandelbarkeit zersplittert sind.[9]

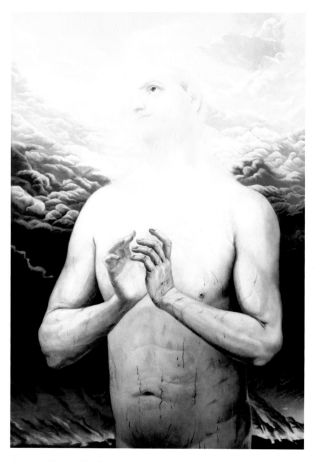

Aurea Aetas, 2006
Acrylic on canvas / Acryl auf Leinwand
170 H x 120 W cm
(66 59/64 H x 47 1/4 W inches)

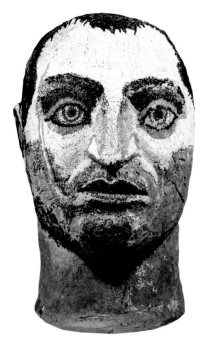

Pagan Christian, 2006–2007
Concrete, glass stones/Beton, Glassteine
66 H x 40 W x 50 D cm
(25 63/64 H x 15 3/4 W x 19 11/16 D inches)

Als Ceaușescu und der Kommunismus 1989 in Rumänien endeten, war der Künstler 12 Jahre alt. Nach einer unsteten Kindheit (fünfmal war er in seinen ersten Lebensjahren mit den Eltern umgezogen) erwachte ebenso frühzeitig wie unvermittelt sein Interesse an der Kunst. Rădvan erinnert sich an eine weit zurückreichende Begeisterung für kunsthistorische Enzyklopädien einerseits und für neu ins Land gekommene Neckermann-Kataloge andererseits, die beide auf ihre Art die Neugier des jungen Alexandru auf die Geschichte und Bildwelt der westlichen Unterhaltungskultur weckten. In den Jahren nach dem Systemwechsel und während seines Studiums (1996–2000) unternahm Rădvan mehrere Reisen, um bedeutende Kunstsammlungen in ganz Europa kennenzulernen, und verbrachte oft mehrere Tage hintereinander in einem Museum. Und während er unumwunden zugesteht, dass in der Folge noch

unzählige weitere Seheindrücke Eingang in sein Werk gefunden haben, war und ist die italienische Malerei unverkennbar das, was ihn am unmittelbarsten geprägt hat. Schon in den ersten Jahren nach seinem Studium war das unverkennbar, etwa anhand der beiden einander ergänzenden Halbporträts *Constantin.Fides* und *Aurea Aetas* (2006), genauer an den verzückten, himmelwärts gerichteten Blicken und der ausdrucksvollen Gestik der Hände, die an Perugino und den in seiner Werkstatt arbeitenden Raffael denken lassen.[10] Auch die Betonköpfe *Morbus* und *Pagan Christian* (2006–7) erinnern sehr an Gestalten aus der Frühzeit Roms, und der gleichfalls aus Beton und Glas gefertigte *Pagan Christian* bringt darüber hinaus durch ebendiese Werkstoffe die Materialkultur Roms ins Spiel.[11] Auch der wie abgeschlagen wirkende Kopf *Spolia Optima* (2006–7) aus Beton und Kupfer lässt Fragen nach den Bedeutungen dieses Aufgreifens geschichtsträchtiger Materialien aufkommen.[12] Die relative Nähe des christlich-orthodoxen Rumänien zum ehemaligen Konstantinopel und heutigen Istanbul äußert sich bei Rădvan in einer umstandslosen Affinität zu byzantinischen frühchristlichen Sujets (insbesondere Kreuzigungen und anderen Bibelmotiven), die auf die Zeit der Wende von der heidnischen zur christlichen Kultur zurückgehen. Die Sagengestalt Minotaurus, die Athleten, die Helden und Schlachten versammelt der Künstler häufig mit Bibelgeschichten zu einer Art Synthese, einem Kompendium der Überschneidungen zwischen den griechisch-jüdischen und christlichen Schemata der Welt. Eine ganze Serie von *Athletes* in Pastell auf Papier (2012) sowie die *Ulysses*-Monotypien (2011) sind Beispiele für diese wechselseitige Durchdring- ung von Mythenerzählungen und Materialitäten in Rădvans Werk. Seine an Sandro Chia erinnernden Athletes lassen darüber hinaus einen zeitgenössischen Einfluss, nämlich das Nachwirken der italienischen Transavanguardia, und aus der Zeit davor vielleicht noch das Vorbild italienischer Maler der 1920er und 1930er Jahre wie Giorgio de Chiricos und sein Bruder Alberto Savinio, erkennen.[13] Der Künstler selbst bekräftigt jedenfalls ausdrücklich die Aneignung und Aufnahme der Kunst von Chia, Clemente oder Paladino in sein Werk.[14]

Die eben genannten Gemälde und Plastiken sind zwar nicht eigentlich Gegenstand dieses Essays über die neuere Arbeit von Alexandru Rădvan, aber aufschlussreich als Belege der eingehenden ikonografischen Kenntnis und umfassenden visuellen Bildung dieses Künstlers sowie der vielfältigen Quellen, die er seiner Kunst im Lauf der vergangenen zwanzig Jahre erschlossen hat. In einer Übergangsphase um den Beginn dieses Jahrzehnts (2008–2013) war seine Arbeit verstärkt von Darstellungen gewaltsamer Über- griffe auf den Körper geprägt. So schuf er als Teil einer Serie von Kohlezeichnungen

über die Grausamkeiten der Kreuzritter Bilder von sterbenden heiligen Märtyrerinnen, und eine weitere Serie mit Zeichnungen und Gemälden unternimmt die verquere Würdigung einer imaginären Menschlichkeit des Judas. Im Rahmen der christlichen Heilsgeschichte konzentriert Rădvan sich bei seinen Gewaltdarstellungen ganz auf das, was Jesus als Menschen widerfuhr, und lässt die hypostatische Union außer Acht. Ebenso behaupten sich in seinen Aktdarstellungen einer kauernden oder liegenden Jungfrau Maria die Natur des Gebärens und das Fleisch gegenüber jeglichen religiösen Aspekten von Jesu Geburt. Eine eigentümliche, anhaltende Spannung entlang der griechischen Dualität von Eros und Agape, erotischer und göttlicher Liebe, zieht sich durch das Bilderschaffen Rădvans. Aus seiner intuitiven Nähe zum Zeitalter und zur Tradition des Barock entwickelt dieser Künstler ein markantes Repertoire des Gefühlsausdrucks, und so verdanken sich auch seine Bildererzählungen von der Gewalt dem Rückgang auf Meister wie Caravaggio und die Familie Carracci, die Begründer des italienischen Barock, deren Einflüsse wie so viele andere in seinem Werk zur Geltung kommen.[15]

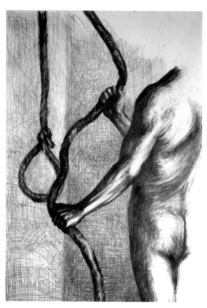

Homage to Judas XXII, 2008
Pencil on paper / Bleistift auf Papier
42 H x 29 W cm
(16 17/32 H x 11 27/64 W inches)
Private collection / Private Sammlung

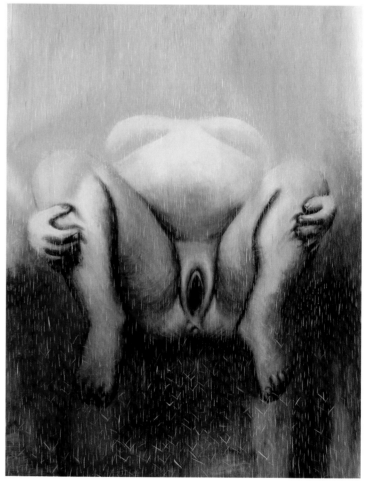

25th of December, 2010
Acrylic on canvas / Acryl auf Leinwand
190 H x 152 W cm
(74 51/64 H x 59 27/32 W inches)

Der Heros

Weiter oben habe ich auf die Verkörperung, auf das Selbst im Anderen, auf eine Übertragung und Behauptung der Selbst-Identifikation im Verfahren der allegorischen Personifizierung hingewiesen.[16] Bei Rădvan ist die Sagengestalt Ulixes (Homers Odysseus) eine derartige Personifizierung. Sie war die erste, die den Künstler auf der Suche nach einer Allegorie seiner selbst und dessen, was er ist, beschäftigte. Denn Odysseus personifiziert den Jedermann, den zähen und unbeirrbaren Helden, dessen Fährnisse das Auf und Ab des Lebens als einer oft beschwerlichen Reise versinnbildlichen.[17] In solchen Gattungsmythen findet sich stets auch ein existenzielles Motiv als Auslöser einer Heldenreise, einer Suche und/oder Verfolgung, im Zuge derer verschiedene Aufgaben zu lösen und Prüfungen zu bestehen sind. Die Heldenreise als solche ist auch der erste allgemeine Ur-Monomythos, seit Menschen einander Geschichten erzählen. Sie findet sich in fast jeder Kultur und jedem Sagenkorpus und gilt manchen sogar als entscheidende historische Voraussetzung für den individuellen und kulturellen Reifeprozess der Menschheit.[18] Die Gestalt des Helden erscheint bei Rădvan in einer ganzen Reihe von Arbeiten, die er in mehreren Anläufen von 2014 bis 2021 dem Herkules bzw. Herakles widmete. Als Sohn des Jupiter (Zeus) und der sterblichen Alkmene bildet dieses exemplarische Mischwesen eine heidnische, allerdings ungleich kraftvollere Parallele zum Christus der Zwei-Naturen-Lehre, indem es Gott und Mensch in sich vereint – wenngleich es sonst kaum Berührungspunkte zwischen den beiden Gestalten gibt. Über einige der zwölf Heldentaten oder Arbeiten des Herkules erzählt Rădvan in seinen Bildern. Diese markieren auch die allmähliche Abkehr des Künstlers von einer eher modulierenden Malweise hin zu einem kräftigeren, mehr zeichnerischen Strich. Im Einsatz der Acrylfarbe auf den größeren Leinwänden und im Tempera bei den kleineren Papierformaten kommt wiederum sein innovativer Umgang mit Materialien zur Geltung. Ein Teil seiner umfassenderen Herkules-Serie nennt sich *Hercules after Carracci* (2014) und bezieht sich zumeist auf die erste Tat des Herakles, nämlich das durch verschiedene Attribute gekennzeichnete Erlegen des Nemeischen Löwen. Dass sich der Künstler für die Herkulesgestalt entschieden hat, verdankt sich mit Sicherheit der Anregung durch die berühmten, Ende des 16. Jahrhunderts im Auftrag von Alessandro Farnese für dessen Palazzo in Rom entstandenen Fresken und Gemälde der Carracci.[19] In technischer Hinsicht hat indes eine deutliche Verlagerung hin zum Denken in gemalten Collagen und Cutouts stattgefunden, die wie découpage-Konturen in malerischen Ausdruck übersetzt sind. Dabei erfahren die Vorlagen der Carracci

durchgehende Verwandlung in die ausdrucksvolle Lebendigkeit einer völlig anderen, modernen Bildsprache: Ihre Farben sind grell und flach, das Wechselspiel der Konturen ist auf ein Minimum reduziert.

Hercules after Carracci V, 2014
Tempera on paper / Tempera auf Papier
70 H x 100 W cm (27 9/16 H x 39 3/8 W inches)

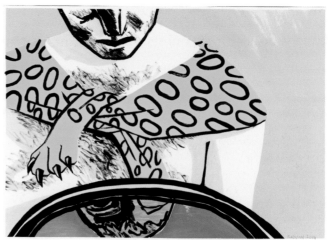

Hercules after Carracci VI, 2014
Tempera on paper / Tempera auf Papier
70 H x 100 W cm (27 9/16 H x 39 3/8 W inches)

In den *Small Hercules*-Bildern aus derselben Zeit (2014) erscheinen die gleichen Motive meist bruchstückhaft, indem etwa nur noch ein Löwenfell oder eine Helden-keule die gedankliche Brücke zur Erzählung bildet. Einige Gemälde mittlerer Größe sind in den Formaten des Diptychons oder Triptychons gehalten und zeigen beispielsweise ein Fragment des dreiköpfigen Kerberos (Wachhund an den Toren zur Unterwelt), das die grimmige Bestie nur noch markiert. Dass der Künstler sich auf die Wiedergabe von Teilobjekten beschränkt, ist ein Hinweis, dass es ihm hier um das Entfalten einer zugleich verschobenen und offenen Erzählung geht, dass wir also seine Bilder nicht einfach als getreue Nacherzählung eines Urmythos zu deuten haben.[20] Sie erschließen sich nicht als lineare oder beschreibende Erzählungen im gewohnten Sinn, sondern eher als vom Künstler projizierte und assoziativ gefundene, in seine eigene Bildwelt eingebettete Personifizierungen. Als Rădvan sich jüngst in Arbeiten wie *Hercules in Halkidiki* oder *Hercules in Vineyard* (2019) diesem Thema erneut zuwandte, wechselte er interessanter-weise den Ton hin zu mediterranen *ut pictora poesis*-Idyllen.[21] Auch der epische Held hat hier nunmehr die Haltung eines nachdenklichen, innere Einkehr haltenden lyrischen Dichters angenommen.[22] Bemerkenswert erscheint nicht zuletzt Rădvans Entscheidung für einen anderen Malgrund, denn die Bilder sind in grellen Farben auf schwarze Leinwand gemalt und erzeugen dadurch im Ausstellungsraum eher die Wirkung von Wandgehängen als die konventioneller Gemälde. Im Aufkommen einer abstrakten,

geometrischen Asymmetrie flächiger, wie freigestellt scharf konturierter Motive erinnern diese Arbeiten an *Meridional*, eine ältere Serie von in die Breite gestreckten Landschaften mittleren Formats, an der Rădvan 2013 zu arbeiten begann. Gemeinsam ist diesen Bildern eine Atmosphäre der schwülen Hitze, die sich durch Schirmpinien, Zikaden und Schmetterlingsmetamorphosen mitteilt, eine Stimmung der Lethargie und Trägheit unter wolkenlosem Sommerhimmel.[23]

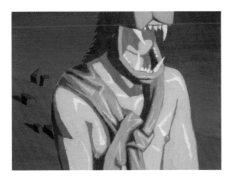 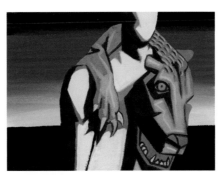 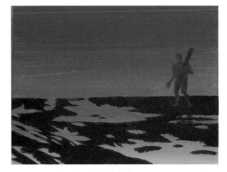

Small Hercules IV, 2014
Acrylic on canvas board /
Acryl auf Malkarton
18 H x 24 W cm
(7 3/32 H x 9 29/64 W inches)

Small Hercules V, 2014
Acrylic on canvas board /
Acryl auf Malkarton
18 H x 24 W cm
(7 3/32 H x 9 29/64 W inches)

Small Hercules VI, 2014
Acrylic on canvas board /
Acryl auf Malkarton
18 H x 24 W cm
(7 3/32 H x 9 29/64 W inches)

Das Herkulesmotiv findet sich bei Rădvan auch noch in mehreren dreidimensionalen Werken, so in der Styropor-Plastik *Hercules and the Erymanthian Boar* über die vierte Aufgabe des Helden und in der Reliefmalerei *Hercules' Victory Dance* (2019). Letztere zeigt eine gefesselte und gepolsterte Herkulesgestalt, die mit dem Löwen ringt und sich dabei aus ihrer Bildebene in den Vordergrund losreißt. Ein anderes raumgreifendes, kürzlich fertiggestelltes Werk mit dem Titel *Fragmentary Hercules at the Oracle* (2019) führt diesen Ansatz noch einen Schritt weiter, indem hier aus einem Leinwand- oder auch Zeltstoff ein Gitterrahmen gewirkt und dieser direkt an der Wand angebracht ist. Rechts davon befindet sich ein gleichfalls stoffgepolsterter Herkules auf weißer Ziege (meistens ein untergeborenes Tier mit allgemeinem heidnischen Mythos und christlichem Hindernis), links der Torso des Orakels mit Riesenbrüsten und vaginalen Öffnungen als den beiden Brennpunkten der Komposition. Beide Werke sind an Gurten als Wandgehänge beziehungsweise verformbare Skulpturenreliefs angebracht, schweben als Gleichnisse der Malerei in einem Zwischenraum und knüpfen darin zugleich an die Reliefarbeiten einiger Künstler der italienischen Transavantgarde und des Achzigerjahre-Neoexpressionismus an.

Eros und Thanatos

Dass Alexandru Rădvan seine Selbstidentifikation auf dem Umweg über verschiedene archaische und mythische, allegorische Personifizierungen betreibt, wird auch an einer neueren Serie schmaler und schlanker Selbstbildnisse deutlich, in denen er sich stehend als nackte, den Ursprung der Geschichte verkörpernde Männerfigur darstellt[24] – außerdem an weiteren Selbstbildnissen etwa als nackte Frau, mithin Sinnbild für den Beginn der Zeit, als Fruchtbarkeitsgöttin, als geschundener Satyr Marsyas, der es gewagt hat, Apollo zum Wettkampf im Flötenspiel herauszufordern, und schließlich zweifelnd im *Self-portrait as a Cautious Hero* (2019).[25] Letzteres ist auch insofern bemerkenswert, als es in seiner Bildsprache anscheinend auf uralte ländliche Maltraditionen Rumäniens zurückgreift. Es zeigt eine fiktive, an Gogols Taras Bulba angelehnte, vage asiatische Männergestalt mit einem von offenen Augen übersäten Körper, die ihre Geschlechsteile schamhaft bedeckt.[26] Damit kommen wir nun auch zu einem Thema, das ich weiter unten noch einmal aufgreife, nämlich zur überragenden Bedeutung des Films für Rădvans künstlerische Entwicklung.[27] Des Menschen Hang und Drang zu begierigem Verschlingen und Zerstören, der sexuelle Lebens- und Todestrieb, wurden bereits in der Antike als einander wechselseitig bedingend zusammengedacht und kamen in den Personifizierungen des Eros (profane Liebe) und Thanatos (Tod) zum Ausdruck, wenngleich man sie damals kaum in ihren innerpsychischen Verflechtungen und libidinalen Prägungen erkannte, die wir ihnen seit Freud zuschreiben.[28] Ein Mythenschatz besteht meist aus historisch gewachsenen, vielfältigen Erzählsträngen und verschiedenen Fassungen derselben Sage, und Rădvan bevorzugt die Nacherzählungen des römischen Dichters Ovid gegenüber den griechischen Theogonien Hesiods und der Orphiker.[29] So auch beim berühmten Mythos von Apollon und Daphne, einer Geschichte der liebestollen Werbung und der Vergeblichkeit, die darin liegt, dass diese ihr Ziel nicht erreicht.[30] Einmal mehr greift der Künstler hier ein Hauptmotiv des Barock auf. In gleich mehreren Arbeiten von 2017 und 2018 entfaltet er das Thema des Mythos, nämlich die Erbarmungslosigkeit der erotischen Begierde und ihres Strebens, und knüpft darin unmittelbar an eine berühmte Plastik von Bernini in der römischen Galleria Borghese an (1622–25).[31] In der ursprünglichen Version wird Phoebus bzw. Apollo von Cupid (Eros), dem Gott der fleischlichen Liebe, für seinen Mangel an Respekt bestraft. Eros schießt einen Pfeil mit Goldspitze auf Apollo ab, der diesem Liebestollheit und überwältigende geschlechtliche Begierde einimpft, und einen zweiten Pfeil mit Bleispitze auf die Najade Daphne, die daraufhin von der Furcht vor erotischer Liebe und Berührung mit dem Männlichen erfasst wird.

Rădvan verarbeitet in seiner Gemäldeserie unterschiedliche Aspekte dieser mythischen und alchemischen – Gold und Blei bilden im Metallschema der Alchemie Gegenpole – Erzählung.[32] In mehreren hochformatigen Bildern und beginnend mit *Eros Cruel God* stellt er sich den geflügelten Eros mit seinem Bogen bei der Rast an den Wassern eines Flusses vor (benannt nach König Peneus, Daphnes Vater) und zeigt ihn von der linken unteren in die rechte obere Bildhälfte schwebend. Daphne wird als Nymphe bzw. Najade aus einer Wald- und Flusslandschaft dargestellt, die Diana (Artemis), der Zwillingsschwester Apollos, geweiht ist. In *Daphne...almost...* wiederum sehen wir Apollo im Moment seiner frenetischen Verfolgungsjagd, gerade als Daphne die anderen Götter um Verwandlung ihrer Gestalt anfleht, damit sie seiner Begierde entgeht. *In The God, The Nymph* schließlich kommt Rădvan in der Art, wie er die Berührung zwischen Gott und Nymphe darstellt, dem Vorbild Berninis am nächsten – gefolgt von *Untouchable Love* (Titel in der linken unteren Bildhälfte), in dem Apollo die nun bereits zum Lorbeerbaum gewordene Daphne küsst.[33] In *Apollo the Sad, Daphne the Poor,* der abschließende Teil dieser geradlinigen Erzählung über eine heidnische Zweisamkeit, erscheint Apollo, parnassischer Gott der Dichtung und Musik, als Dreivierteltorso beim zärtlichen Spiel auf einer Leier zum Loblied auf seine verflossene Liebe. Die in diesen Mythos eingewirkten Symbolbedeutungen sind zahlreich, etwa indem der Lorbeer nicht nur auf intellektuelle Kraftakte auf den Gebieten des Denkens und der Dichtung, sondern auch auf Ruhmestaten gesellschaftlicher und politischer Art verweist. Ausgeführt sind diese Gemälde sämtlich als flächige Farb- und Bildebenen, auf die das Geschehen mit grafischem Pinselstrich und harten Konturen übertragen ist. Ein hohes Maß an erotischer Spannung entfaltet auch die Großplastik *After Ovid – Apollo and Daphne* aus galvanisierten Blechen und Halbedelsteinen: Die fliehende Nymphe und die losen Metallsträhnen ihres Haares umfangen einen Torso in Gestalt eines stoßenden Phallus. Die Gemäldeserie lässt sich ebenso wie die vorangegangenen Collagen auf Karton und die in Acrylstift auf Karton ausgeführten Arbeiten von 2015–17 auf anderer Ebene als ein Bangen des Künstlers um die eigene Überzeugungskraft verstehen, d. h. als das (allen schöpferischen Menschen eigene) Unbehagen angesichts der unvermeidlichen Kluft zwischen dem, was der Geist entwirft, und dem, was die ausführende Hand daraus macht. Die Collagen zum Apollo-und-Daphne-Thema sind häufig mit gemalten Texten im Geist anspielungsreicher poiesis versehen, beispielsweise *The Sad Story of Daphne the Naiad and Apollo the God* oder die schlicht *...almost* genannte Arbeit von 2017.[34] Diese Köpfe, so dürfen wir vermuten, sind dunkel erahnte Personifizierungen Apollos wie auch des Künstlers selbst.

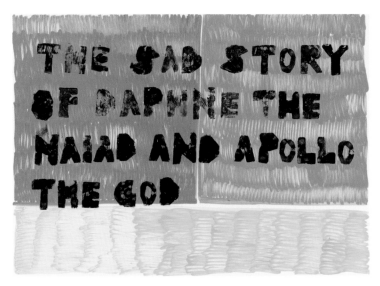

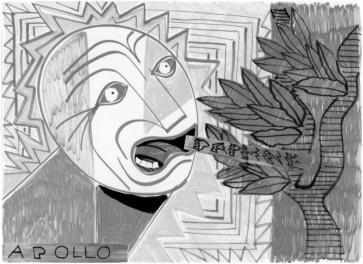

The Sad Story of Daphne the Naiad and Apollo the God, 2017
Acrylic, acrylic marker on cardboard /
Acryl, Acrylmarker auf Karton
51 H x 72 W cm
(20 5/64 H x 28 11/32 W inches)

Apollo, 2017
Acrylic, acrylic marker, collages on cardboard /
Acryl, Acrylmarker, Collage auf Karton
51 H x 72 W cm
(20 5/64 H x 28 11/32 W inches)

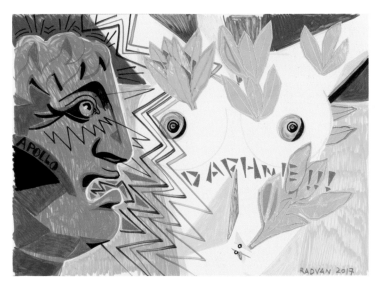

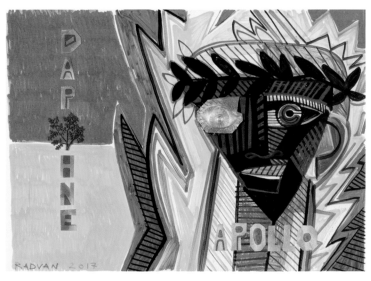

Apollo Daphne!!!, 2017
Acrylic, acrylic marker, collages on cardboard /
Acryl, Acrylmarker, Collage auf Karton
51 H x 72 W cm
(20 5/64 H x 28 11/32 W inches)

Daphne Apollo, 2017
Acrylic, acrylic marker, collages on cardboard /
Acryl, Acrylmarker, Collage auf Karton
51 H x 72 W cm
(20 5/64 H x 28 11/32 W inches)

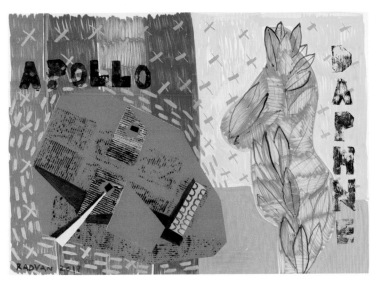

Apollo / Daphne, 2017
Acrylic, acrylic marker, collages on cardboard /
Acryl, Acrylmarker, Collage auf Karton
51 H x 72 W cm
(20 5/64 H x 28 11/32 W inches)

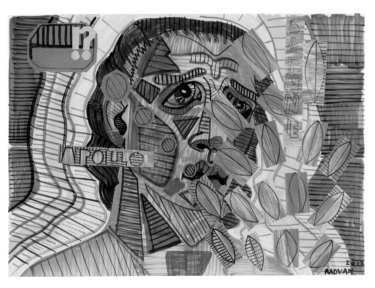

?! Apollo Daphne, 2017
Acrylic, acrylic marker, collages on cardboard /
Acryl, Acrylmarker, Collage auf Karton
51 H x 72 W cm
(20 5/64 H x 28 11/32 W inches)

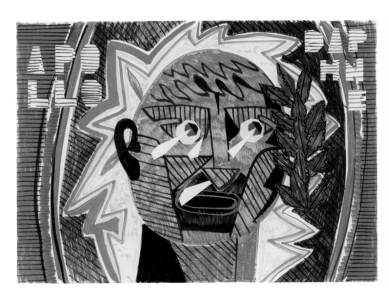

Apollo Daphne, 2017
Acrylic, acrylic marker, collages on cardboard /
Acryl, Acrylmarker, Collage auf Karton
51 H x 72 W cm
(20 5/64 H x 28 11/32 W inches)

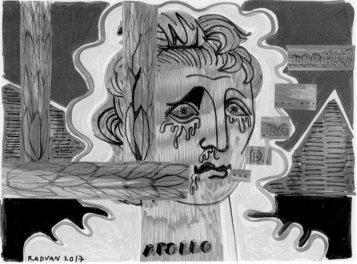

Daphne... Apollo, 2017
Acrylic, acrylic marker, collages on cardboard /
Acryl, Acrylmarker, Collage auf Karton
51 H x 72 W cm
(20 5/64 H x 28 11/32 W inches)

Die Bilder betonen sehr die verführerische Sinnlichkeit des Frauenleibs, und dass Apollos Kopf von seinem Körper getrennt ist, bringt Vorstellungen einer inneren Distanz wie auch der voyeuristischen Provokation ins Spiel. Beides tritt ebenso in der vorangegangenen, 2015 vollendeten Serie *Strange Women* mit Darstellungen weiblicher Torsi in lüstern-aufreizenden Verrenkungen zutage. In diesem Zusammenhang erwähnt der Künstler „eine Begegnung" mit Umberto Eco und eine Fahrt zu einer namenlosen Insel, die er später (2014) in *Island for Umberto* mitsamt den dort gesehenen, allerdings in seiner Vorstellung gründlich verwandelten Frauen malte. Es handelt sich bei diesen Figuren in keinem nachvollziehbaren Sinn um Bildnisse, sondern um Plastiken aus Menschenfleisch. Die Frauen sind allesamt nackt sowie mit drastisch überzeichneten Brüsten und Vulven in großen, farbigen, die Kontrastwirkungen betonenden Zeichnungen dargestellt, wobei auch hier wieder die Faszination des Künstlers für mediterrane Motive und Sujets durchdringt. Oft und gern erzählt Rădvan, wie sehr er die Hitze, das Mittelmeer und Inseln liebt. Er erinnert sich an seine jugendliche Begeisterung für die Filme des berühmten Meeresforschers Jacques Cousteau und an seinen Wunsch, selbst Taucher zu werden. Obwohl das Sujet zunächst einen Verdacht chauvinistischer Erotomanie erregen mag, empfiehlt es sich doch, diese Bilder mehr im Sinne einer inneren Personifizierung und allegorischen Darstellung der Begierde im Modus chthonischer Naturformen zu deuten. Die lüsternen Waldnymphen, in denen der Puls der Erde schlägt, verkörpern einen Fruchtbarkeitskult. Sie sind archaische Göttinnen – Dienerinnen des Thanatos.[35]

Personifizierung als Gestaltwandel

Die suggestive Macht des Films als Bild- und Erzählmedium und seine Fähigkeit, einem Moment seine prägende Gestalt zu verleihen, faszinierten Rădvan schon früh. Während er in den Jahren des Kommunismus und auch in der ersten Zeit danach kaum Reisemöglichkeiten hatte, um Ausstellungen oder Kunstsammlungen im Ausland zu besuchen, erlangte er unmittelbar nach 1990 Zugang zum internationalen Filmschaffen. Vor allem Pasolini und Fellini waren entscheidend für sein Geschichts- und Mythenverständnis, da beide den alten Geschichten in ihren Filmen eigenwillige Gestalt verliehen hatten und Rădvan dadurch neue Deutungen erschlossen. Ihre Bilder wirkten auf den jungen Künstler zunehmend wie Inszenierungen eines mythischen Fleisches oder einer paradoxen, substanzlosen Substanz. In *Edipo Re*, im *Decameron* und in den *Tolldreisten Geschichten* von Pasolini erkannte Rădvan historisch-mythische Erzählungen mit dem

Potenzial, auf anderen Wegen zu einer ästhetischen Wahrheit zu führen.[36] Abgesehen von den *Tolldreisten Geschichten*, die er als ersten Pasolini-Film überhaupt gesehen hat, verarbeitet der Künstler in seinem Werk übrigens fast ausschließlich die Kulturen und Mythen des sonnigen Südens und des griechisch-römischen Kulturkreises. An den nordischen oder germanischen Mythen zeigte er bislang kein Interesse. Das chthonische Element, die pantheistische Wald-Erde als nährende Mutter, ist zentraler Inhalt etlicher Arbeiten, die meist schlicht mit „Mythologien" oder „Rituale und die Sonne" betitelt sind. Die raumgreifenden Skulpturen-installationen *The Sleeping Centaur, Narcissus* (auch er eine wiederkehrende Gestalt im Werk Rădvans) und *Prometheus* (der den Göttern das Feuer stahl, um es den Menschen zu schenken) sind dreidimensionale Epen, die ihre erzählerische Fortführung in zahlreichen themenverwandten Collagen und Gemälden erfahren.

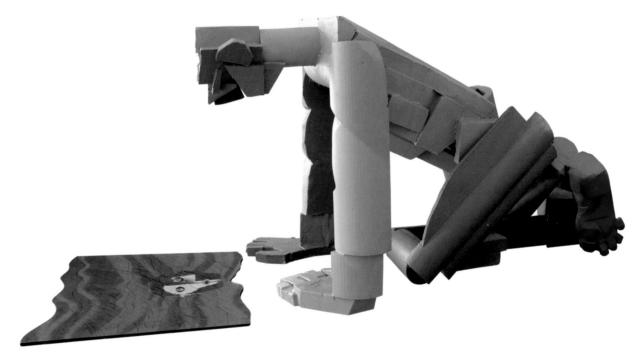

Narcissus, 2019
Polystyrene, polyurea resin, spray, painted wood / Polystyrol, Polyharnstoffharz, Spray, bemaltes Holz
154 H x 150 W x 350 D cm (60 5/8 H x 59 1/16 W x 137 51/64 D inches)

Auch die große (üppig) grüne Plastik *Mother of All Things* (2019) knüpft an das Urmuttermotiv an und weist in ihrem Hermaphroditentum einen Weg ins Leben. Hier wie in so vielen anderen Arbeiten des Künstlers steht das Weibliche im Mittelpunkt der Erkundung archaischer Riten und Verwandlungsmythen, da sich die allerersten Metamorphosen des Menschen allein der Verkörperung durch die Frau verdanken. In diesem Zusammenhang von Verwandlung zu sprechen, bedeutet zugleich, mit dem Gedanken einer Läuterung zu etwas Schönerem und Höherstehendem zu spielen.[37]

Das weibliche Geschlecht ist Ort der Entstehung und Erscheinung des Menschen in der Welt und als solches auf den großformatigen Leinwänden *Rite of Spring* und *Rite of Spring 2* wie auch in der Collage *Le Sacre du Printemps* auf Karton in Form eines Ritus thematisiert. Innerhalb der von Rădvan sogenannten Werkkategorie „Mythologien" und insbesondere bei den Arbeiten, die sein geliebtes Mare Nostrum zum Inhalt haben, kommt es zu etlichen Neuerungen auch auf dem Gebiet des Materialeinsatzes. Neben den häufigen Hochformaten in den Diptychen und verschiedenförmigen Triptychen finden sich ovale Formate und Zusammenstellungen mehrerer rechteckiger Werkteile sowie Holzkisten mit darin komponierten Elementen, etwa *Holiday* (2015), *Archaic Couple* (2016) oder *Meridian* (2016). Diese Kisten verbinden die innere Vorstellungswelt des Künstlers mit der Welt der Schaubühne, die ja mindestens in der abendländischen Kultur ebenfalls mit den Tragödien und Komödien der Griechen begann.

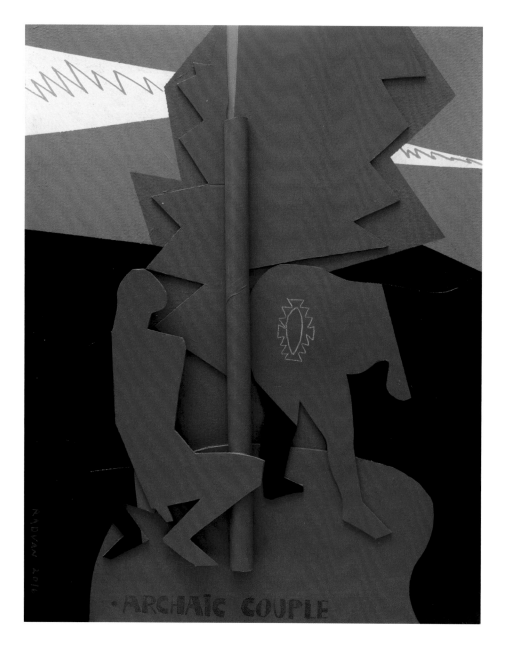

Archaic Couple, 2016
Acrylic, acrylic marker on cardboard without wodden box /
Acryl, Acrylmarker auf Karton ohne Holzkiste
125 H x 100 W x 7 D cm
(49 7/32 H x 39 3/8 W x 2 3/4 D inches)

Koitusdarstellungen erscheinen hier und da, so in *Mythologies VI–IV*, doch sie zielen auf keine unmittelbar erotische Wirkung, da sie sich von Radierungen oder Holzschnitten mit antiken oder archaischen Motiven wie den „Kopflosen" (acephale) oder „Blemmyern" ableiten, die als Fabelwesen mittelalterliche Manuskripte und illustrierte Bestiarien bevölkerten.[38]

 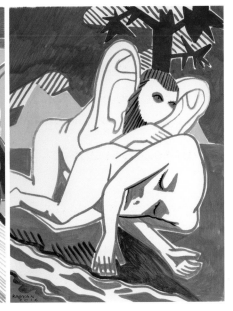

Mythological IV (Two Blems), 2016
Acrylic marker on canvas /
Acrylmarker auf Leinwand
60 H x 45 W cm
(23 5/8 H x 17 23/32 W inches)

Mythological V (Blem), 2016
Acrylic marker on canvas /
Acrylmarker auf Leinwand
60 H x 45 W cm
(23 5/8 H x 17 23/32 W inches)

Mythological VI (Panot and Blem), 2016
Acrylic marker on canvas /
Acrylmarker auf Leinwand
60 H x 45 W cm
(23 5/8 H x 17 23/32 W inches)

Weiters finden sich Anklänge an die Musik, beispielsweise im großformatigen Gemälde *Prokofiev* (2014) als Narzissmythos oder mit Bezug auf den *Sacre du printemps* als Initiationsritual.[39] Als äußerst wirkungsvoll erweist sich die ungewöhnlich große Vielfalt der gestischen Zeichen, Striche und Formen in diesen Gemälden und Collagen. Der Künstler nutzt hierzu verschiedene Arten reduzierter Strichzeichnung, Schraffuren, wunderschön abstrahierte Blatt- und andere stilisierten Naturformen, Symmetrien und Asymmetrien, Farbflecken und mit dem Pinselkopf aufgetragenen Kleckse, versetzte oder verschobene Linien wie in *Mythological (Faun)* und Muster wie in *Mythological III (Bacchus)* mit ihren gegenläufigen, weit ausholenden Schrägschraffuren nach einem Verfahren, das Jasper Johns in den 1970er Jahren in ähnlicher Weise anwandte.[40]

Nirgendwo tritt Rădvans fortwährende Mutation personifizierender Selbstverweise im Reich des offenen Zeichens klarer hervor als in seiner Verarbeitung des Pygmalion-Mythos. Schon in der Fassung Ovids gerät diese Sage zu einer Polemik, und seither ist kaum ein

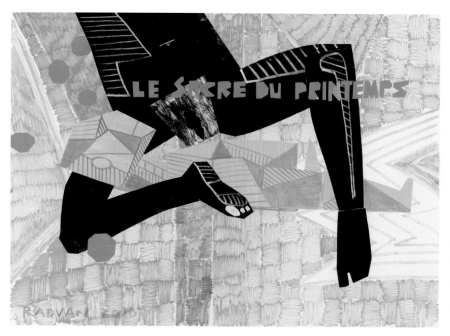

Le Sacre du Printemps, 2016
Acrylic, acrylic marker, collage on cardboard /
Acryl, Acrylmarker, Collage auf Karton
70 H x 100 W cm
(27 9/16 H x 39 3/8 W inches)

anderes mythisches Gleichnis des Selbstausdrucks (der Selbstschöpfung durch die Projektion von Alterität) so eingehend psychologisch und/oder ästhetisch befragt worden. In Theaterstücken und Filmen, Musikbearbeitungen und Romanen und zahlreichen inhaltlich anknüpfenden Texten wurde die Geschichte des Bildhauers Pygmalions auf allen Ebenen der Hoch- und Populärkultur durchdekliniert[41] – als eine im Grunde einfache Erzählung, deren Komplexität erst aus den Deutungen der Überlieferung entsteht. Pygmalion bleibt, da „empört ob der Menge der Laster des Weibergeschlechtes", Junggeselle. „Aber er bildet indessen geschickt ein erstaunliches Kunstwerk, weiß wie Schnee, ein elfenbeinernes Weib, wie Natur es nie zu erzeugen vermag, und... verliebt sich ins eigne Gebilde."[42]

Pygmalion behandelt seine Statue wie eine lebende Frau. Er kleidet und schmückt sie, er küsst und liebkost sie, er stellt sich vor, dass sie seine Küsse erwidert, bringt sie in aufreizende Posen, überreicht ihr Geschenke – macht also aus seinem Bildwerk das, was wir heute seinen ganz persönlichen Fetisch nennen würden. Nach einer Opfergabe und inständigen Bitten beim jährlichen Fest der Venus auf Zypern gibt die Göttin seinem Drängen nach: Als Pygmalion nach Hause kommt, ist seine Statue zum Leben erwacht. Er heiratet sie, und neun Monate später gebiert sie ihm einen Sohn. All das ist in gewisser Weise eine Hommage und Würdigung unbeirrbarer Hoffnung, wenngleich den Fraue bewegungen der heutigen Zeit die glückliche Auflösung kaum gefallen wird. Es enthält auch Anklänge an die Schöpfungsgeschichte in der Bibel, in der Eva durch göttliches Wirken aus einer Rippe Adams entsteht. Doch für Rădvan ist das eigentlich Interessante an der Geschichte die Person des Bildhauers, die Schaffenskraft und

Macht des Künstlers, sich selbst und die Welt rundherum neu zu erschaffen, in und mit künstlerischem Wirken der Stimmung und dem Gefühl einer Zeit ihre Gestalt zu geben, ein anderes, ein gesteigertes Lebensgefühl zu erzeugen. *In Sculptor. Pygmalion* (triptych) (2014) wird uns die Welt des Bildhauers-Künstlers vorgeführt. In den Collagen *Pygmalion I–III* (Acryl auf Papier, 2015) sieht man diesen Bildhauer bei der Arbeit an großbrüstigen biomorphen Plastiken. *Pygmalion – The Artist and the Model* (2015) (ein gleichnamiges, großformatiges Gemälde von 2017) versteht sich als eigenständige Serie von Collagen, nicht als Skizzen oder Entwürfe für die Gemälde, obwohl durchaus Übernahmen und Entsprechungen zwischen den Arbeiten zu erkennen sind. Bei *Sculptor Studio, with the Endless Column* stehen wir vor der einladenden Szenerie eines großen, roten Atelierraums voller Plastiken (Matisse lässt grüßen).

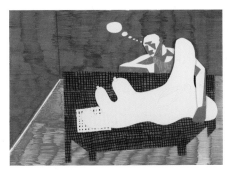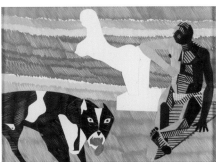

Pygmalion I, 2015
Acrylic marker and collage on paper /
Acrylmarker und Collage auf Papier
51 H x 72 W cm
(20 5/64 H x 28 11/32 W inches)

Pygmalion II, 2015
Acrylic marker and collage on paper /
Acrylmarker und Collage auf Papier
51 H x 72 W cm
(20 5/64 H x 28 11/32 W inches)

Pygmalion III, 2015
Acrylic marker and collage on paper /
Acrylmarker und Collage auf Papier
51 H x 72 W cm
(20 5/64 H x 28 11/32 W inches)

Wie es scheint, entfernt sich Brâncuși nie weit aus dem Bewusstsein eines rumänischen Künstlers. *Remembering a Great Love* (2019) ist ein Bild voll Feuer und grellbunter Hitze: Der Künstler sitzt inmitten all dessen und in inniger Zweisamkeit mit seinem Bildwerk. Oder, wie Rădvan selbst sagt: „Ich besame all die Mythen der Welt und erwecke sie in meinem Fleisch zum Leben." Er bringt damit die allegorische Verkörperung mythischen Fleisches, die in seinem Werk stattfindet, auf den Punkt. Das mag manchem eine allzu romantische Sicht der Welt ergeben. Alexandru Rădvan bekennt sich offen und ohne Rückhalt eben dazu.

©Mark Gisbourne

Endnoten

1 Ein Gemälde ist Ding- und Denkbild zugleich; als darstellendes „Ding" weist es eine ressemblance (Ähnlichkeit) auf und zielt auf einen bestimmten Gedanken oder eine Idee. Demgegenüber ist das „Denkbild" eher gleichnishafte similitude (Gleichartigkeit), es unterliegt einer unabgeschlossenen Variierbarkeit und Interpretation als Zeichen. Vgl. Michel Foucault, „Malen ist nicht Behaupten", in: *Dies ist keine Pfeife*, München 1974. (In dem Text geht es hauptsächlich um Magrittes Gemälde *La trahison des images* – „Ceci n'est pas une pipe" von 1929).

2 Zu den Unterschieden zwischen der Semiotik Saussures und der Semiologie nach Charles S. Pierce, vgl. Robert E. Innes (Hrsg.), *Semiotics: An Introductory Anthology*, Bloomington und London 1985.

3 Die Allegorie und der Vorgang der „Allegorese" nach griechisch „allos" für „der andere" sind die jedem Bild eigene Polysemie oder Mehrdeutigkeit. Sie lassen sich so verstehen, dass die gegenständliche Malerei zwar eine Illusion (eine „Bildlüge") ist, sich durch Anspielungsreichtum jedoch zu einer Offenbarung der Wahrheit „allegorisieren" lässt. Vgl. Maureen Quilligan, *The Language of Allegory: Defining the Genre*, Ithaca and London 1979, S. 26, 46. Einen Überblick zum Thema bietet Jeremy Tambling, *Allegory*, London 2010.

4 Das Kunstwollen, ein anhaltend wissenschaftlich debattierter Begriff, wurde als ein teleologisches Streben in der Kunst erstmals 1958 von Heinrich Brunn formuliert und in den Schriften von Alois Riegl und der Wiener Schule der Kunstgeschichte ausgearbeitet. Vgl. Andrea Reichenberger, *Riegls „Kunstwollen": Versuch einer Neubetrachtung*, Sankt Augustin 2003. Der Begriff unterlief traditionelle Stilauffassungen der Kunstgeschichte, denen zufolge es Höhepunkte und Niederungen in der Entwicklung der Kunst gebe, und verband das Kunstschaffen mit einem bestimmten jeweiligen Zeitmoment als seinem Inhalt und Gegenstand. Siehe Margaret Iversen, *Alois Riegl: Art History and Theory*, Cambridge, MA, 2003.

5 Maurice Merleau Ponty, „Fragen und Dialektik", in: ders., *Das Sichtbare und das Unsichtbare*, München 2004, S. 88f. Merleau-Ponty ging in dieser Untersuchung eines „Wahrnehmungsglaubens" als vorreflexiver Überzeugung davon aus, das uns die Wahrnehmung die Welt zeige, wie sie tatsächlich ist, obwohl alle Wahrnehmung jedem einzelnen von uns durch unsere jeweiligen leiblichen Sinne gegeben ist.

6 Merleau-Ponty, „Das Auge und der Geist", in: *Das Auge und der Geist. Philosophische Essays*, Hamburg 1984. S. 278, letzter veröffentlichter Text des Autors vor seinem Tod im Jahr 1961.

7 Frühe Besiedlung durch Griechen, Kelten und Daker, nach denen die römische Provinz den Namen Dacia erhielt. Siehe Vlad Georgescu, *The Romanians: A History*, Columbus, 1991.

8 Der Glaube an einen unmittelbaren schöpferischen Strom zwischen Traumdenken und Bewusstsein, zwischen Mythos und Wirklichkeit, war ein Hauptmerkmal der surrealistischen Ästhetik. Vgl. André Breton, *Die kommunizierenden Röhren*, München 1973.

9 Unter den vorsokratischen Denkern, d.h. vor dem platonischen Idealismus und dem aristotelischen Materialismus, standen das Bewegliche oder Elementare, der Materialismus und Atomismus von Heraklit, Demokrit und anderen, dem Denken in Erscheinungen und ewig unwandelbaren Ideen (Parmenides und Eleaten) gegenüber. Vgl. D. W. Graham (Hg.), *The Texts of Early Greek Philosophy: The Complete Fragments and Selected Testimonies of the Major Presocratics*, 2 Bde., Cambridge 2010.

10 Das Bild lässt an einige Figuren in Raffaels Mond-Kreuzigung (Gavari-Kapelle, 1502-3) in der Londoner National Gallery denken. Dieses stark von Perugino beeinflusste Altarbild kennt Rădvan sehr gut, seit er im Alter von 19 Jahren, um das Jahr 1996, drei Wochen London besucht und dort viel Zeit in den Museen verbracht hat. Zu Raffael siehe A. Roy, M. Spring und C. Plazzotta, „Raphael's Early Work in the National Gallery: Paintings before Rome", *National Gallery Technical Bulletin*, Bd. 25, S. 4-35.

11 Mörtel war eine Erfindung der Römer, und auch das ursprünglich aus dem Zweistromland und Ägypten stammende Glas, das sie aus Alexandria importierten, wurde erst von ihnen für die Massenproduktion nutzbar gemacht (etwa wie Plastik in unserer Zeit). Nicht zufällig verwendete der Künstler daher in seinem Frühwerk gerade diese Materialien. Vgl. D. F. Grose, „Early Imperial Roman Cast Glass: The Translucent Coloured and Colourless Fine Wares", in: *Roman Glass: Two Centuries of Art and Invention*, Society of Antiquaries of London, London 1991.

12 Alexandru Rădvan, ©*Memoriile Lui Constantin/Memories of Constantine*, Anaid Art Gallery, Bukarest 2006.

13 Achille Bonito Oliva, *The Italian Trans-Avantgarde/Transavangurdia Italiana*, Mailand 1978.

14 Das griechische Motiv des „Universalathleten" stammt unverkennbar aus der Antike. Vgl. die in Alexandru Rădvan, Anaid Art Gallery, Bukarest 2012, abgebildete Serie.

15 Ruxandra Demetrescu, Diana Dochia und Roxana Rădvan, *For Tomorrow: Investigating new Materials in the works of Alexandru Rădvan*, Bukarest 2014.

16 Personifizierung lässt sich definieren als „eine Sonderform der Allegorie, bei der ein abstrakter Gedanke durch eine erfundene Gestalt dargestellt wird." Sie ist demgemäß Maske einer unsichtbaren, abwesenden, ungreifbaren oder unlebendigen Qualität und erweckt als solche den Anschein einer eigenständigen Identität. Vgl. „Medieval and Renaissance Personification", in: Tambling, *Allegory*, wie Anm. 3, S. 40–61, Glossar S. 176.

17 Das Motiv der Lebensreise findet sich schon im Gilgamesch-Epos (ca. 1800 v. Chr.), einem der ältesten Dokumente der Weltliteratur.

18 Zur anthropologischen und philosophischen Analyse des Monomythos vom Helden siehe Joseph Campbell, *Der Heros in tausend Gestalten*, Princeton 1968.

19 Die Werkstatt der Familie Carracci in Bologna und insbesondere deren Fresken und Gemälde im Palazzo Farnese (ca. 1595) gelten in der Kunstgeschichte als die Anfänge des italienischen Barock. Vgl. John Rupert Martin, *The Farnese Gallery*, Princeton 1965; Stefano Colonna, *La Galleria die Carracci in Palazzo Farnese a Roma*, Rom 2016.

20 Das „objet petit a" ist nach Lacan das immer schon verlorene, im anderen gesuchte Objekt der Begierde, also die Fantasievorstellung. Vgl Jaques Lacan, *Seminar, Buch V (1957–1958): Die Bildungen des Unbewussten*, Wien und Berlin 2006. Ein Versuch der Definition bei Alan Sheridan, „Translator's Note", in: Jacques Lacan, *The Four Fundamental Concepts of Psychoanalysis*, London 1992, S. 282; zum Rückgang auf die Antike vgl. Oliver Harris, *Lacan's Return to Antiquity: Between Nature and the Gods*, London 2017, S. 21.

21 Der Ausdruck „ut pictura poesis" stammt aus der *Ars poetica des Horaz* (65–8 v. Chr.) und bedeutet „wie in der Malerei, so auch in der Dichtung". (19 v. Chr.)

22 Die „Idylle" ist eine Gattung der Schäferdichtung, die auf Theokritus (300–260 v. Chr.) zurückgeht, vgl. Richard L. Hunter, *Theocritus and the Archaeology of Greek Poetry*, Cambridge 1996.

23 Alexandru Rădvan, *Torrid Geometry*, Anaid Art Gallery, Berlin Art Week (13. bis 18. September 2016), Berlin 2016.

24 Die „Selbstbildnisse" wurden gemeinsam mit den Plastiken in der Einzelausstellung *The Oldest Day* vom 14. Mai bis 23. Juni 2019 am Bukarester Kulturzentrum ARCUB gezeigt.

25 Das Bild *Self-Portrait as a Super Ancient Goddess* (2019) war in der Ausstellung *Partner for the Abyss*, Bazis Contemporary (7.5.–15.6.2019), Cluj (Klausenburg), Rumänien, zu sehen.

26 Taras Bulba ist der gleichnamige Held in einer berühmten Novelle von Nikolai Gogol (1835). Die Geschichte wurde viele Male verfilmt und vielleicht am bekanntesten durch die Hollywood-Version von 1962 mit Yul Brynner und Tony Curtis in den Hauptrollen. Die Darstellung des Helden bei Rădvan ähnelt dem Erscheinungsbild von Brynner mit kahl rasiertem Schädel und Pferdeschwanz.

27 Der Künstler ist mit Filmen wie: *Die 120 Tage von Sodom* (1975) und *Edipe Re* (1967) von Pier Paolo Pasolini oder auch Frederico Fellinies *Satyricon* (1969), die allesamt Mythen und antike Motive verarbeiten, vertraut. Eine Installation (hauptsächlich mit Plastiken) des Künstlers namens *Romantic Tomb for Pasolini* bei Kube Musette in Bukarest 2015 verstand sich als Hommage an den italienischen Filmemacher und Schriftsteller.

28 In Freuds psychoanalytischer Begrifflichkeit stehen Eros und Thanatos für die Liebes- und Todestriebe. Vgl. Sigmund Freud, *Jenseits des Lustprinzips* (1920), GW 13.

29 Publius Ovidius Naso (43 v. Chr.–17 n. Chr.) schrieb als Liebesdichter zuerst die *Amores* und *Heroides* (Liebesbriefe verlassener Frauen an ihre ehemaligen Liebhaber oder Ehemänner) sowie die Ars Amatoria. Sein eigentlicher Ruhm gründet aber auf den im Jahr 8 v. Chr. veröffentlichten Mythenerzählungen der *Metamorphosen*.

30 Ebd., Zeilen 453–568.

31 Das Motiv wurde erstmals in den Kreisen Lorenzo di Medicis und der Neuplatoniker im Florenz der 1470er und 1480er Jahre aufgegriffen. Ein Beispiel dafür ist das Werk *Apollo und Daphne* von Piero und/oder Antonio del Pollaiuolo, dargestellt ebenfalls im Moment der Verwandlung in den Lorbeerbaum, das zum Vorbild vieler weiterer Darstellungen dieser Sage wurde. Das Gemälde befindet sich heute in der National Gallery, London. Vgl. Alison Wright, *The Pollaiuolo Brothers: The Arts of Florence and Rome*, Newhaven 2005.

32 Der alchemische „Stein der Weisen" sollte niedrige Metalle wie Blei oder Quecksilber in Gold verwandeln. Siehe C.J.S. Thompson, „The Philosopher's Stone and the Elixir of Life", in: *Alchemy and Alchemists*, Kap. Xi, New York 2002 (1932).

33 Diana Dochia, Alexandru Rădvan, *Untouchable Love*, Anaid Art Gallery (27.4.–26.5.2018), Berlin 2018.

34 Im Gastmahl spricht Diotima von „poiesis" als dem Streben der Sterblichen nach Unsterblichkeit. Diese wird in dem berühmten Dialog Platons auf dreierlei Arten bestimmt: geschlechtliche Fortpflanzung, Heldentum im Kreis der Stadt, Streben der Seele nach Tugend und Weisheit. Vgl. Robert Cavalier, „The Nature of Eros", http://caae.phil.cmu.edu/Cavalier/80250/Plato/Symposium/Sym2.html

35 Der Mythos des vergossenen Samens zieht sich durch die Erzählwerke Homers und Hesiods und darüber hinaus bis in die Gegenwartsliteratur. Siehe Rachel Hills, *The Sex Myth: The Gap Between Our Fantasies and Reality*, New York 2015, S. 60. In dieser Tradition gilt der Mythos von Erichthonius als antike Erörterung des „vorzeitigen Samenergusses".

36 Sophokles, *König Ödipus* (ca. 429 v. Chr.), Giovanni Bocaccio, *Decamerone* (1453), Geoffrey Chaucer (1387–1400), *The Canterbury Tales.*

37 Elinor Gadon, *The Once and Future Goddess: A Symbol of Our Time*, San Francisco and London, 1989.

38 Die Blemmyer (– der Name stammt vom römischen Geografen Strabo aus dem 1. Jh. n. Chr., der ihn auch auf Fabelwesen wie zweiköpfige Menschen, einäugige Zyklopen und Menschen mit Tierköpfen ausdehnte, die er aus den Historien des Herodot (5. Jh. v. Chr.) kannte. Diese Fabelwesen tauchen in unzähligen mittelalterlichen Manuskripten und Bestiarien auf, ebenso in Drucken, über die es jede Menge Literatur gibt. Rădvan hat die Idee möglicherweise von Umberto Eco übernommen, der auf sie in seinem Roman *Baudolino* (Mailand 2000) Bezug nimmt. Das Buch spielt im Konstantinopel des 12. Jahrhunderts.

39 Angeblich ein uraltes heidnisches Fest in Russland, ist es hauptsächlich aus Sergej Djagilews „Ballets Russes"-Inszenierungen von Igor Strawinskis Ballett mit dem Tänzer Vaslav Nijinsky und den Bühnen- und Kostümbildern von Nicholas Roerich von 1913 bekannt. Vgl. Peter Hill, *Stravinsky: The Rite of Spring*, Cambridge 2000.

40 Zu Jasper Johns siehe ausführlich: Kirk Varnadoe (Hrsg.), *Jasper Johns: A Retrospective*, Museum of Modern Art, New York 1996.

41 Freud in der Psychoanalyse und George Bernard Shaw mit seinem Theaterstück *Pygmalion* (1913), das 1956 als Musical inszeniert wurde und 1964 als der berühmte Film *My Fair Lady* in die Kinos kam. Der Pygmalion-Mythos spielte auch für die frühen Vertreter des Surrealismus in Frankreich eine wichtige Rolle (1924–59).

42 Ovid, *Metamorphosen*, ÜS Hermann Breitenbach, Stuttgart 1988, 10. Buch, Zeilen 245ff.

THE FRAGMENTARY MYTHS OF ALEXANDRU RĂDVAN

The great art historian and theorist Erwin Panofsky[1] stated at one point that our civilisation invented the future using fragments of the past. One of the most appreciated Romanian artists of the 2000 generation, Alexandru Rădvan, thinks and creates his discourse in the spirit of Panofsky. Remains of the past - fragments of Greek and Roman sculptures and paintings; the great myths and stories of antiquity, the ancient legends and beliefs—are studied, researched and interrogated in order to be reinterpreted in the manner of contemporary artistic discourse. The uniqueness of Rădvan's art lies in the power of interrogation, in the passion used to project his visions in large canvases and sculptures. His artistic creation describes a history of the fragment, of the truncated narration, the lost legends and the forgotten myths. Rădvan treats his heroes as his equals, they are characters with whom he can talk, either calmly or in contradiction. His creation is divided into extensive series of works aimed at reinterpreting myths and mythologies—Pygmalion, Apollo and Daphne, Hercules—are just a few examples.

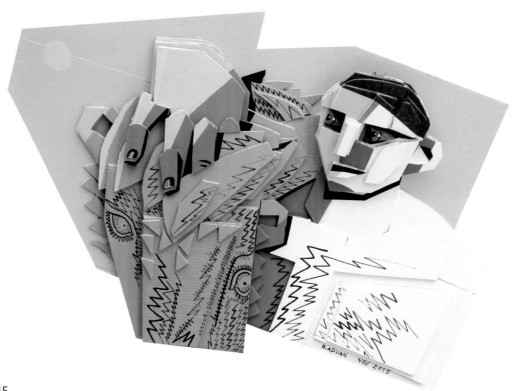

Hercules, 2015
Acrylic, acrylic marker on cardboard /
Acryl, Acrylmarker auf Karton
87 H x 131 W x 17 D cm (34 1/4 H x 51 37/64 W x 6 11/16 D inches)

Mythical and mythological characters parade before our eyes, coming from the mists of time with the desire to question the contemporary world. The artist's relation to the fundamental myths of mankind and their discussion in the light of the contemporary society is the foundation of his creation. Rădvan is fascinated by mythology, symbols, the fabulous and the ineffable, the story and the legend itself. His heroes arise from the deep desire of the artist to master the myth, to understand the springs that formed its basis and to deliver them to the viewer in a form that does not take into account rules and conventions.

As for the mission of art, the great German writer Bertolt Brecht wrote at one point that art is not a mirror held up to reality, but a hammer with which to shape it.[2] Or this is exactly what Alexandru Rădvan tries to do by dissecting the myth, the legend, their meaning and their significance, with the sharpness of a surgeon. The catalogue 'Mythical Flesh' includes the artist's creation of the last seven years – the period 2014—2021 – offering an exhaustive way of treating the work through three media of artistic representation– painting, collage and sculpture. In this new series of works, although he continues to use large formats and strong colours, he started to integrate, more and more often in the creative process, three-dimensional elements, either through the different textures of the materials used, such as cardboard or textiles, or through the sculptures or the elements of sheet metal or resin. Through them he tries to transcend the limitations imposed by the two-dimensionality of the canvas and to create the sensation of an incandescent space and atmosphere through the power of colours. Strong colours intensify or reduce the feeling of spatial movement and three-dimensionality. Regarding the use of strong, solar colours, the artist says: 'There is not enough orange, yellow and red in the world to be able to reproduce the dry incandescence of the worlds I dream of. The characters are drunk with light and they drug themselves with the brightness of the colours. The forms are irradiated by the hot atmosphere and they become more and more purified, tense and clarified, until they begin to resemble figures of the beginning of the world, namely massive, brutal and candid at the same time. It is a warm, imperfect, human geometry. It is an order stirred by strong emotions, by feelings without nuances. Everything in a dim light.'[3]

'Mythical Flesh' is about the beginnings of the world, about the days when the goddesses, the centaurs, the tyrants used to populate the earth, arousing jealousies, struggles, desires, sacrifices. His large canvases depict fundamental rituals using the entire arsenal of art history such as the peacock, the shadow, the lily flowers, the idol, the muse, the

mermaid, etc. His oversized sculptures remind us of the ancient giants of Greece and Rome, who by their mere presence used to dominate the world. His installations question the fragment, once again, as a means of reviving the dialogue with the past. His collages bring in the limelight a hidden desire of creators to give life to the characters they create. The myth of Pygmalion is not chosen at random, the beautiful statue of Galatea comes to life, giving its creator the fulfillment of a dream.

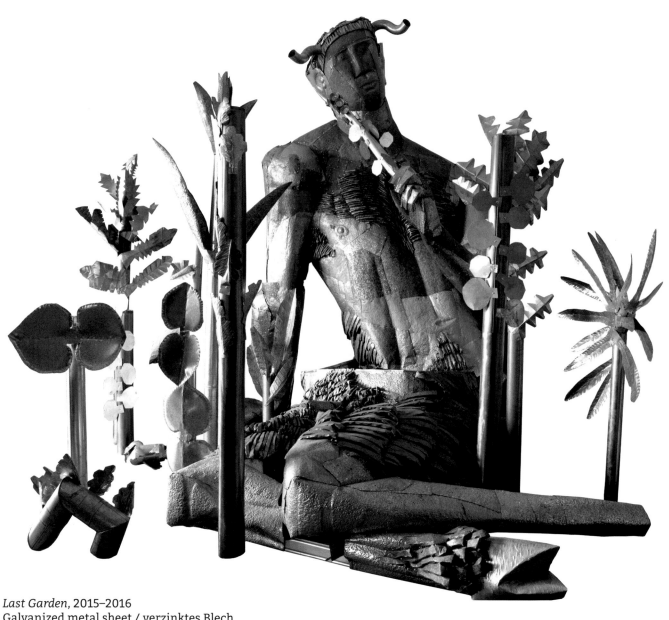

Last Garden, 2015–2016
Galvanized metal sheet / verzinktes Blech
360 H x 490 W x 370 D cm (141 47/64 H x 192 29/32 W x 145 43/64 D inches)

Hegel considered the work of art to be essentially a question/interrogation since it opens a direct dialogue with the viewer.[4] It is precisely from this perspective that the work of Alexandru Rădvan should be seen and interpreted. An important cycle of works highlights one of the most represented myths in the history of art—Apollo's

obsessive love for the chaste Daphne. Apollo, the god of light, day and art insulted the god of love, Eros, who took revenge on him, making Apollo fall in love with Daphne. This game of impossible love, of constant rejection outlines a deaf battle in which the characters intertwine borrowing elements from each other, creating the impression of osmosis in the absence of a real touch. The works of art release a great erotic charge describing the tension between the chaste Daphne and the growing desire of the god Apollo. A generic and timeless Apollo crushed by desire and impossibility. Daphne chose the ultimate sacrifice, turning into a bay tree with evergreen leaves.

The heroes that the artist takes over are often the ones who are put in impossible situations or who have to face many obstacles. No matter if it's Pygmalion, Apollo or Hercules, they are all undergoing a series of trials. One of the most extensive series of works is the one dedicated to Hercules. Hercules is a demigod, an ordinary man with supernatural powers who has had to face his difficult destiny over time. He becomes in literature and art a symbol of the human condition, an inspirational figure. Somehow Hercules is an Alter Ego of the artist. A temperamental, solar, powerful Hercules, a multifaceted figure with often contradictory features.

Our world, as we see and feel it today, has been built on fragments of these legends and myths. The French philosopher Jean François Lyotard considers that contemporary society excludes/rejects grandiose universal structures such as religions, geniuses, myths, etc., in favour of local narratives and personal myths.[5] It is a world that functions as an anti-system, but at the same time borrows and appropriates elements from various cultures and ideologies, which settle in this process of fragmentation.

At the beginning of the world—Pygmalion, Prometheus, Marsyas, centaurs, goddesses —they lived their sexuality organically and naturally, their dramas, jealousies, desires making legends happen and stories come to life. Today, as it appears in the work 'May we live in interesting times' the mystery has been destroyed, the story or legend has lost its greatness; there is nothing left but two individuals—a he and a she—disconnected from each other, looking directly into the eye of the viewer and having a certain element that unites them, the grill. It is the moment when reality killed the myth.

The junction with the contemporary world is made through Narcissus. A current Narcissus dominated by permanent and selfish reporting to himself. A Narcissus

who obsessively mirrors himself in each character. Rădvan's multi-faceted self-portraits are also a reference to Narcissus, a reflection of his own Self in various interpretations. This is how the four self-portraits are born—*Self-portrait as a Cautious Hero; Self-portrait in the Beginning of History; Self-portrait in the Beginning of Time; Self-portrait as Marsyas*—through the representation of a doubled 'I'.

Alexandru Rădvan, one of the most controversial artists of his generation, tries tirelessly to penetrate the darkest and most abyssal human desires. There, in the inner darkness, in the grave silence, the artist shapes his heroes and goddesses in oversized self-portraits, in which his own 'I' becomes an alter ego of the mythical characters. His self-portraits describe an inner state, a permanent desire to find an 'Other' capable of deciphering, understanding and accepting an 'I' born from the abyss, coming from a deep precipice where the feeling of inadequacy is based on the artist's sense of alienation, by distancing himself from his own person. True knowledge needs conflicts, breaks, contrasts and leaps, a total change.

The idea of body fragment also evokes the idea of fragmented self. For Jacques Lacan,[6] in his theory of 'the body in pieces/fragmented body', the driving force behind the creation of the ego as a mirror-image was the prior experience of the fragmented body. The basis of the imaginary origin is the formation of the ego in the 'mirror' stage, therefore the ego is formed by identifying with the counterpart image and the relationship whereby the ego is constituted by identification is a locus of 'alienation', another feature of the imaginary, with elements which are fundamentally narcissistic. Deleuze defines the imaginary 'by games of mirroring, of duplication, of reversed identification and projection, always in the mode of the double'.[7]

Alexandru Rădvan's paintings and sculptures are carried out on large surfaces attracting the viewer both by their impressive dimensions and by the addressed topics. The rough, unveiled sexuality often seeks the marginal, the exception, the abnormal, the fabulous. Concerns in the area of sexual interrogations, of obvious facts and transgressions appear as early as the beginning of the artist's creation being developed in two works—*Cancer* (2007) and *Homage to Judas XXXI* (2008)—which are a benchmark of Romanian art after the fall of the Iron Curtain. In the post-communist period and especially in the first decade of the 2000s, taboo sexual subjects and the reinterpretation of sexuality in art lead to a series of exhibitions, often considered obscene. The deformed body, in

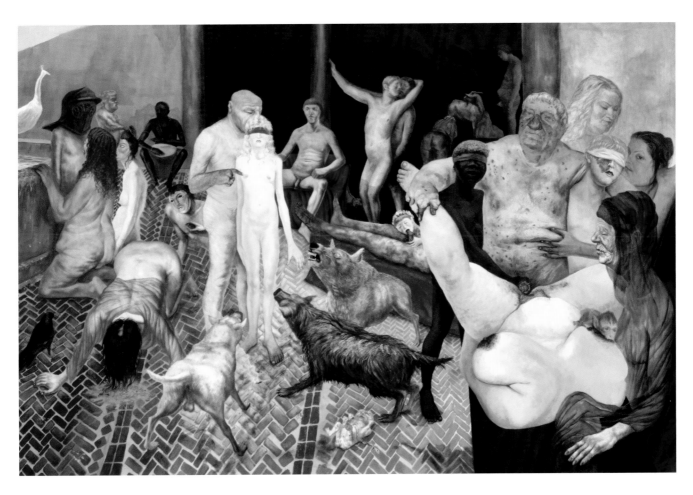

Cancer, 2007
Acrylic on canvas / Acryl auf Leinwand
200 H x 300 W cm (78 47/64 H x 118 7/64 W inches)

sadomasochistic positions, within sexual orgies, describes a sexuality at the limit. The body seen as a fragment or as a trauma becomes a way of self-reflection and of understanding of the contemporary society. The cultural and socio-political context in which the artist works also describes the prudishness of the public and its revolt towards transgressive art. Transgressive art tries to suspend taboos without replacing them. In front of a transgressive work the viewer feels pleasure as well as pain; attraction as well as revolt; seduction as well as repulsion. Edward Lucie-Smith says: 'Moreover, the art created and the critical discourse on art in general emphasize social, political, and sexual contexts rather than the formal value, the meaning of the work deriving from its figurative content, often in relation to sexuality and gender'.[8]

Alexandru Rădvan is himself a product of the idea of fragment. Born in 1977 in Bucharest, Romania, at that time a country belonging to the Communist Bloc, he was educated and trained during the communist period. He graduated from the University of Art Bucharest in 2000 and became the assistant of Florin Mitroi, professor and artist. He has been

exhibiting frequently since the late 1990s, being one of the most visible artists of the new wave after the fall of the Iron Curtain. He has exhibited together with important names in contemporary art—Bill Viola, Andres Serrano, Georg Baselitz—but his artistic approach remains unique in the Romanian art landscape. His creation depicts a world beyond any norm, full of contradictions, anxieties, conflicts, desires that are somehow isolated from the society around him.

Diana Dochia

Endnotes

1 Erwin Panofsky, *Renaissance and Renascences in Western Art*, ed. Routledge, London, 1972.

2 Bertolt Brecht, 'The Modern Theatre is the Epic Theatre' in: *Theater in Theory 1900-2000: An Anthology*, ed. David Krasner, Oxford: Blackwell Publishing, 2008, 171-173.

3 Interview with Alexandru Rădvan in 2015.

4 *Lectures on Aesthetics (Vorlesungen für Ästhetik)* is a compilation of notes from university lectures on aesthetics given by Georg Wilhelm Friedrich Hegel in Heidelberg in 1818 and in Berlin in 1820/21, 1823, 1826 and 1828/29. T was compiled in 1835 by his student Heinrich Gustav Hotho.

5 Jean François Lyotard, *La Condition postmoderne: Rapport sur le savoir*, Le Édition Minuit, Paris, 1979.

6 Jacques Lacan, *Jacques. Écrits: A Selection*, Tavistock Publications, London, 1977.

7 Gilles Deleuze, 'How Do We Recognize Structuralism?' (1972) in David Lapoujade (ed.), *Desert Islands and Other Texts, 1953 – 1974*, *Semiotext(e)*, New York, 2004, p. 172.

8 Edward Lucie – Smith, *Sexuality in Western Art*, ed. Thames and Hudson, London, 1995, p. 8.

DIE FRAGMENTARISCHEN MYTHEN
VON ALEXANDRU RĂDVAN

Der große Kunsthistoriker und Theoretiker Erwin Panofsky[1] hat einmal gesagt, dass unsere Zivilisation die Zukunft aus den Fragmenten der Vergangenheit geschafft hat. Alexandru Rădvan, einer der am meisten geschätzten rumänischen Künstler der Generation 2000, denkt und schafft seinen Diskurs im panofskyianischen Geist. Die Überreste der Vergangenheit – Fragmente von griechischen und römischen Skulpturen und Gemälde; die großen Mythen und Geschichten der Antike, die uralten Legenden und Glauben werden untersucht, erforscht und unter die Lupe genommen, um in der Art des zeitgenössischen künstlerischen Diskurses neu interpretiert zu werden. Die Einzigartigkeit der Kunst von Rădvan besteht in der Stärke der Befragung, in der Leidenschaft, mit der er seine Visionen auf die großen Leinwände und Skulpturen projiziert. Sein künstlerisches Schaffen beschreibt eine Geschichte des Fragments, der gekürzten Erzählung, der verlorenen Legenden und der vergessenen Mythen. Rădvan behandelt Helden als seine-ihm gleichgestellt, es sind Charaktere, mit denen er entweder ruhig oder widersprüchlich reden kann. Seine Kreation ist in umfangreiche Reihen von Werken unterteilt, mit dem Ziel, Mythen und Mythologien neu zu interpretieren. Pygmalion, Apollo und Daphne, Hercules – sind nur einige Beispiele. Die mythischen und mythologischen Charaktere gehen vor unseren Augen vorbei, sie kommen aus den Nebeln der Zeit und wollen die heutige Welt infrage stellen. Das Verhältnis des Künstlers zu den grundlegenden Mythen der Menschheit und ihre Besprechung in Hinblick auf die heutige Gesellschaft bilden die Grundlage seiner Schöpfung. Rădvan ist fasziniert von Mythologie und Symbolen, vom fabelhaften und unbeschreiblichen, von Geschichte und Legende. Seine Helden entstehen aus dem tiefen Wunsch des Künstlers, die Herrschaft über den Mythos zu übernehmen, ihre grundlegenden Quellen zu verstehen, und diese dem Zuschauer in einer Form darzustellen, welche die Regeln und Konventionen nicht berücksichtigt.

Der große deutsche Schriftsteller Bertolt Brecht schrieb einmal über den Zweck der Kunst, dass diese kein Spiegel der Realität sein sollte, sondern ein Hammer, um damit diese Realität zu gestalten.[2] Nun, Alexandru Rădvan versucht genau das zu tun, in-

dem er den Mythos, die Legende, und ihre Bedeutung mit der Finesse eines Chirurgen zergliedert. Der Katalog *Mythical Flesh* enthält die Kreationen des Künstlers aus den letzten sieben Jahren – vom Zeitraum 2014 bis 2021 – und bietet eine umfassende Art, um das Werk über drei Medien künstlerischer Repräsentation zu behandeln – Malerei, Collage und Skulptur. Obwohl er in dieser neuen Reihe von Werken weiterhin große Formate und kräftige Farben verwendet, beginnt er im kreativen Prozess immer häufiger dreidimensionale Elemente zu integrieren, entweder über die unterschiedlichen Texturen der verwendeten Materialien, wie Pappe oder Textilien oder durch Skulpturen oder Blech- oder Harzelementen. Dadurch versucht er, die durch die Bidimensionalität der Leinwand auferlegten Grenzen zu überwinden und durch die Kraft der Farben das Gefühl eines glühenden Raumes und einer glühenden Atmosphäre zu erwecken. Die starken Farben verstärken oder vermindern das Gefühl der räumlichen Bewegung und der Dreidimensionalität. In Bezug auf die Verwendung von starken Sonnenfarben erklärte der Künstler: „Es gibt nicht genug Orange, Gelb und Rot auf dieser Welt, um das trockene Glühen der Welten wiederzugeben, von denen ich träume. Die Charaktere sind vom Licht betrunken und von der Helligkeit der Farben betäubt. Die Formen werden von der heißen Atmosphäre bestrahlt und bereinigt, angespannt und geklärt, bis sie Weltanfanggestalten Figuren ähneln, massiv, brutal und unschuldig zugleich. Es ist eine warme, unvollkommene, menschliche Geometrie. Es ist eine Ordnung, die von starken Emotionen und Gefühlen ohne Nuancen aufgeregt wird."[3]

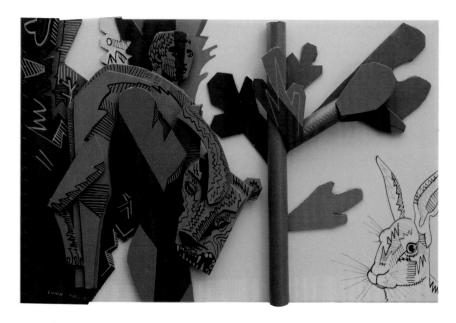

Hercules with Rabbit, 2015
Acrylic, acrylic marker on cardboard / Acryl, Acrylmarker auf Karton
82 H x 122 W x 11 D cm (32 9/32 H x 48 1/32 W x 4 21/64 D inches)

Artist collection / Künstler Sammlung

Bei *Mythical Flesh* (*Mythisches Fleisch*) handelt es sich um den Weltanfang, die Tage, als, die Göttinnen, die Zentauren und die Tyrannen auf der Erde wohnten, und dabei Eifersucht, Kämpfe, Begierde und Opfer hervorriefen. Seine großen Leinwände zeigen grundlegende Rituale, die das gesamte Arsenal der Kunstgeschichte benutzen, wie der Pfau, der Schatten, die Lilienblumen, das Idol, die Muse, die Meerjungfrau, usw. Die überdimensionierten Skulpturen erinnern an die alten Giganten des antiken Griechenland und Roms, die durch ihre bloße Präsenz die Welt dominierten. Seine Installationen stellen erneut das Fragment infrage, als Wiederbelebungsmittel des Dialogs mit der Vergangenheit. Seine Collagen bringen im Vordergrund einen verborgenen Wunsch der Schöpfer, den geschaffenen Charakteren Leben zu geben. Der Mythos von Pygmalion wird nicht zufällig ausgewählt, die schöne Statue von Galatea erwacht zum Leben und erfüllt somit ein en Traum ihres Schöpfers.

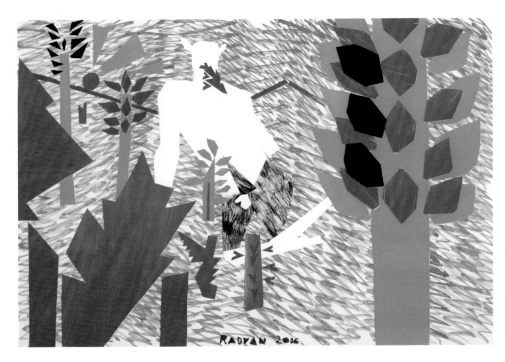

Last Garden, 2016
Acrylic, acrylic marker,
collage on cardboard /
Acryl, Acrylmarker, Collage
auf Karton
70 H x 100 W cm
(27 9/16 H x 39 3/8 W inches)

Hegel betrachtete das Kunstwerk im Wesentlichen als Fragebogen/Befragung, da es einen direkten Dialog mit dem Betrachter eröffnet.[4] Nun, aus diesem Gesichtspunkt sollte auch die Arbeit von Alexandru Rădvan betrachtet und interpretiert werden. Ein wichtiger Zyklus von Werken stellt einen der am häufigsten vertretenen Mythen der Kunstgeschichte infrage – Apollos obsessive Liebe zur keuschen Daphne. Apollo, der Gott des Lichts, der Tage und der Kunst, beleidigt Eros, den Gott der Liebe, und dieser rächt sich, indem er Apollo dazu bringt, sich in Daphne zu verlieben. Dieses Spiel der unmöglichen Liebe, der ständigen Ablehnung beschreibt einen stillen Kampf, in dem sich die Charaktere gegenseitig durchdringen, Elemente voneinander nehmen

und den Eindruck einer Osmose außerhalb einer echten Berührung erwecken. Die Werke setzen eine große erotische Komponente frei, welche die Spannung zwischen der keuschen Daphne und dem steigenden sexuellen Verlangen des Gottes Apollo beschreibt. Ein generischer und zeitloser Apollo, der zwischen Verlangen und Unmöglichkeit zerquetscht wird. Dapne wird zum ultimativen Opfern, indem sie sich in einen Lorbeerbaum mit immergrünen Blättern verwandelt.

Die Helden, die vom Künstler übernommen werden, sind oft diejenigen, die in unmögliche Situationen geraten oder viele Hindernisse überwinden müssen. Ob es um Pygmalion, Apollo oder Herkules geht, alle werden einer Reihe von Versuchungen unterworfen. Eine der umfangreichsten Reihen von Werken ist diejenige, die Herkules gewidmet ist. Herkules ist ein Halbgott, ein gewöhnlicher Mann mit übernatürlichen Kräften, der im Laufe der Zeit gegen sein schwieriges Schicksal kämpfen musste. Er wurde in der Literatur und in der Kunst zum Symbol des menschlichen Daseins, zu einer inspirierenden Figur. Herkules ist irgendwie ein Alter Ego des Künstlers. Ein temperamentvoller, solarischer, kraftvoller Herkules, eine facettenreiche Figur mit oft widersprüchlichen Merkmalen.

Unsere Welt, wie wir sie heute sehen und empfinden, wurde auf den Fragmenten dieser Legenden und Mythen aufgebaut. Der französische Philosoph Jean François Lyotard ist der Meinung, dass die heutige Gesellschaft die grandiosen universellen Strukturen wie Religionen, Genies, Mythen usw. zugunsten von lokalen Erzählungen und persönlichen Mythen ausschließt/ablehnt.[5] Es geht um eine Welt, die als Antisystem fungiert, die aber gleichzeitig Elemente aus verschiedenen Kulturen und Ideologien ausleiht und sich aneignet, die sich in diesem Fragmentierungsprozess abscheiden.

Am Anfang der Welt erbten - Pygmalion, Prometheus, Marsyas, die Zentauren, die Göttinnen – lebten ihre Sexualität, ihre Dramen, Eifersucht und Wünsche organisch und natürlich, dabei verwirklichten sie die Legenden und erweckten die Geschichten zum Leben. Heute, wie es aus dem Werk *May We Live in Interesting Times* erscheint, ist das Geheimnis schon zerstört worden, die Geschichte oder die Legende haben ihre Pracht verloren; es bleiben nur noch zwei Personen – er und sie – voneinander getrennt, die direkt dem Betrachter ins Auge schauen und nur ein Element gemeinsam haben, das sie verbindet, das Gitter. Es ist der Augenblick, in dem die Realität den Mythos getötet hat.

Die Verbindung mit der heutigen Welt erfolgt durch Narziss. Ein gegenwärtiger Narziss, der von einer ständigen und selbstsüchtigen Bezugnahme zur eigenen Person dominiert wird. Ein Narziss, der wie besessen sich in jedem Charakter widerspiegelt. Rădvans facettenreiche Selbstporträts beziehen sich auch auf Narziss, ein Spiegelbild des eigenen Egos in verschiedenen Interpretationen. So entstehen die vier Selbstporträts – *Self-portrait as a Cautious Hero; Self-portrait in the beginning of History; Self-portrait in the Beginning of Time; Self-portrait as Marsyas* – durch die Darstellung eines gespalteten „Ego".

Alexandru Rădvan, einer der umstrittensten Künstler seiner Generation, versucht unermüdlich, die dunkelsten und abgrundtiefsten menschlichen Begierden zu durchdringen. Dort, in der inneren Dunkelheit, in den Grabstillen, gestaltet der Künstler seine Helden und Göttinnen, die die Form von übergroßen Selbstporträts annehmen, in denen sein eigenes „Ich" zum Alter Ego der mythischen Charaktere wird. Seine Selbstporträts beschreiben einen inneren Zustand, einen permanenten Wunsch, um ein „Anderes" zu finden, das in der Lage ist, ein aus dem Abgrund entstandenes „Ich" zu entschlüsseln, zu verstehen und zu akzeptieren, das aus einem tiefen Abgrund kommt, in dem das Gefühl der Unzulänglichkeit seine Unterstützung im Entfremdungsgefühl des Künstlers findet, indem er sich von seiner eigenen Person distanziert. Das wahre Wissen braucht Konflikte, Brüche, Kontraste und Sprünge, eine totale Veränderung.

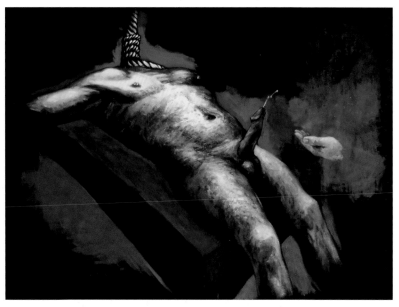

Homage to Judas XXXI, 2008
Acrylic on unprimed canvas / Acryl auf nicht grundierter Leinwand
108 H x 155 W cm (42 33/64 H x 61 1/32 W inches)

Private collection / Private Sammlung

Die Idee des Körperfragments ruft auch die Idee des fragmentierten Egos hervor. Jacques Lacan,[6] in der Theorie des „zerkleinerten/fragmentierten Körpers", beschreibt das Entstehen des Egos als Spiegelbild nach der ersten Erfahrung des fragmentierten Körpers. Die Grundlage des Ursprungs des Imaginären ist das Entstehen des Egos im „Spiegel"- Stadium, sodass das Ego durch Identifikation mit dem äquivalenten Bild entsteht, und die Beziehung, in der das Ego durch Identifikation konstruiert wird, ist ein Ort der „Entfremdung", ein weiteres Merkmal des Imaginären mit zutiefst narzisstischen Elementen. Deleuze hat das Imaginäre als „Spiel der Spiegelung, der Vervielfältigung, der invertierten Identifikation und Projektion, immer im Doppelmodus" definiert.[7] Die Gemälde und Skulpturen von Alexandru Rădvan entfalten sich auf großen Flächen, die den Betrachter sowohl durch die imposanten Dimensionen als auch durch die angesprochenen Themen dominieren. Die einfache, unverhüllte Sexualität sucht oft den Rand, die Ausnahme, das Abnormale, das Fabelhafte. Das Anliegen auf sexuellen Fragen, auf das Offensichtliche und Transgressionen erscheint seit dem Beginn der Kreation des Künstlers in zwei Werken – *Cancer* (2007) und *Homage to Judas XXXI* (2008) –, diese stellen einen Bezugspunkt zur rumänischen Kunst nach dem Fall des Eisernen Vorhangs dar. In der postkommunistischen Zeit und insbesondere im ersten Jahrzehnt der 2000er Jahre führten die verbotenen sexuellen Themen und die Neuinterpretation der Sexualität in der Kunst zu einer Reihe von Ausstellungen, die oft als obszön angesehen wurden. Der deformierte Körper, in sadomasochistischen Positionen, im Kontext von sexuellen Orgien, beschreibt eine Sexualität am Rande. Der Körper, der als Fragment oder als Trauma betrachtet wird, wird zu einem Weg der Selbstreflexion und des Verstehens der heutigen Gesellschaft. Der kulturelle und gesellschaftspolitische Kontext, in dem der Künstler arbeitet, beschreibt auch die Prüderie des Publikums und dessen Revolte gegen die grenzüberschreitende Kunst. Die grenzüberschreitende Kunst versucht die Tabus aufzuheben, ohne sie zu ersetzen. Vor einem grenzüberschreitenden Werk empfindet der Zuschauer sowohl Vergnügen als auch Schmerz; Attraktion, aber auch Empörung; Verführung, aber auch Abstoß. Edward Lucie-Smith schrieb: „Darüber hinaus heben die erstellte Kunst und der kritische Diskurs über die Kunst im Allgemeinen eher die sozialen, politischen und sexuellen Kontexte hervor als den formalen Wert, die Bedeutung des Werks, abgeleitet aus ihrem figurativen Inhalt, oft in Bezug auf Sexualität und Geschlecht."[8]

Alexandru Rădvan ist selbst ein Produkt des Fragment-Konzepts. Geboren 1977 in

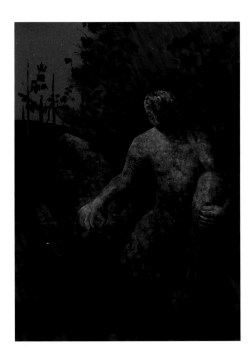

Nobody, 2013
Acrylic on canvas / Acryl auf Leinwand
296,5 H x 216,5 W cm (116 47/64 H x 85 15/64 W inches)

Private collection / Private Sammlung

Bukarest, Rumänien, damals ein Land im Kommunistischen Block; er studierte und wurde gebildet während der kommunistischen Ära. Er absolvierte die Hochschule für Kunst in Bukarest im Jahre 2000 und wurde zum Assistenten des Professors und Künstlers Florin Mitroi. Er begann gegen Ende der 1990er Jahre, häufig auszustellen, und ist einer der sehr sichtbaren Künstler der neuen Welle nach dem Fall des Eisernen Vorhangs. Er stellt zusammen mit wichtigen Namen der zeitgenössischen Kunst aus – Bill Viola, Andres Serrano, Georg Baselitz –, aber sein künstlerisches Anliegen bleibt einzigartig in der Landschaft der rumänischen Kunst. Sein Werk stellt eine Welt jenseits jeder Norm, voller Widersprüche, Ängste, Konflikte und Begehren vor, die von der umliegenden Gesellschaft einigermaßen isoliert ist.

Diana Dochia

Endnoten

1 Erwin Panofsky, *Renaissance and Renascencens in Western Art*, London 1972.

2 Bertolt Brecht, „The Modern Theatre is the Epic Theatre." („Das moderne Theater ist das epische Theater."), in: *Theater in Theory 1900–2000: An Anthology*, hrsg. von David Krasner, Oxford 2008, 171–173.

3 Interview mit Alexandru Rădvan von 2015.

4 *Vorlesungen für Ästhetik* ist eine Zusammenstellung von Notizen aus Universitätsvorlesungen über Ästhetik von Georg Wilhelm Friedrich Hegel in Heidelberg 1818 und Berlin in 1820/21, 1823, 1826 und 1828/29. Sie wurde 1835 von seinem Studenten Heinrich Gustav Hotho zusammengestellt.

5 Jean François Lyotard, *La Condition postmoderne: Rapport sur le savoir (Das postmoderne Wissen: Ein Bericht)*, Paris 1979.

6 Jacques Lacan, *Écrits: A Selection*, London 1977.

7 Gilles Deleuze, „How Do We Recognize Structuralism?" („Wie erkennt man den Strukturalismus?"), in: David Lapoujade (Hrsg.), *Desert Islands and Other Texts, Semiotext(e)*, New York 2004, S. 172.

8 Edward Lucie-Smith, *Sexualität in der westlichen Kunst*, London 1995, S. 8.

Chapter I: On Rituals and Sun

'Through hundreds of breasts the Mother of all things is nursing Time. Conceiving new days, each day, nourished day by day, gazing as to how they fade away in the night, giving them birth endlessly, till her exhausted sex turns to minerals and her breasts dry out. Ancient beings, present at the first birth gather the past days and preserve them with care. They saw all the days rising and fading away, as they will see continuously. I realize that I possess billions of years, that all past and previous days have been left to me, to which I have to add those that are my nowadays. I will journey with the centaurs, gods, titans, to gather the rest of the days. Among all these old days, I will search for a special day when parents were young and happy.'

Alexandru Rădvan, artist

Kapitel I: Über Rituale und Sonne

„An Hunderten Brüsten stillt die Mutter aller Dinge die Zeit. Jeden Tag neue Tage zu empfangen, sie Tag um Tag zu nähren, zu sehen, wie sie in der Nacht verblassen, endlos zu gebären, bis sich ihr ermattetes Geschlecht in Mineral verwandelt und ihre Brüste austrocknen. Uralte Wesen, die bei der ersten Geburt dabei waren, sammeln die vergangenen Tage und bewahren sie sorgfältig. Sie haben alle aufgehen und schwinden sehen, so wie sie es fortwährend sehen. Ich weiß, ich habe Milliarden von Jahren, alle vergangenen Tage wurden mir hinterlassen, und ihnen muss ich die Tage, die mir widerfuhren, hinzufügen, dann werde ich zusammen mit Zentauren, Göttern, Titanen die übrigen Tage sammeln. Dann werde ich unter all den alten Tagen nach einem Tag suchen, an dem die Eltern jung und glücklich waren.“

Alexandru Rădvan, Künstler

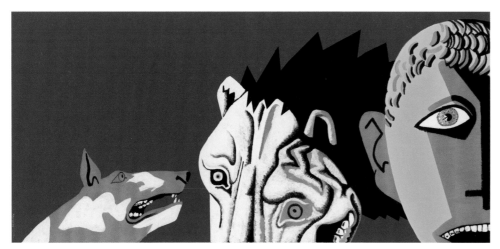

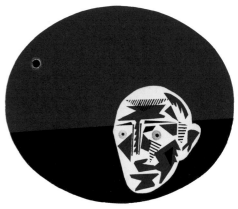

Mythological Scenes, 2014
Acrylic on canvas / Acryl auf Leinwand
70 H x 150 W cm / 60,5 H x 50 W cm
(27 9/16 H x 59 1/16 W inches / 23 13/16 H x 19 11/16 W inches)

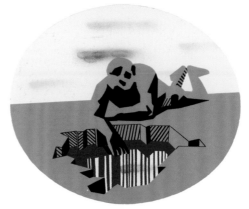

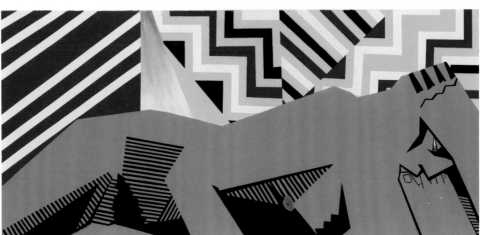

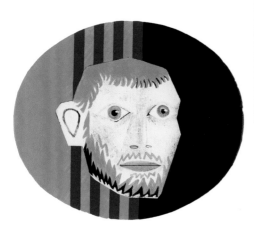

Funk, 2014
Acrylic on canvas / Acryl auf Leinwand
60,5 H x 50 W cm / 70 H x 150 W cm / 60,5 H x 50 W cm
(23 13/16 H x 19 11/16 W inches / 27 9/16 H x 59 1/16 W inches / 23 13/16 H x 19 11/16 W inches)

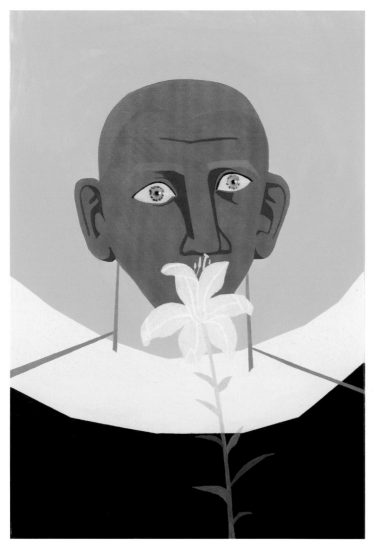
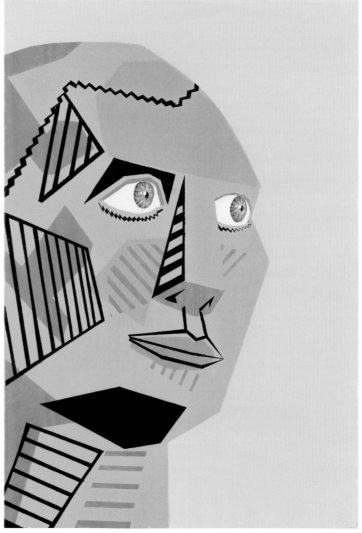

Poetic *(diptych / Diptychon)*, 2014
Acrylic on canvas / Acryl auf Leinwand
100 H x 140 W cm (je 100 H x 70 W cm)
(39 3/8 H x 55 1/8 W inches (each 39 3/8 H x 27 9/16 W inches))

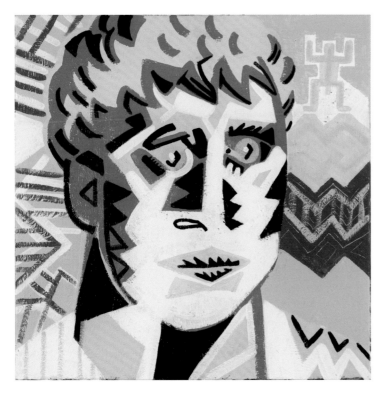

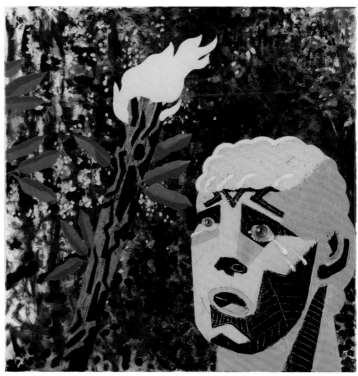

Portrait with Totem, 2017
Acrylic on canvas / Acryl auf Leinwand
70 H x 70 W cm
(27 9/16 H x 27 9/16 W inches)

Head Crying in the Wood, 2017
Acrylic on canvas / Acryl auf Leinwand
70 H x 70 W cm
(27 9/16 H x 27 9/16 W inches)

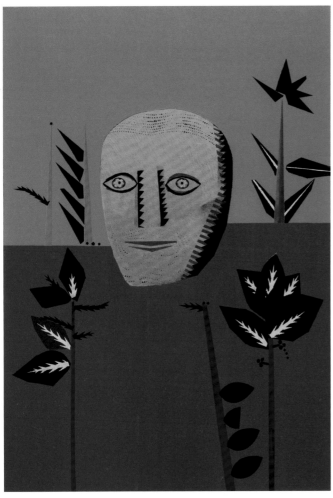

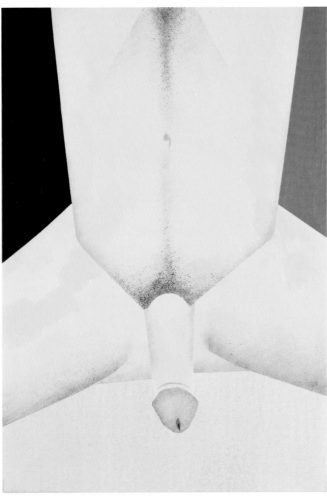

Thought *(diptych / Diptychon)*, 2014
Acrylic on canvas / Acryl auf Leinwand
200 H x 70 W cm (je 100 H x 70 W cm)
(78 47/64 H x 27 9/16 W inches (each 39 3/8 H x 27 9/16 W inches))

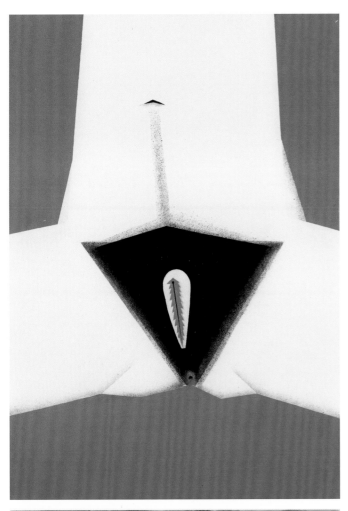

Impression *(triptych / Triptychon)*, 2014
Acrylic on canvas / Acryl auf Leinwand
200 H x 140 W cm (je 100 H x 70 W cm)
(78 47/64 H x 55 1/8 W inches (each 39 3/8 H x 27 9/16 W inches))

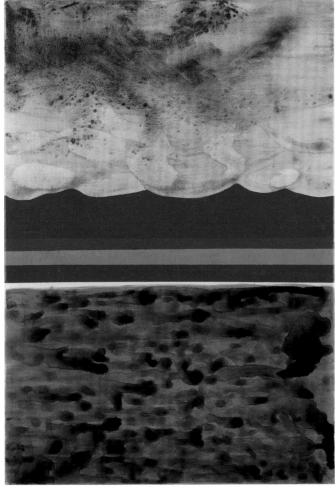

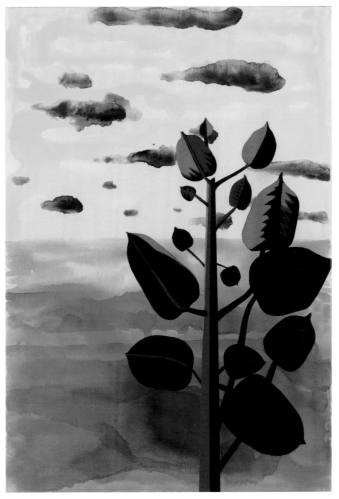

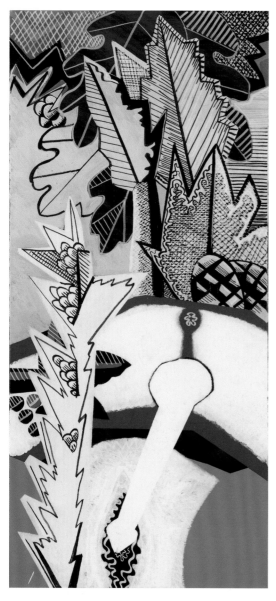

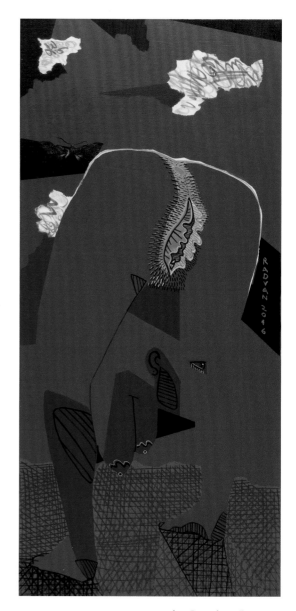

Tropical Animal, 2016
Acrylic, acrylic marker on canvas /
Acryl, Acrylmarker auf Leinwand
150 H x 70 W cm
(59 1/16 H x 27 9/16 W inches)

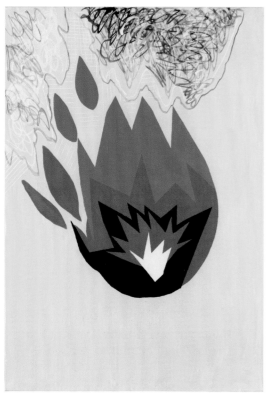

Tropical Animal (diptych / Diptychon)**,** 2014–2015
Acrylic, acrylic marker on canvas /
Acryl, Acrylmarker auf Leinwand
250 H x 70 W cm (je 150 H x 70 W cm / 100 H x 70 W cm)
(98 27/64 H x 27 9/16 W inches (each 59 1/16 H x 27 9/16 W inches /
39 3/8 H x 27 9/16 W inches))

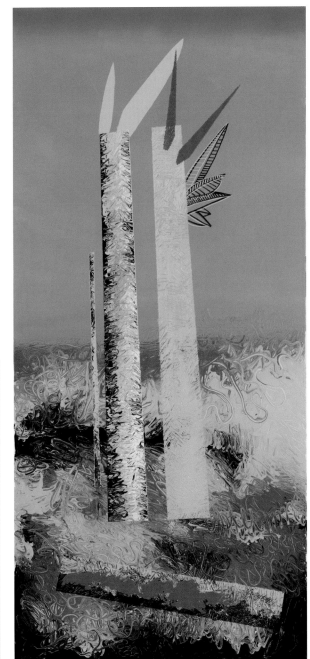

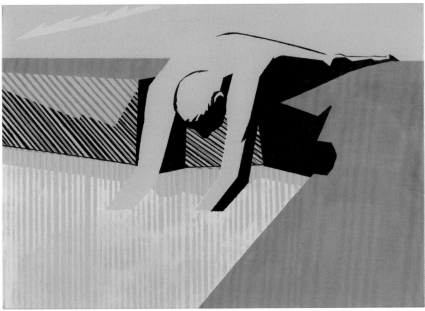

The Pit *(diptych / Diptychon),* 2015
Acrylic, acrylic marker on canvas /
Acryl, Acrylmarker auf Leinwand
150 H x 170 W cm (je 70 H x 100 W cm / 150 H x 70 W cm)
(59 1/16 H x 66 59/64 W inches (each 27 9/16 H x 39 3/8 W inches / 59 1/16 H x 27 9/16 W inches))

Prokofiev, 2014 ▶
Acrylic, acrylic marker on canvas /
Acryl, Acrylmarker auf Leinwand
200 H x 285 W cm
(78 47/64 H x 112 13/64 W inches)

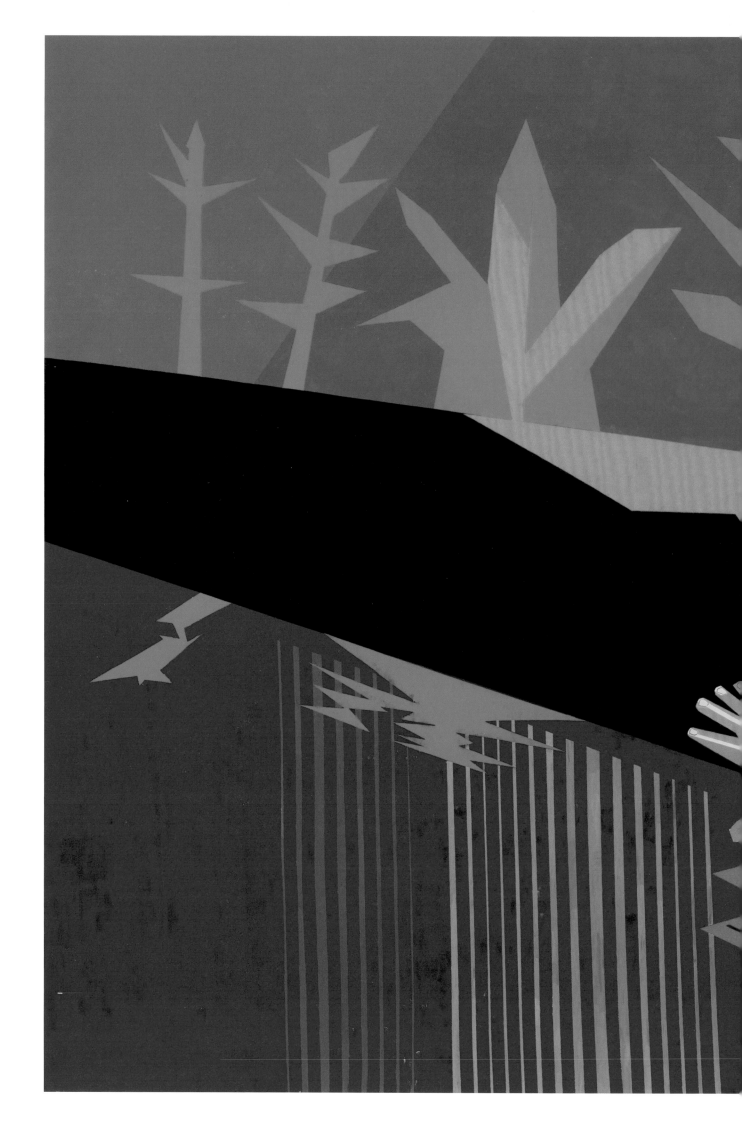

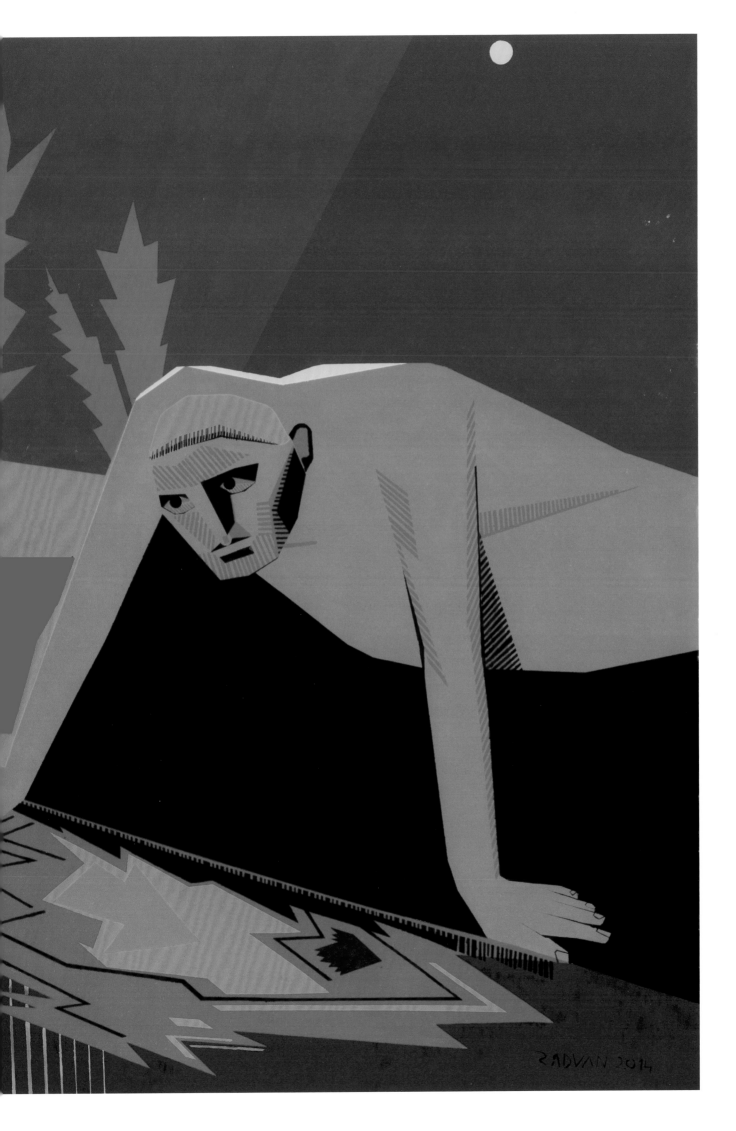

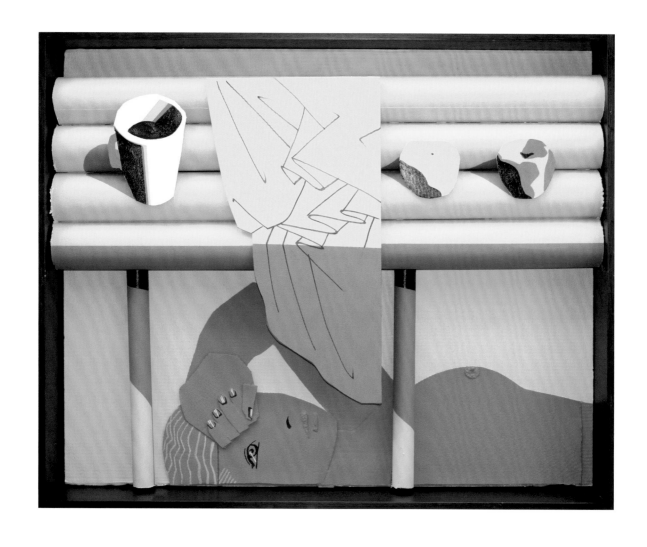

Holiday, 2015
Mixed technique: acrylic, acrylic marker on cardboard in wooden box /
Mischtechnik: Acryl, Acrylmarker auf Karton in Holzkiste
104 H x 130 W x 17 D cm
(40 15/16 H x 51 3/16 W x 6 11/16 D inches)

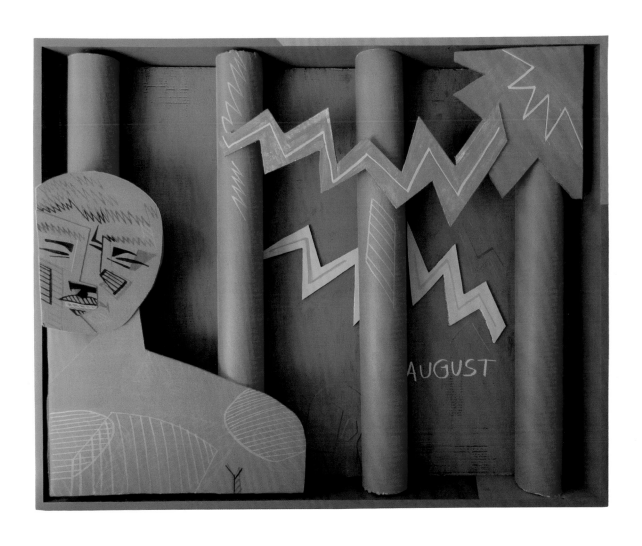

August, 2016
Mixed technique: acrylic, acrylic marker on cardboard in wooden box /
Mischtechnik: Acryl, Acrylmarker auf Karton in Holzkiste
103 H x 129 W x 30 D cm
(40 35/64 H x 50 25/32 W x 11 13/16 D inches)

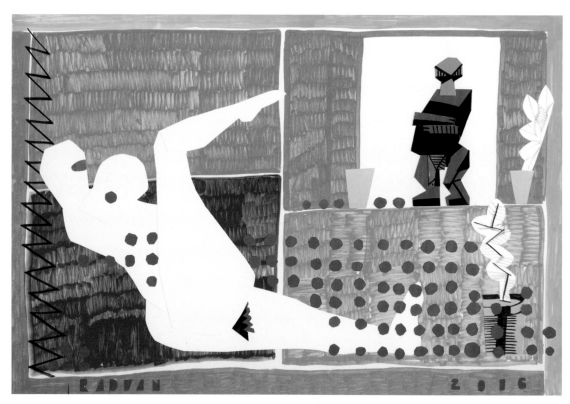

Women with Idol I, 2016
Acrylic, acrylic marker, collage on cardboard /
Acryl, Acrylmarker, Collage auf Karton
70 H x 100 W cm
(27 9/16 H x 39 3/8 W inches)

Private Collection / Private Sammlung

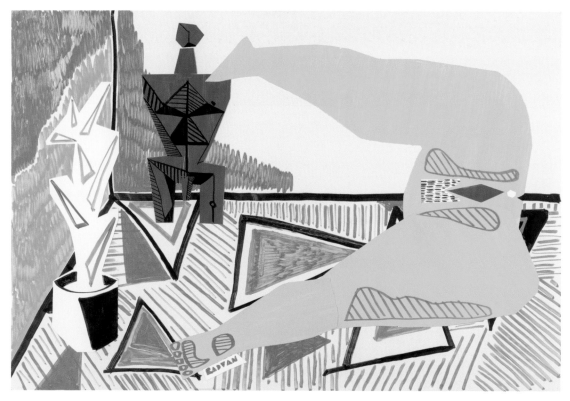

Women with Idol II, 2016
Acrylic, acrylic marker, collage on cardboard /
Acryl, Acrylmarker, Collage auf Karton
70 H x 100 W cm
(27 9/16 H x 39 3/8 W inches)

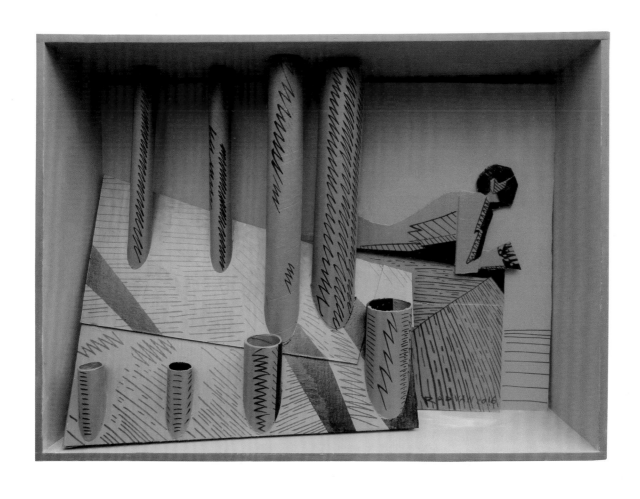

Meridian, 2016
Mixed technique: acrylic, acrylic marker on cardboard in wooden box /
Mischtechnik: Acryl, Acrylmarker auf Karton in Holzkiste
90 H x 122 W x 29,5 D cm
(35 7/16 H x 48 1/32 W x 11 39/64 D inches)

Evening Lake, 2016 ▶
Acrylic on canvas /
Acryl auf Leinwand
200 H x 312 W cm
(78 47/64 H x 122 53/64 W inches)

RADVAN 2016

78

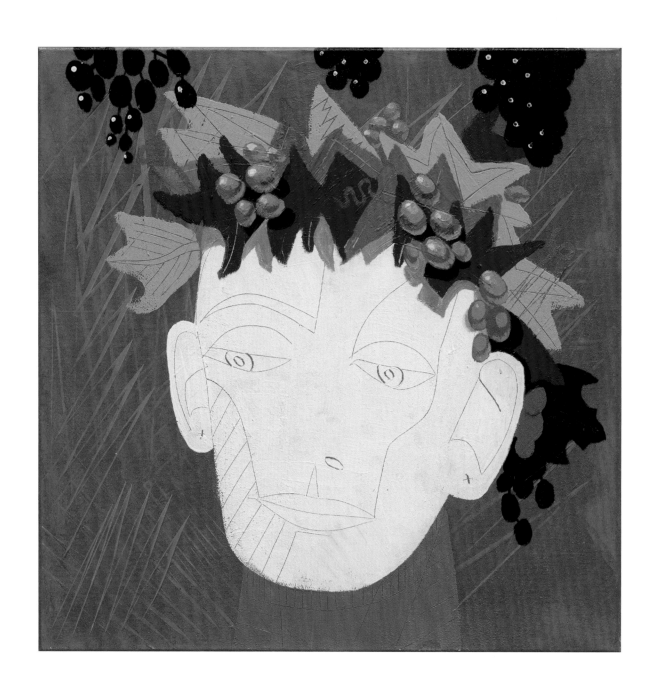

Study for a Medieval Miniature, 2019
Acrylic on canvas / Acryl auf Leinwand
70 H x 70 W cm
(27 9/16 H x 27 9/16 W inches)

Private collection / Private Sammlung

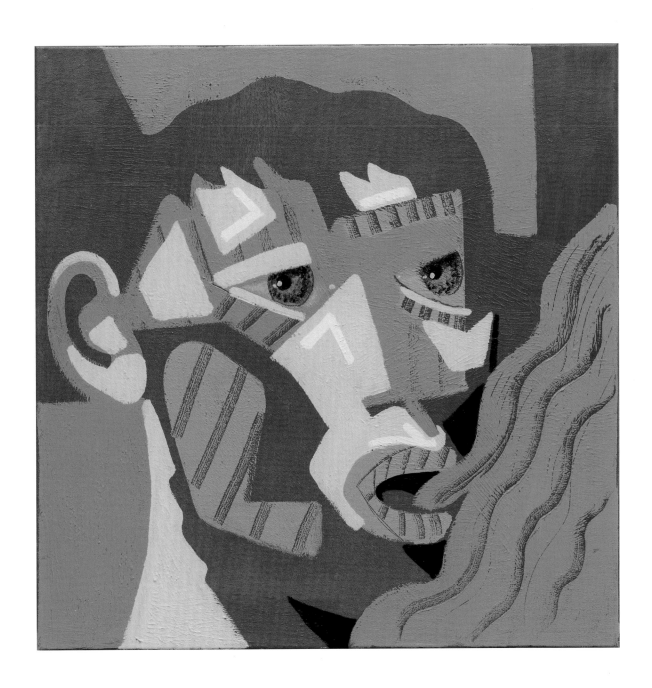

Study for a Portrait at the Spring, 2019
Acrylic on canvas / Acryl auf Leinwand
70 H x 70 W cm
(27 9/16 H x 27 9/16 W inches)

Private collection / Private Sammlung

The Rite of Spring, 2016 ▶
Acrylic, acrylic marker on canvas /
Acryl, Acrylmarker auf Leinwand
210 H x 340 W cm
(82 43/64 H x 133 55/64 W inches)

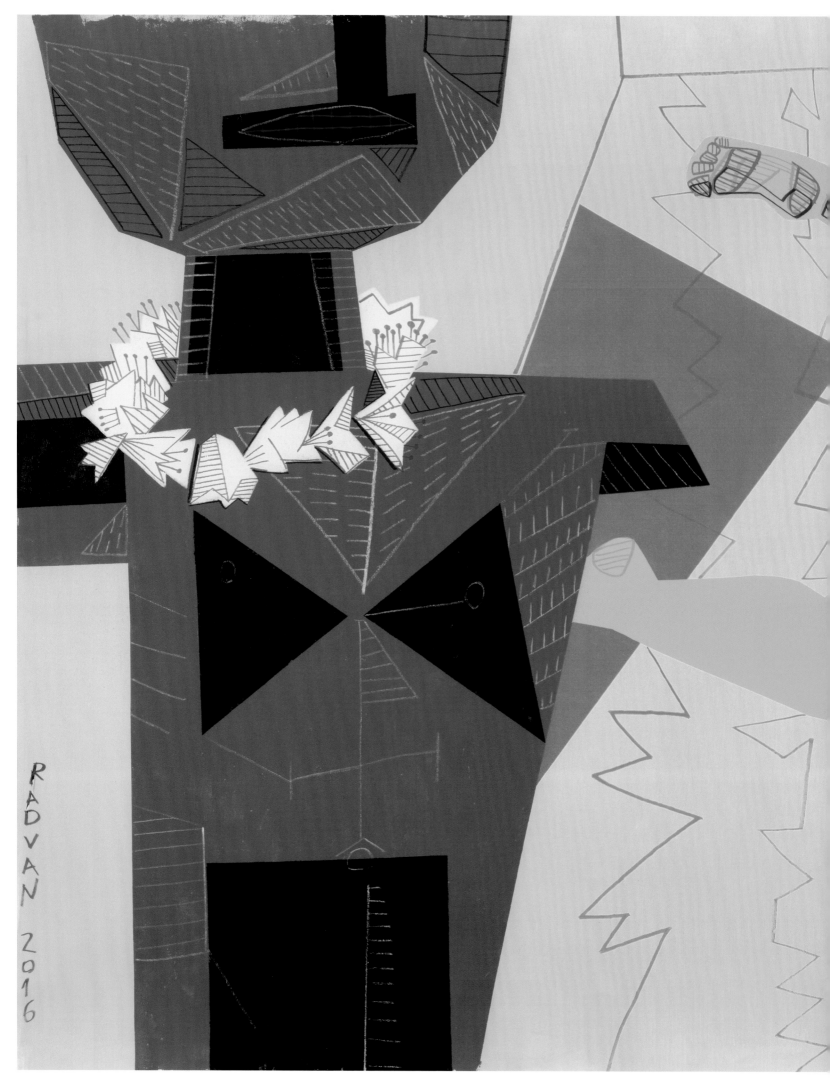

RADVAN 2016

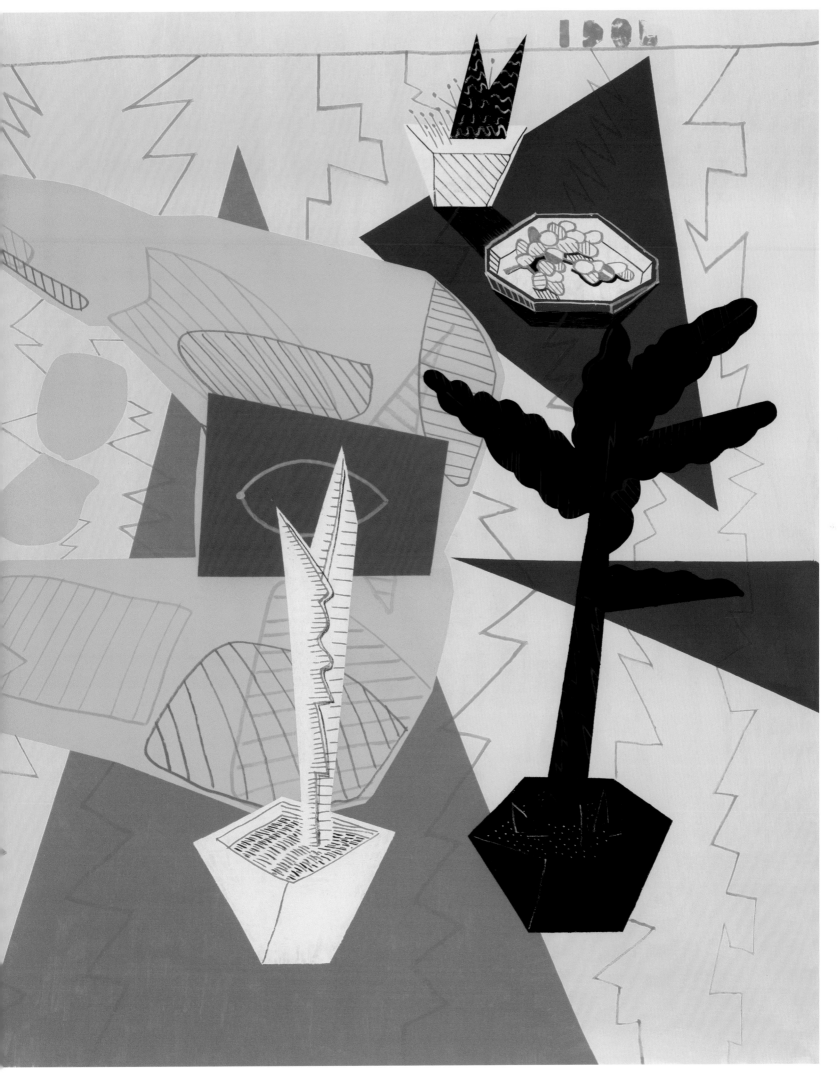

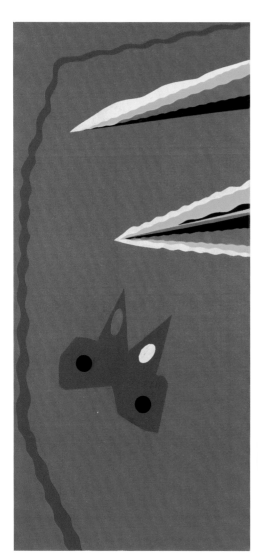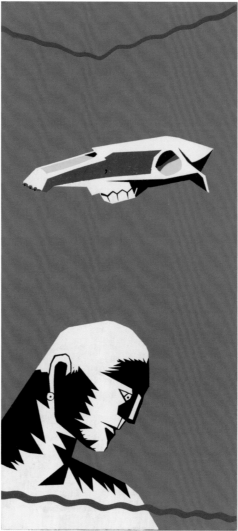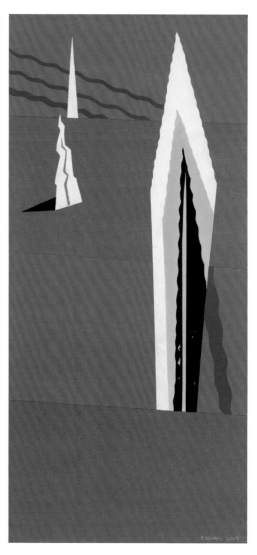

Island for Umberto *(triptych / Triptychon),* **2014**
Acrylic on canvas /
Acryl auf Leinwand
150 H x 210 W cm (je 150 H x 70 W cm)
(59 1/16 H x 82 43/64 W inches (each 59 1/16 H x 27 9/16 W inches))

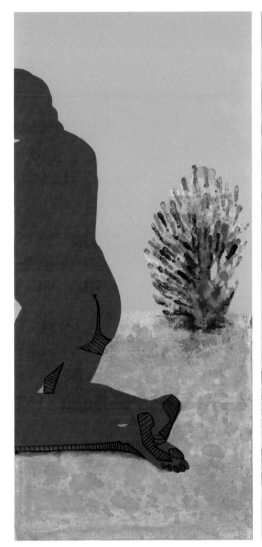
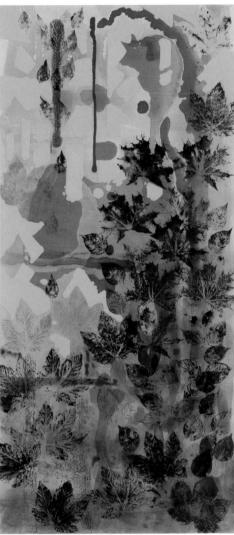
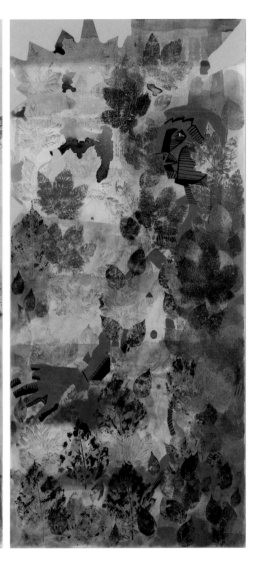

Voyeur (triptych / Triptychon), 2016
Acrylic, acrylic marker on canvas /
Acryl, Acrylmarker auf Leinwand
150 H x 210 W cm (je 150 H x 70 W cm)
(59 1/16 H x 82 43/64 W inches (each 59 1/16 H x 27 9/16 W inches))

The Rite of Spring 2, 2016 ▶
Acrylic on canvas /
Acryl auf Leinwand
210 H x 354 W cm
(82 43/64 H x 139 3/8 W inches)

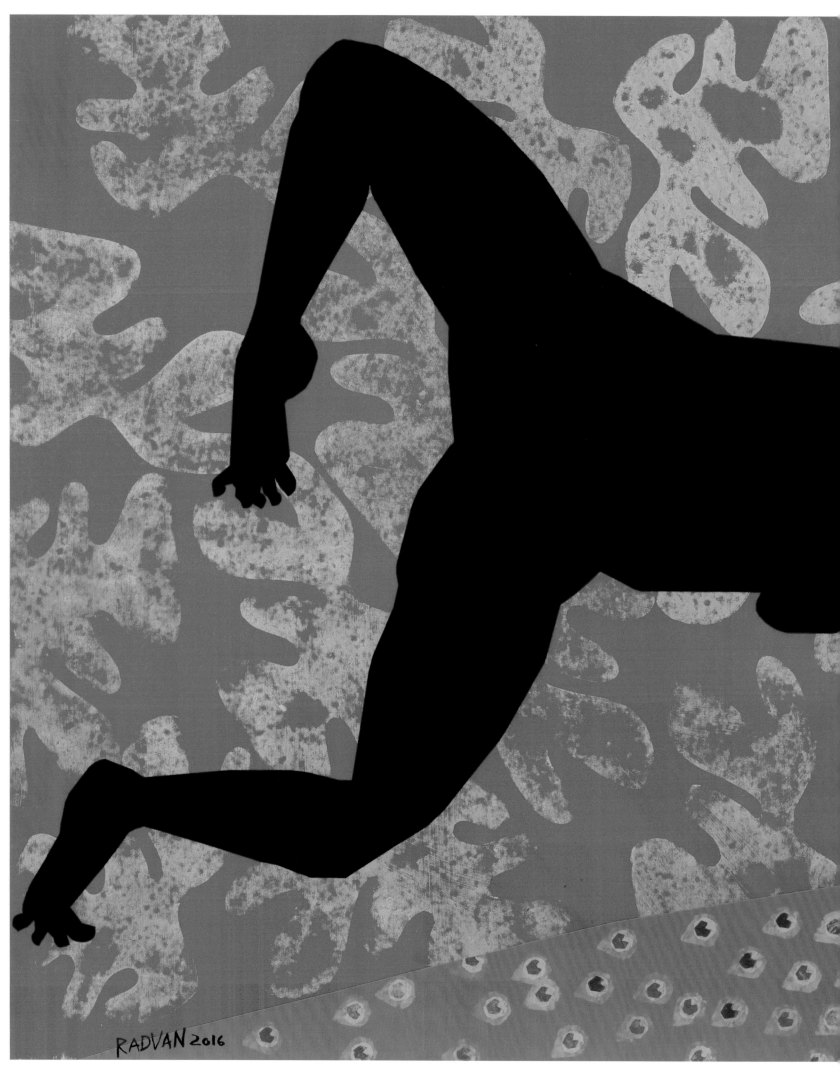

RADVAN 2016

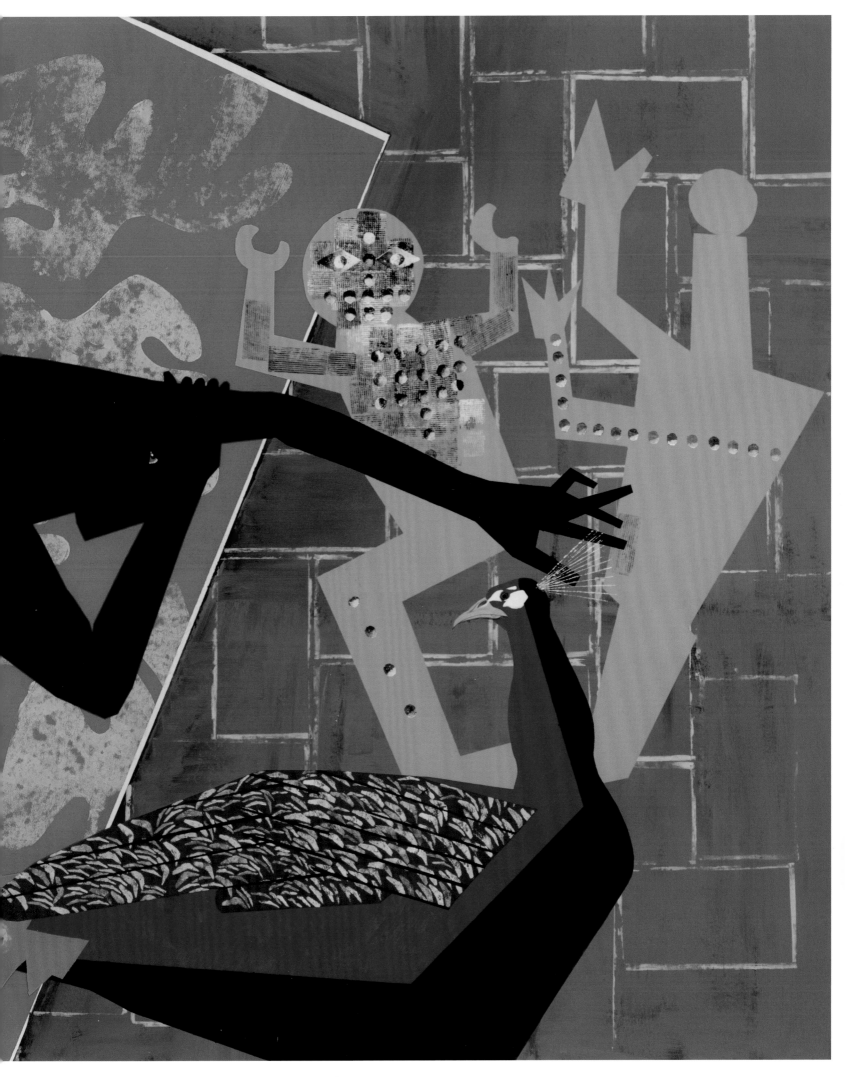

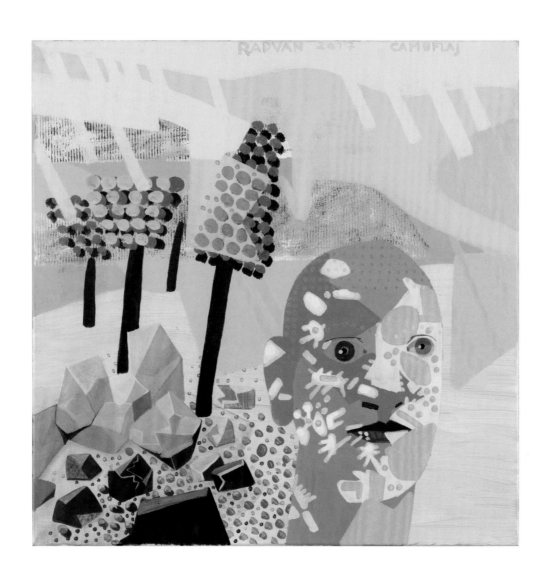

Camouflage – South, 2017
Acrylic on canvas / Acryl auf Leinwand
70 H x 70 W cm
(27 9/16 H x 27 9/16 W inches)

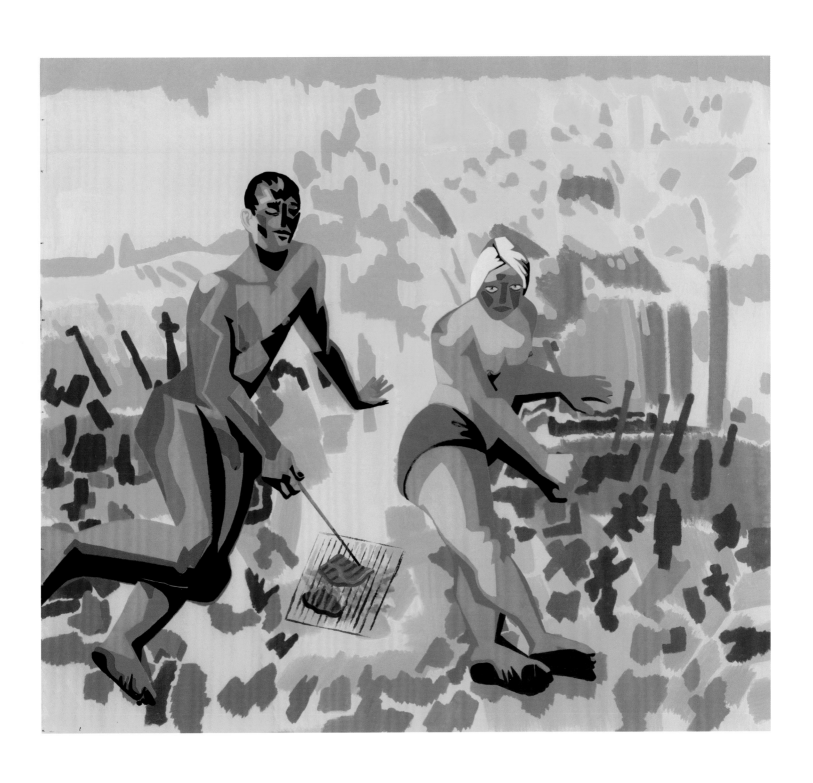

May We Live in Interesting Times, 2019
Acrylic on canvas / Acryl auf Leinwand
210 H x 230 W cm
(82 43/64 H x 90 35/64 W inches)

Mother of All Things, 2019
Polystyrene, polyurea resin, spray /
Polystyrol, Polyharnstoffharz, Spray
308 H x 130 W x 125 D cm
(121 17/64 H x 51 3/16 W x 49 7/32 D inches)

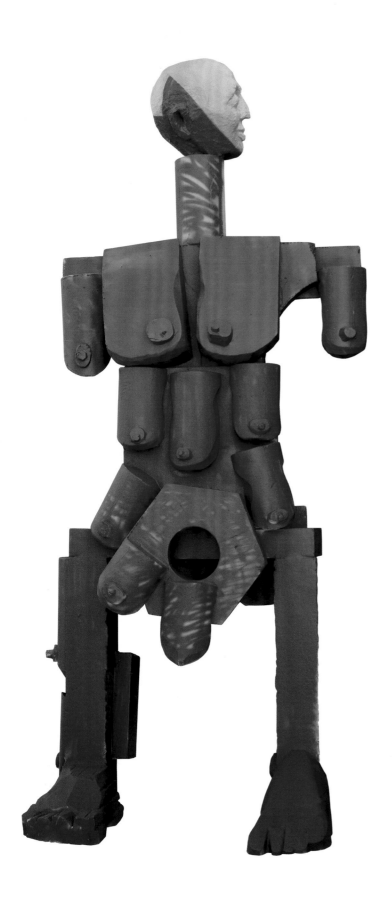
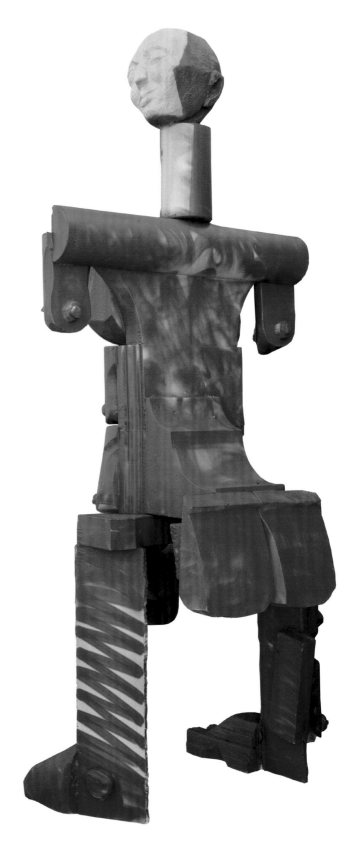

Prometheus, 2019
Polystyrene, polyurea resin, spray /
Polystyrol, Polyharnstoffharz, Spray
280 H x 140 W x 300 D cm
(110 15/64 H x 55 1/8 W x 118 7/64 D inches)

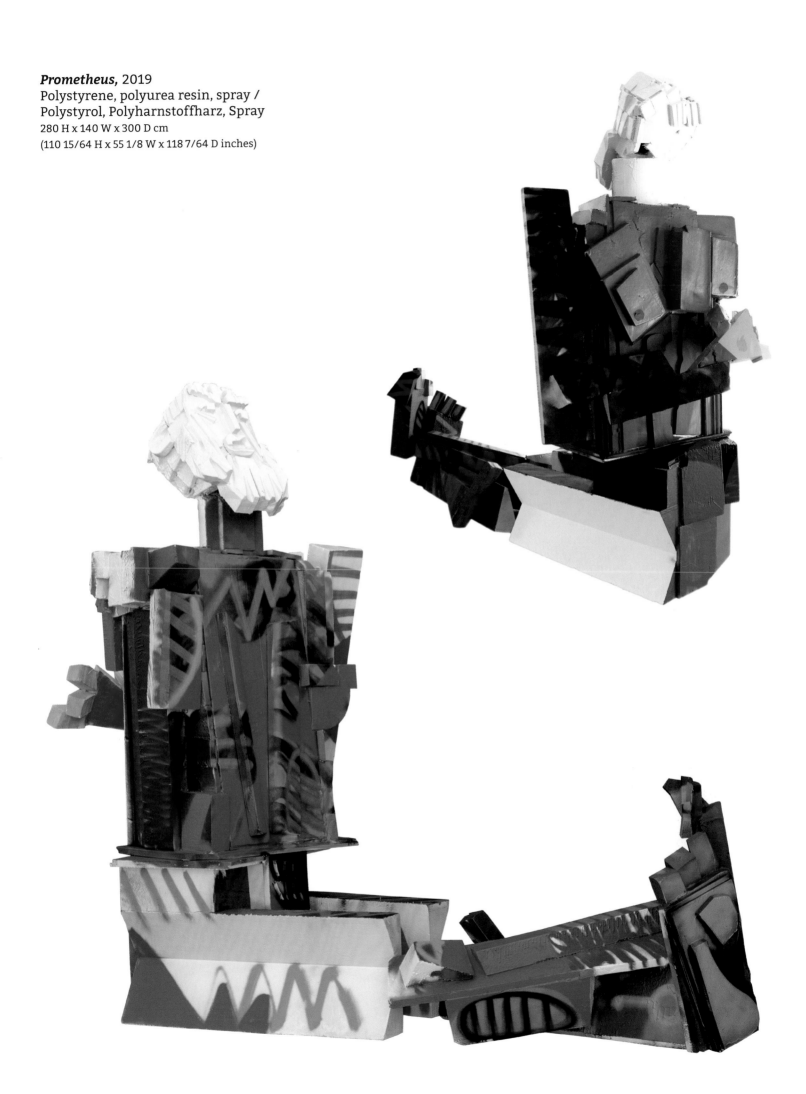

Chapter II: Meridional

'The beautiful sound of the cicadas... The air is still. The wings of heavy butterflies cut through the hot skies, yet still nothing moves. A never-ending noon away from the grey of the North, a never ending 2 o'clock under the sun, waiting for a faun to appear on the beach.'

Alexandru Rădvan, artist

Kapitel II: Meridional

„Der herrliche Klang der Zikaden ... Die Luft ist still. DieFlügel schwerer Schmetterlinge durchschneiden den heißen Himmel, und doch bewegt sich nichts. Ein nicht enden wollender Mittag weit weg vom Grau des Nordens, ein nicht enden wollender 2-Uhr-Nachmittag unter der Sonne, der darauf wartet, dass ein Faun auftaucht am Strand."

Alexandru Rădvan, Künstler

Meridional I, 2013
Tempera on paper / Tempera auf Papier
70 H x 100 W cm (27 9/16 H x 39 3/8 W inches)

Private collection / Private Sammlung

Meridional II, 2013
Tempera on paper / Tempera auf Papier
70 H x 100 W cm (27 9/16 H x 39 3/8 W inches)

Private collection / Private Sammlung

Meridional III, 2013
Tempera on paper / Tempera auf Papier
70 H x 100 W cm (27 9/16 H x 39 3/8 W inches)

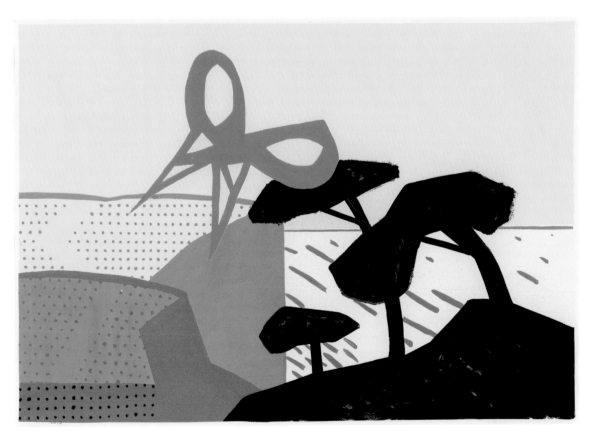

Meridional IV, 2013
Tempera on paper / Tempera auf Papier
70 H x 100 W cm (27 9/16 H x 39 3/8 W inches)

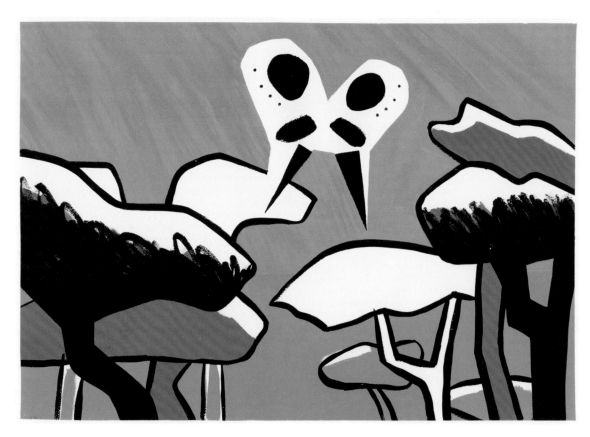

Meridional V, 2013
Tempera on paper / Tempera auf Papier
70 H x 100 W cm (27 9/16 H x 39 3/8 W inches)

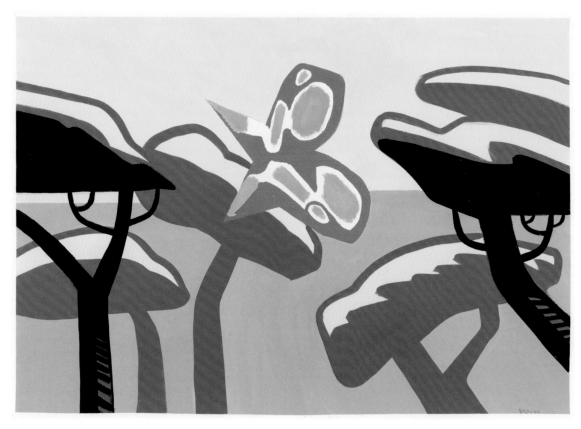

Meridional VI, 2013
Tempera on paper / Tempera auf Papier
70 H x 100 W cm (27 9/16 H x 39 3/8 W inches)

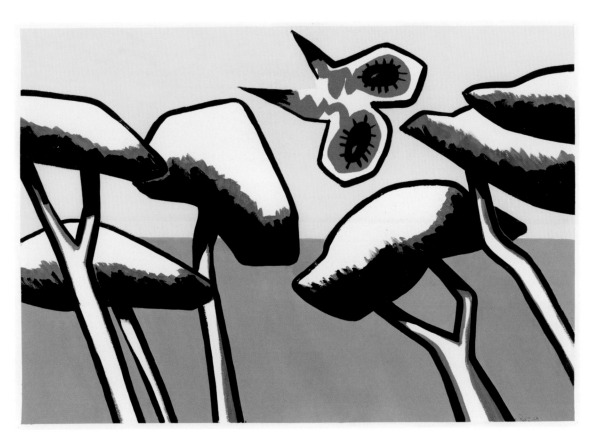

Meridional VII, 2013
Tempera on paper / Tempera auf Papier
70 H x 100 W cm (27 9/16 H x 39 3/8 W inches)

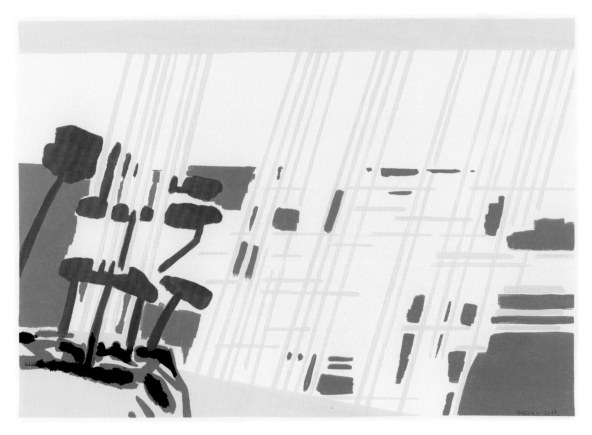

Meridional VIII, 2013
Tempera on paper / Tempera auf Papier
70 H x 100 W cm (27 9/16 H x 39 3/8 W inches)

Chapter III: Pygmalion

'Pygmalion was not a lunatic. He was only obsessed with an idea. "Don't be afraid my love, I will transform your body, I will recreate your alluring shapes, I will ignore the warm, pulsating flesh I will see the monument in you. I will purge and purify your forms until I will be the only one who understands them. This thing of ours is too sacred to be touched by other eyes. I will broaden your three orifice so I can walk inside you, live, sleep and eventually die in there. Don't be afraid my love ".'

Alexandru Rădvan, artist

Kapitel III: Pygmalion

„Pygmalion ist kein Wahnsinniger. Er war nur von einer Idee besessen. ‚Fürchte dich nicht, Liebste, ich werde deinen Körper verwandeln, ich werde deine verführerischen Formen neu erschaffen, ich werde das warme, pulsierende Fleisch ignorieren und in dir das Denkmal sehen. Ich werde deine Formen säubern, bis ich der Einzige bin, der sie versteht. Diese unsere Sache ist zu heilig, um von anderen Augen berührt zu werden. Ich werde all deine drei Öffnungen erweitern, damit ich in dir herumgehen, leben, schlafen und schließlich darin sterben kann. Fürchte dich nicht, Liebste. '"

Alexandru Rădvan, Künstler

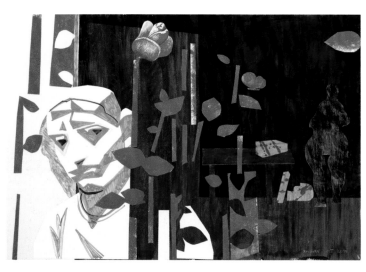

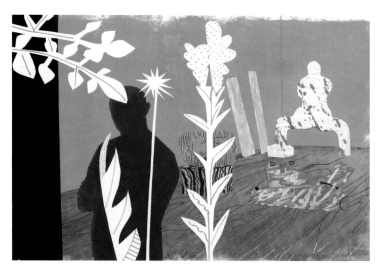

Pygmalion – Sculptor Studio I, 2015
Acrylic, acrylic marker, collage on cardboard /
Acryl, Acrylmarker, Collage auf Karton
70 H x 100 W cm
(27 9/16 H x 39 3/8 W inches)

Pygmalion – Sculptor Studio II, 2015
Acrylic, acrylic marker, collage on cardboard /
Acryl, Acrylmarker, Collage auf Karton
70 H x 100 W cm
(27 9/16 H x 39 3/8 W inches)

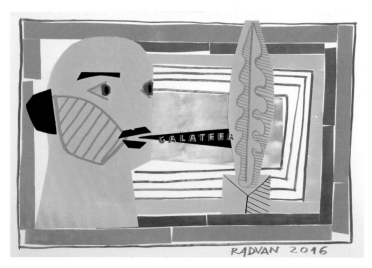

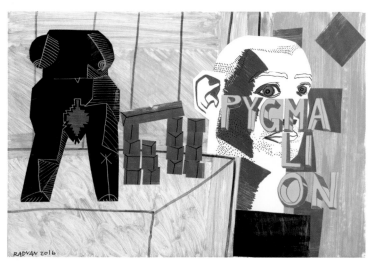

Pygmalion – Galateea, 2016
Acrylic, acrylic marker, collage on cardboard /
Acryl, Acrylmarker, Collage auf Karton
70 H x 100 W cm
(27 9/16 H x 39 3/8 W inches)

Pygmalion, 2016
Acrylic, acrylic marker, collage on cardboard /
Acryl, Acrylmarker, Collage auf Karton
70 H x 100 W cm
(27 9/16 H x 39 3/8 W inches)

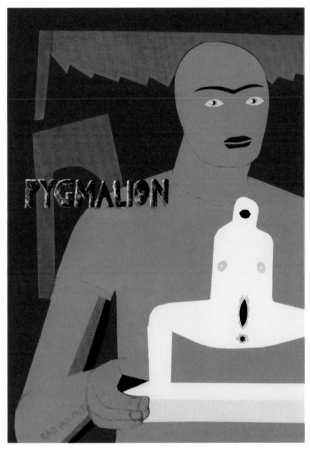

Pygmalion *(Diptych / Diptychon)*, 2015
Acrylic on canvas/ Acryl auf Leinwand
100 H x 170 W cm (je 100 H x 70 W cm / 70 H x 100 W cm)
(39 3/8 H x 66 59/64 W inches
(each 27 9/16 H x 39 3/8 W inches / 39 3/8 H x 27 9/16 W inches))

Sculptor Studio, with the Endless Column, 2016 ▶
Acrylic on canvas / Acryl auf Leinwand
210 H x 374 W cm
(82 43/64 H x 147 1/4 W inches)

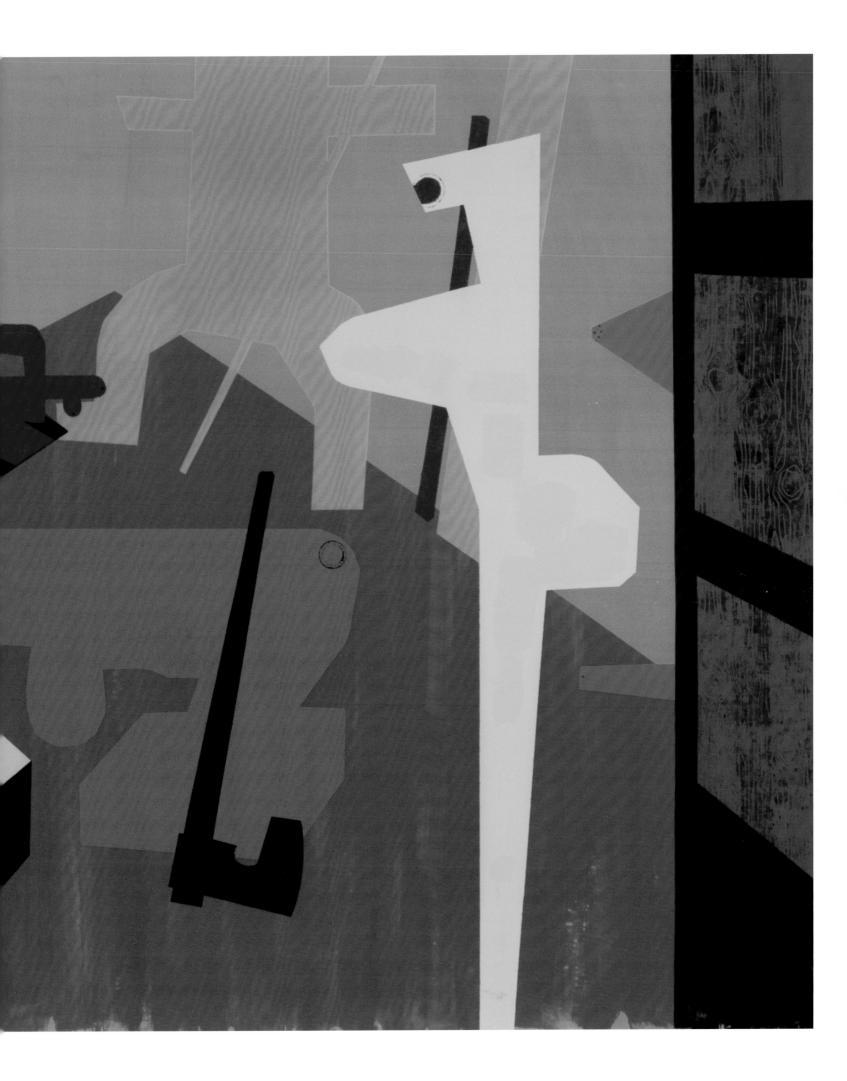

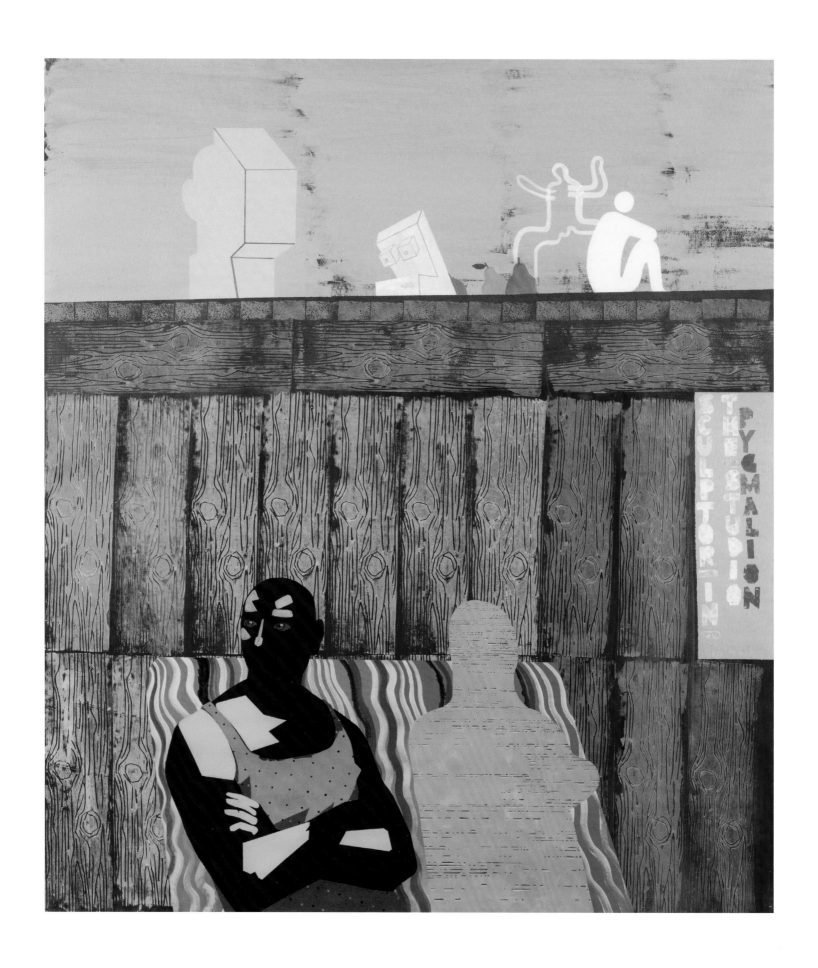

Sculptor in the Studio – Pygmalion, 2017
Acrylic on canvas / Acryl auf Leinwand
230 H x 210 W cm
(90 35/64 H x 82 43/64 W inches)

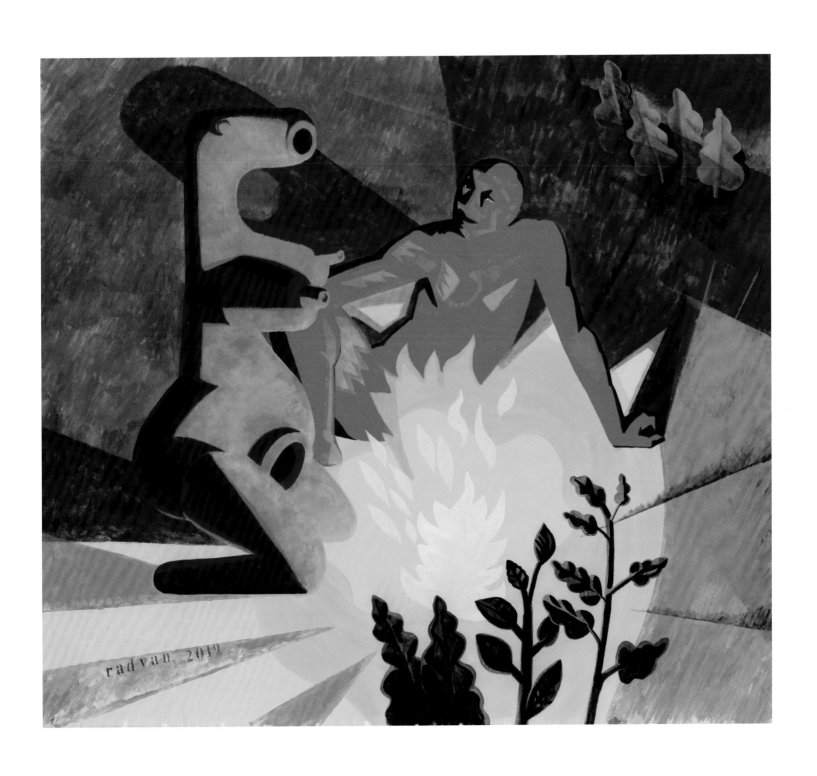

Remembering a Great Love, 2019
Acrylic on canvas / Acryl auf Leinwand
210 H x 240 W cm
(82 43/64 H x 94 31/64 W inches)

Chapter IV: Strange Women

'There must be an island out there that cannot be found. Strange rituals organize life on that piece of rock. I call it "the island for Umberto" because he took me there once. I have learned the way and I became a frequent visitor to that land. Among the splendid creatures who live there, one can find Strange women. I don't know their names; I call them strange because they are magnificent, overwhelming, excessive, massive, primitive and gloriously sexual. They are calm, move slowly and have the gift of making a visitor to the island feel immortal.'

Alexandru Rădvan, artist

Kapitel IV: Seltsame Frauen

„Es muss da draußen eine Insel geben, die nie entdeckt wurde. Seltsame Rituale organisieren das Leben auf diesem Felsbrocken. Ich nenne sie ‚die Insel für Umberto‘, weil er mich einmal dorthin mitgenommen hat. Ich habe mir den Weg gemerkt und bin jetzt ein häufiger Besucher dieses Landes. Zu den prächtigen Kreaturen, die dort leben, gehören auch die Seltsamen Frauen. Ich kenne ihre Namen nicht; ich nenne sie seltsam, weil sie prachtvoll, überwältigend, exzessiv, massiv, primitiv und herrlich sexuell sind. Sie sind ruhig, bewegen sich langsam, und sie haben die Gabe zu bewirken, dass der Besucher der Insel sich unsterblich fühlt.“

Alexandru Rădvan, Künstler

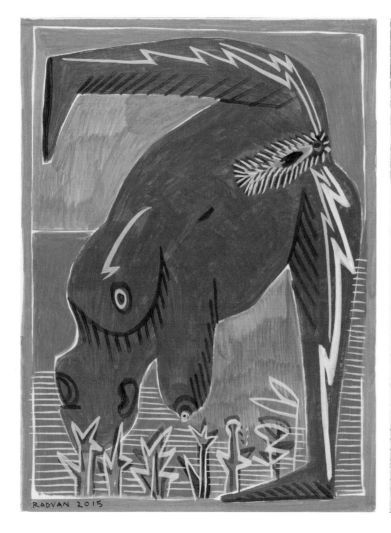 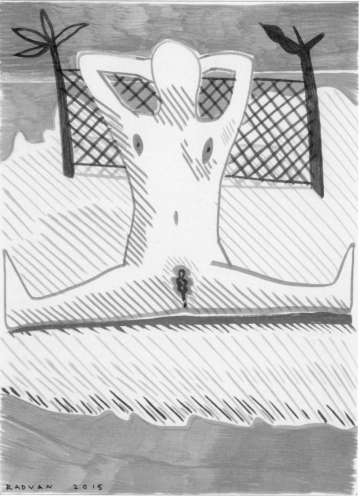

Strange Woman I, 2015
Acrylic marker on canvas /
Acrylmarker auf Leinwand
60 H x 45 W cm
(23 5/8 H x 17 23/32 W inches)

Strange Woman II, 2015
Acrylic marker on canvas /
Acrylmarker auf Leinwand
60 H x 45 W cm
(23 5/8 H x 17 23/32 W inches)

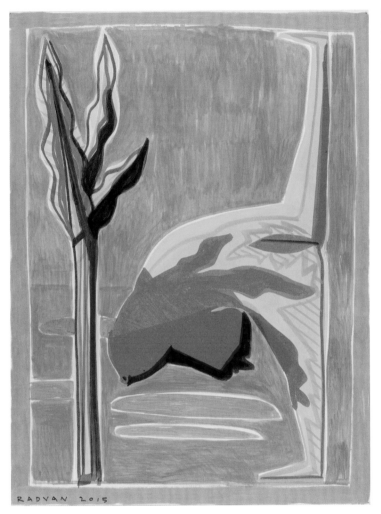

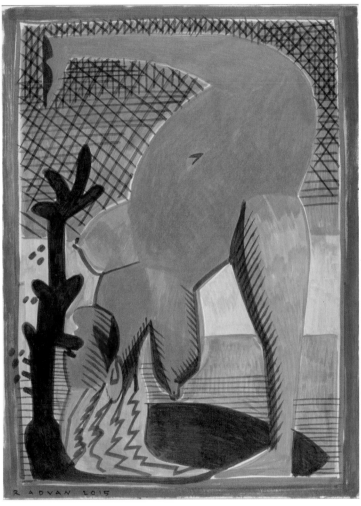

Strange Woman III, 2015
Acrylic marker on canvas /
Acrylmarker auf Leinwand
60 H x 45 W cm
(23 5/8 H x 17 23/32 W inches)

Strange Woman IV, 2015
Acrylic marker on canvas /
Acrylmarker auf Leinwand
60 H x 45 W cm
(23 5/8 H x 17 23/32 W inches)

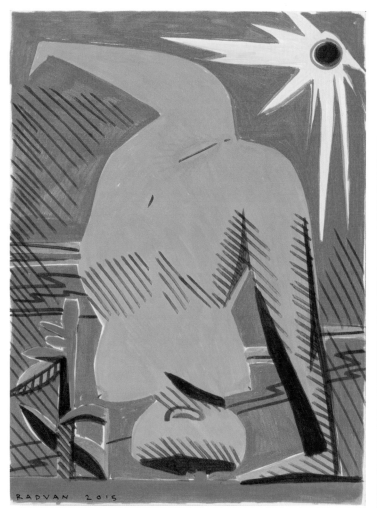

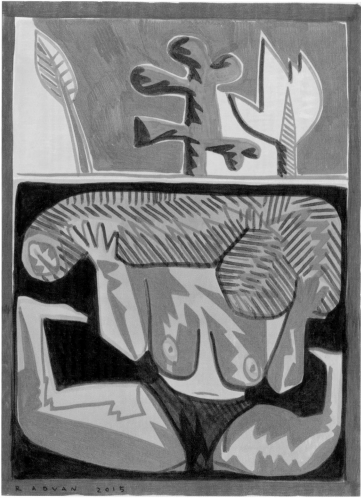

Strange Woman V, 2015
Acrylic marker on canvas /
Acrylmarker auf Leinwand
60 H x 45 W cm
(23 5/8 H x 17 23/32 W inches)

Strange Woman VI, 2015
Acrylic marker on canvas /
Acrylmarker auf Leinwand
60 H x 45 W cm
(23 5/8 H x 17 23/32 W inches)

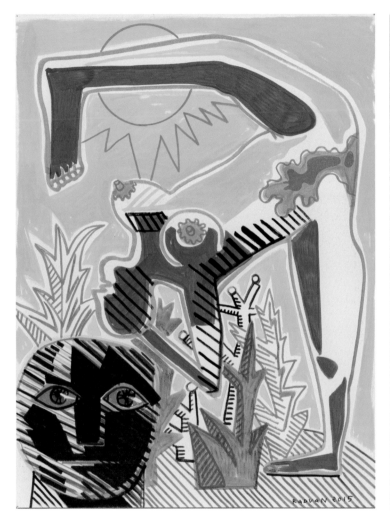

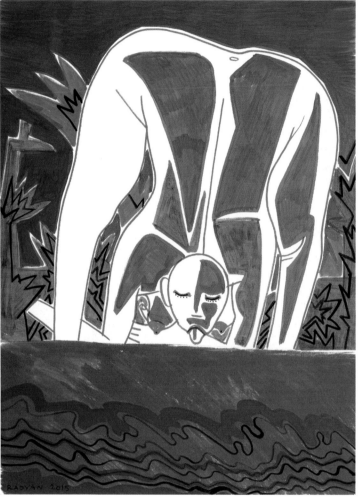

Strange Woman VII, 2015
Acrylic marker on canvas /
Acrylmarker auf Leinwand
60 H x 45 W cm
(23 5/8 H x 17 23/32 W inches)

Strange Woman VIII, 2015
Acrylic marker on canvas /
Acrylmarker auf Leinwand
60 H x 45 W cm
(23 5/8 H x 17 23/32 W inches)

Private collection / Private Sammlung

Chapter V: Apollo & Daphne

'Love, lust, despair. A god loses unexpectedly the object of his passion. Huge tears, swollen eyelids, running nose, a stupid look on the face, while calling her name in vain. We all have been there at least once. We are no different from a god in those moments, for even they become like the most vulnerable man.'

Alexandru Rădvan, artist

Kapitel V: Apollo & Daphne

„Liebe, Wollust, Verzweiflung. Ein Gott verliert unversehens das Objekt seiner Leidenschaft. Gigantische Tränen, geschwollene Augenlider, laufende Nase, blöder Gesichtsausdruck, vergebliches Rufen ihres Namens. Wir alle waren wenigstens einmal da. In diesen Momenten unterscheiden wir uns nicht von einem Gott, und ein Gott selbst wird zum verwundbarsten Menschen.“

Alexandru Rădvan, Künstler

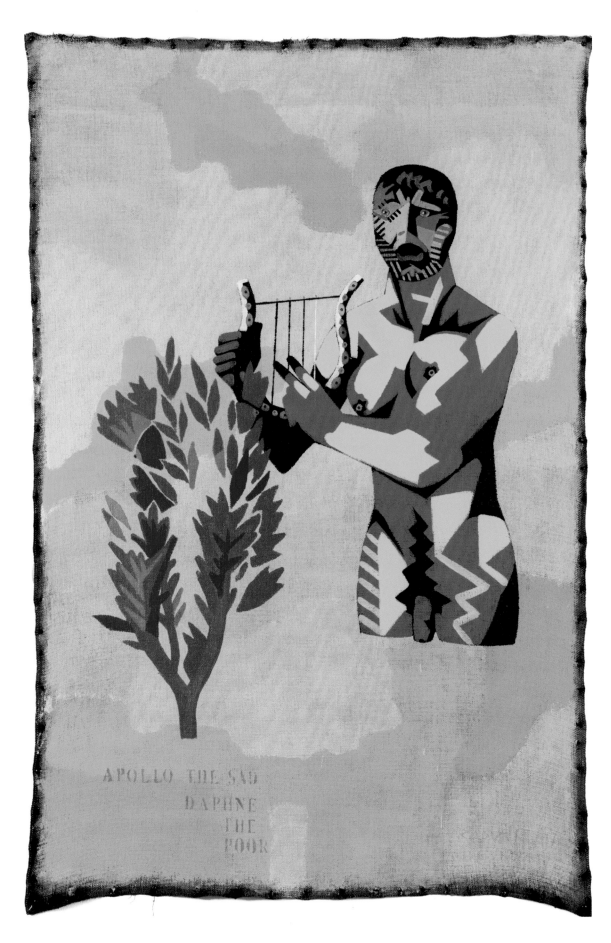

Apollo the Sad, Daphne the Poor, 2017
Acrylic on canvas / Acryl auf Leinwand
206 H x 140 W cm
(81 7/64 H x 55 1/8 W inches)

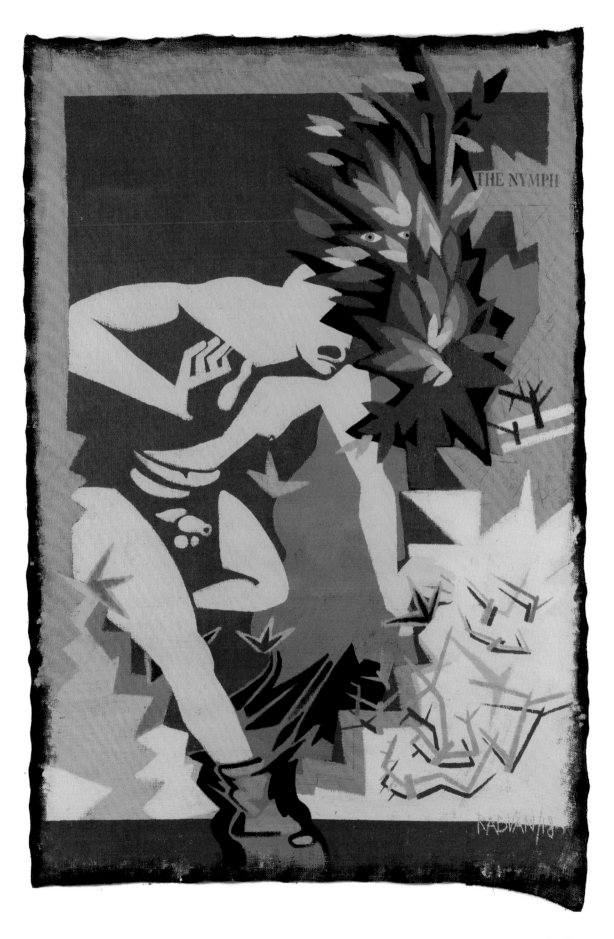

The God, The Nymph, 2018
Acrylic on canvas / Acryl auf Leinwand
210 H x 140 W cm
(82 43/64 H x 55 1/8 W inches)

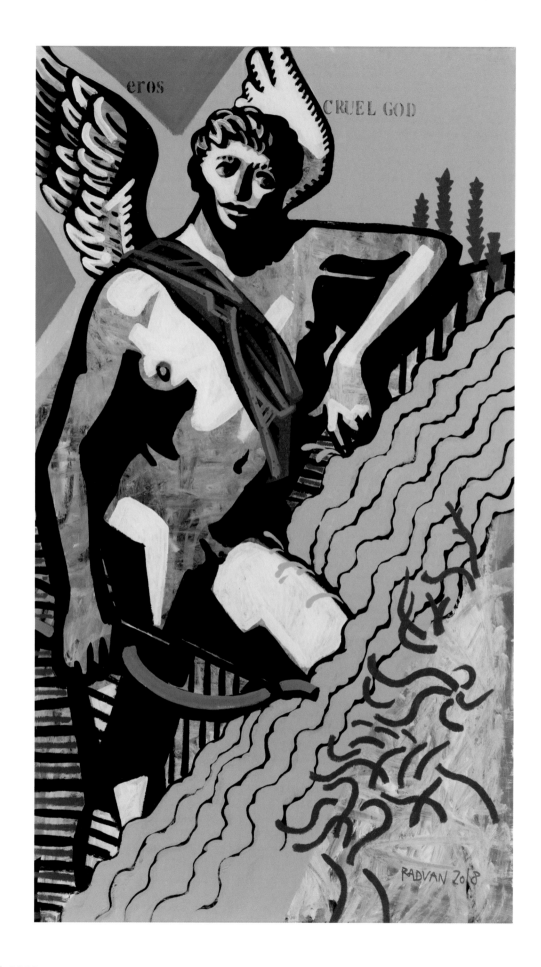

Eros Cruel God, 2018
Acrylic on canvas / Acryl auf Leinwand
210 H x 120 W cm
(82 43/64 H x 47 1/4 W inches)

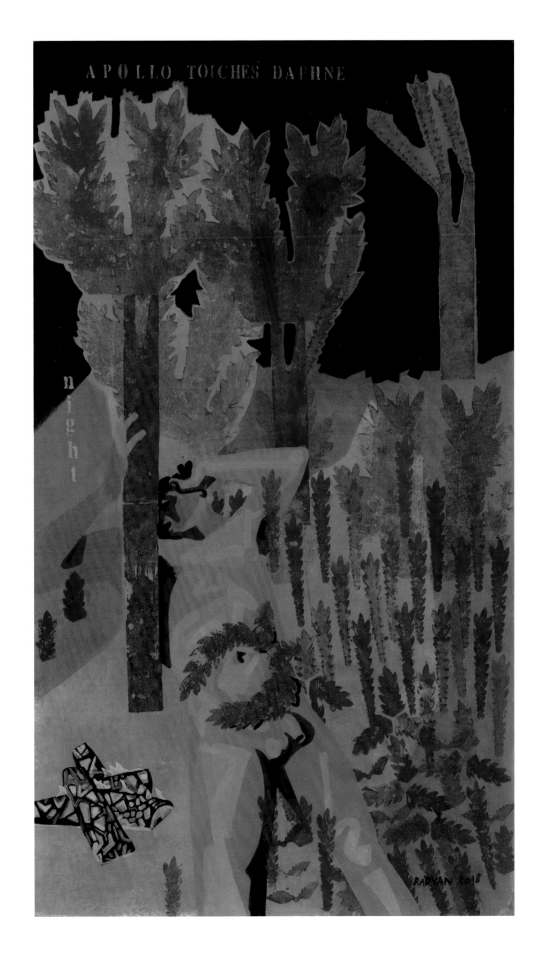

Apollo Touches Daphne, 2018
Acrylic on canvas / Acryl auf Leinwand
210 H x 120 W cm
(82 43/64 H x 47 1/4 W inches)

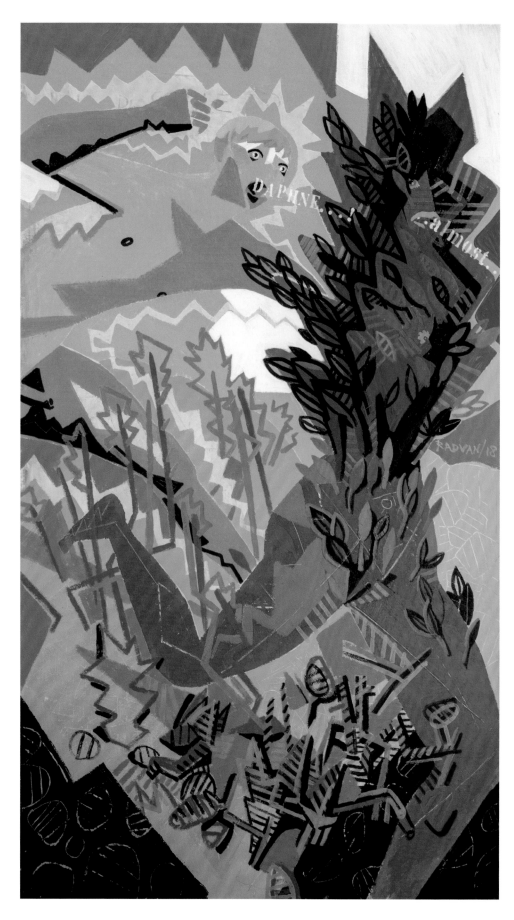

Daphne... almost..., 2018
Acrylic on canvas / Acryl auf Leinwand
210 H x 120 W cm
(82 43/64 H x 47 1/4 W inches)

Private collection / Private Sammlung

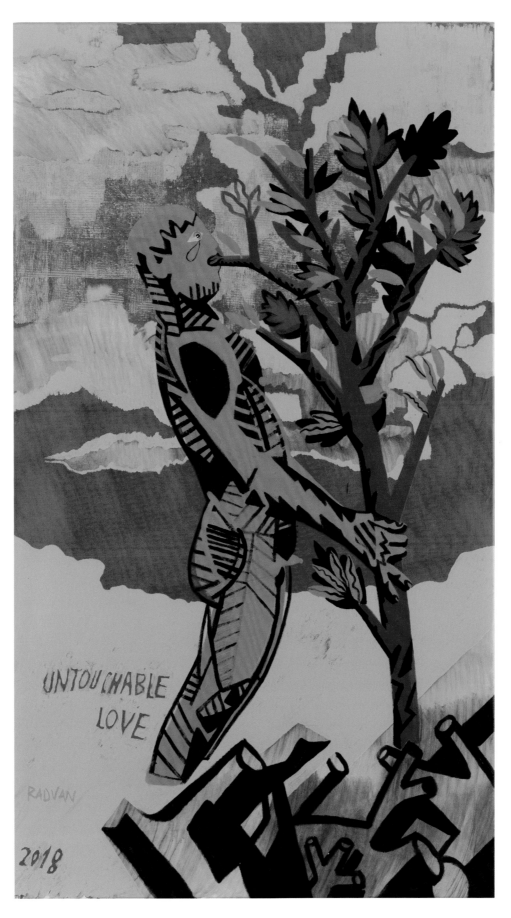

Untouchable Love, 2018
Acrylic on canvas / Acryl auf Leinwand
210 H x 120 W cm
(82 43/64 H x 47 1/4 W inches)

Chapter VI: Hercules

'I have Hercules in my womb, in my arms and knees. He is half god and I am not. He loses his temper and I lose my temper. Both of us regret it afterwards, seeing the damage we have done. Hercules works hard and builds things; I work very hard (yet I am only human) and try to build a world. I love him and he would probably appreciate me. I feel I could hold the skies on my shoulders, move a mountain or journey to the Underworld and back if needed. All I have to do is believe that he did it before me. Every morning is a new labor, every evening is a new territory to conquer, every night marks the return home, to hear your woman's breathe while she sleeps, to feel the warmth of the skin on her belly, and the smell of her nipples. The veins are filled with lava, melted gold and godly power. One day I will drink my wine with Hercules and Ulysses, and we will eat a herd of oxen.'

Alexandru Rădvan, artist

Kapitel VI: Herkules

„Ich habe Herkules in meinem Schoß, in meinen Armen und Knien. Er ist halb Gott, und ich bin es nicht. Er verliert die Beherrschung, und ich verliere die Beherrschung. Uns beiden tut es hinterher leid, wenn wir den Schaden sehen, den wir angerichtet haben. Herkules arbeitet hart und errichtet Dinge; ich arbeite sehr hart (weil ich nur ein Mensch bin) und versuche, eine Welt zu errichten. Ich liebe ihn, und er würde mich wahrscheinlich schätzen. Ich habe das Gefühl, ich könnte den Himmel auf meinen Schultern tragen, einen Berg versetzen oder, wenn nötig mich, in die Unterwelt begeben und wiederkehren. Ich brauche dafür nur zu denken, dass er es vor mir getan hat. Jeder Morgen ist eine neue Arbeit, jeder Abend ist ein neues Territorium, das es zu erobern gilt, jede Nacht markiert die Rückkehr nach Hause, den Atem deiner Frau im Schlaf zu hören, die Wärme der Haut auf ihrem Bauch zu spüren, den Geruch ihrer Brustwarzen. Die Adern sind gefüllt mit Lava, geschmolzenem Gold und göttlicher Kraft. Eines Tages werde ich meinen Wein mit Herkules und Odysseus trinken, und wir werden eine Herde von Ochsen verzehren."

Alexandru Rădvan, Künstler

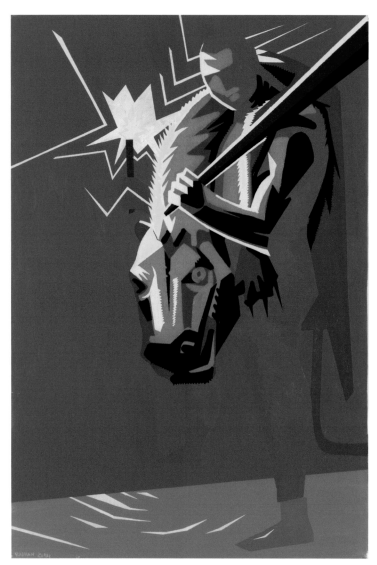

Diptych, 2014
Acrylic on canvas / Acryl auf Leinwand
130 H x 178 W cm (je 130 H x 89 W cm)
(51 3/16 H x 70 5/64 W inches (each 51 3/16 H x 35 3/64 W inches))

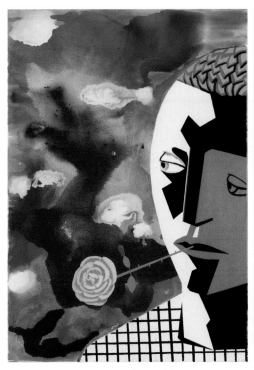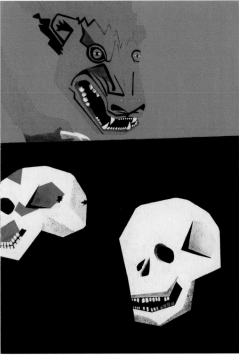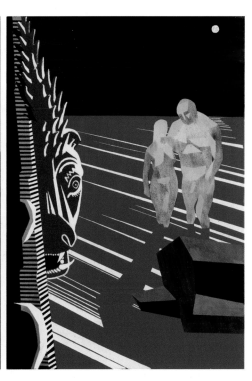

Hercules after Carracci *(triptych / Triptychon),* 2014
Acrylic on canvas / Acryl auf Leinwand
100 H x 210 W cm (je 100 H x 70 W cm)
(39 3/8 H x 82 43/64 W inches (each 39 3/8 H x 27 9/16 W inches))

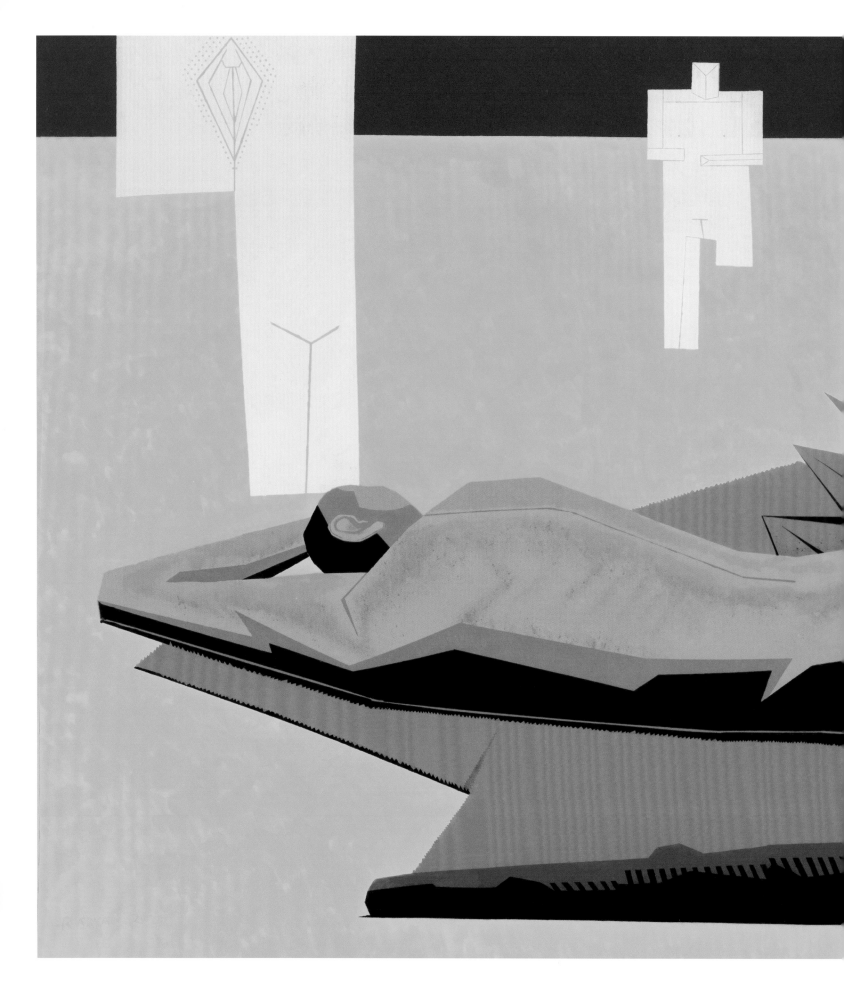

Hercules after Carracci, 2014
Acrylic on canvas / Acryl auf Leinwand
200 H x 375 W cm
(78 47/64 H x 147 41/64 W inches)

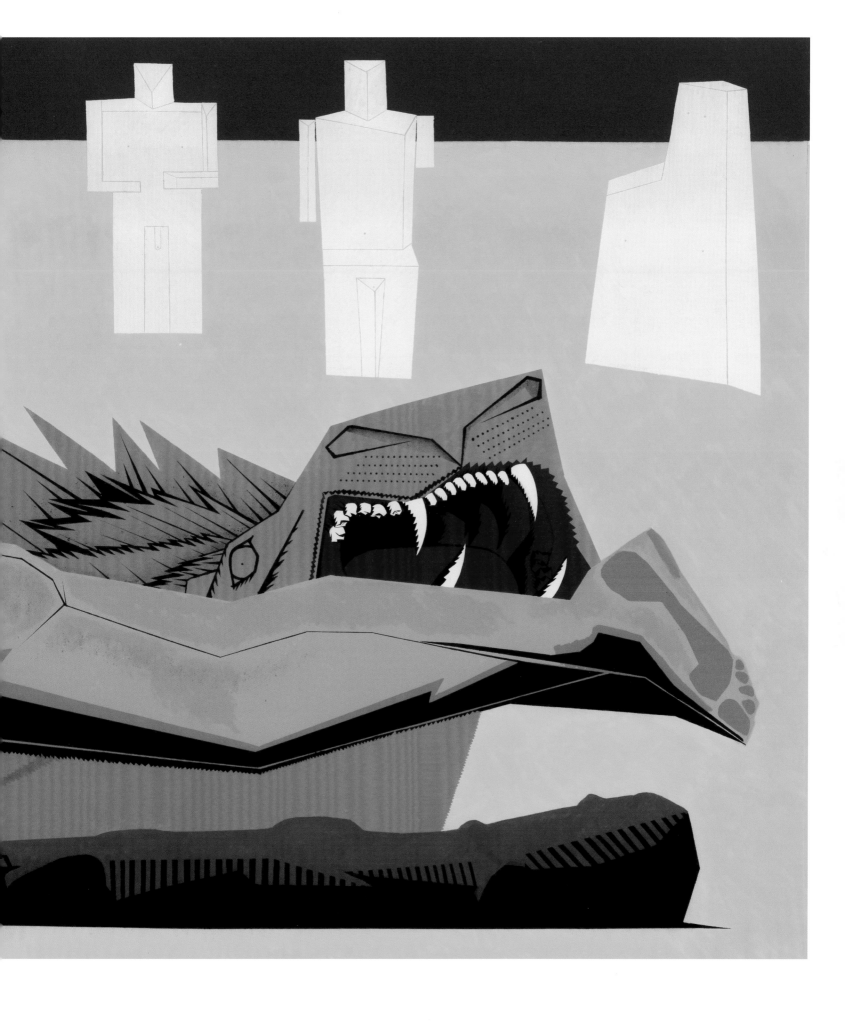

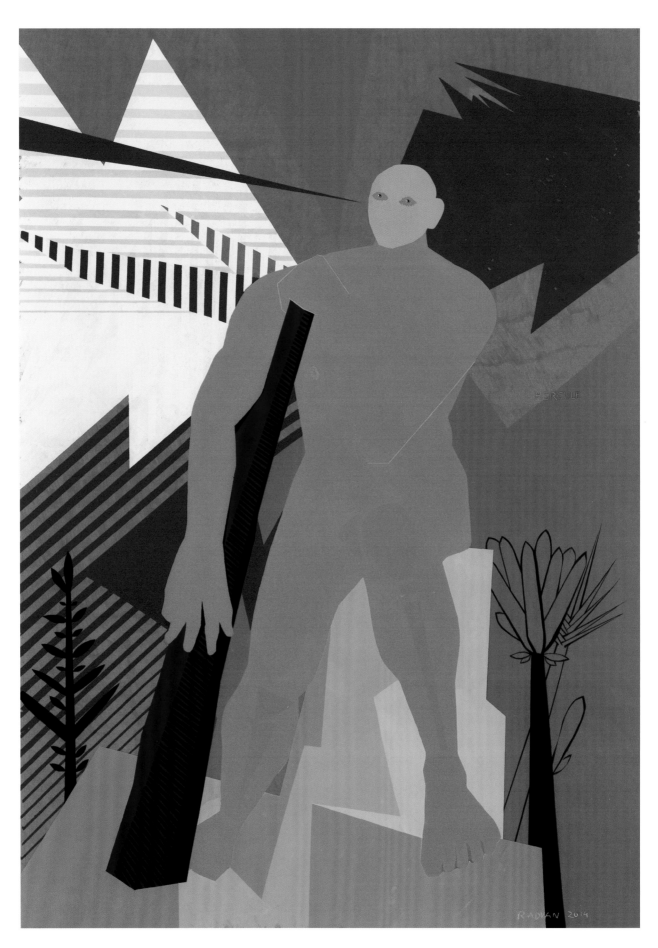

Hercules after Carracci, 2014
Acrylic on canvas / Acryl auf Leinwand
282 H x 200 W cm
(111 1/32 H x 78 47/64 W inches)

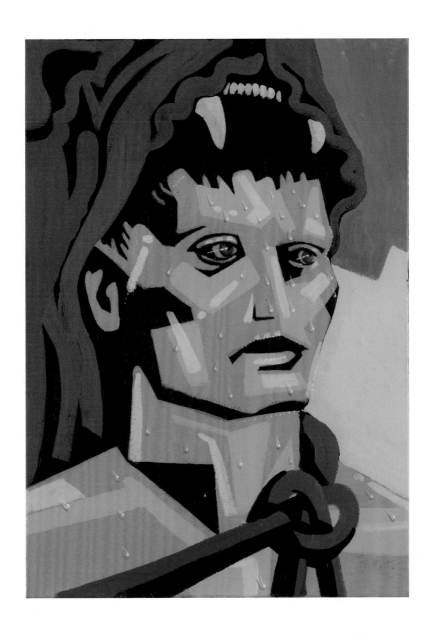

Sweating Hercules, 2017
Acrylic on canvas / Acryl auf Leinwand
70 H x 50 W cm
(27 9/16 H x 19 11/16 W inches)

Hercules, 2015 ▶
Acrylic on canvas / Acryl auf Leinwand
200 H x 308 W cm
(78 47/64 H x 121 17/64 W inches)

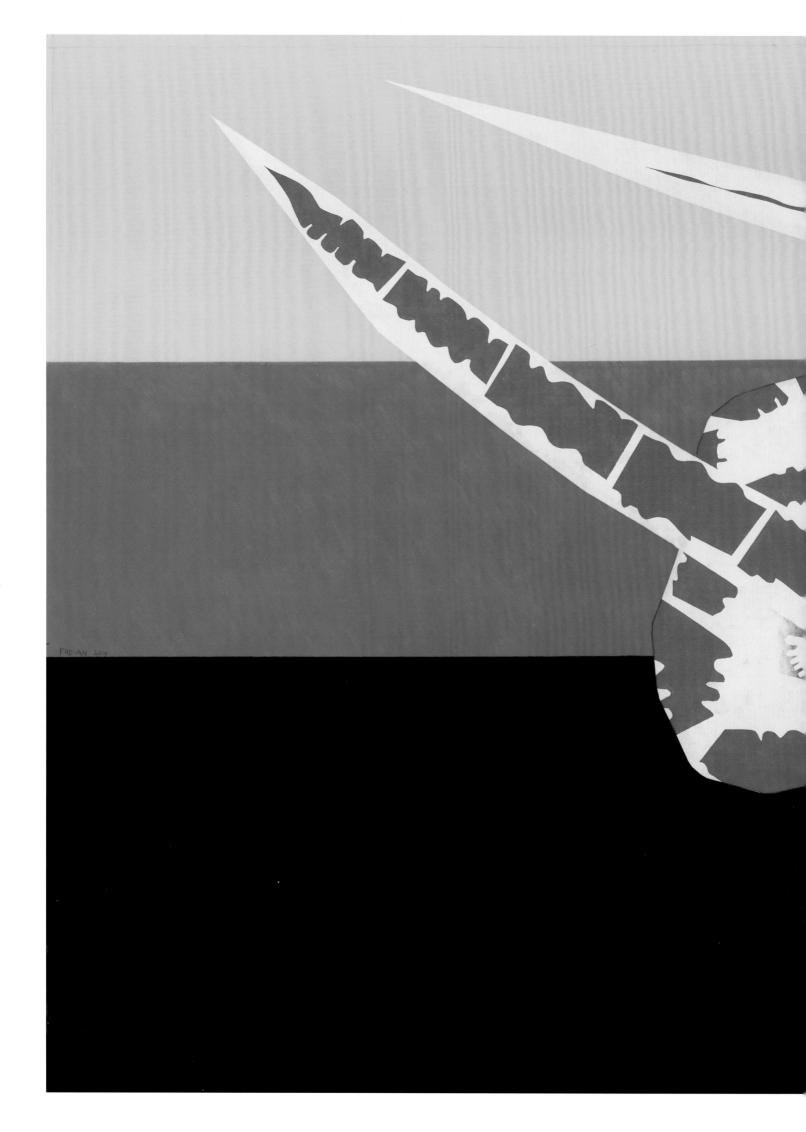

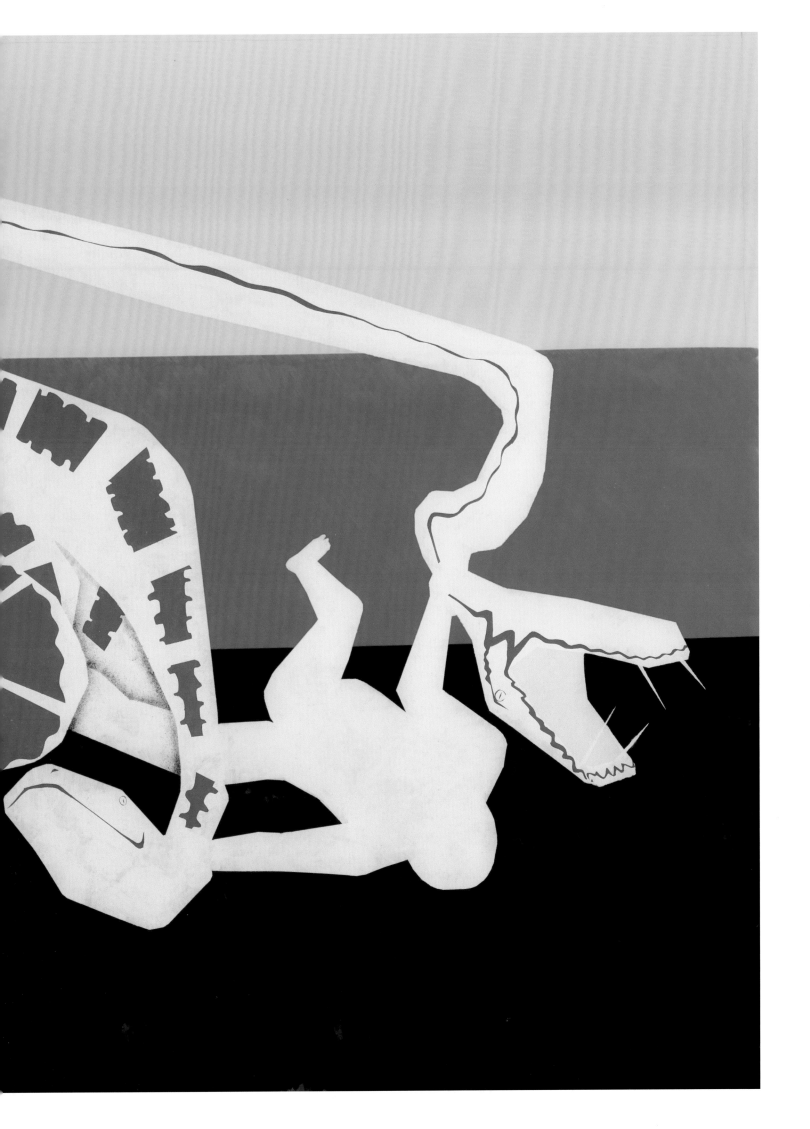

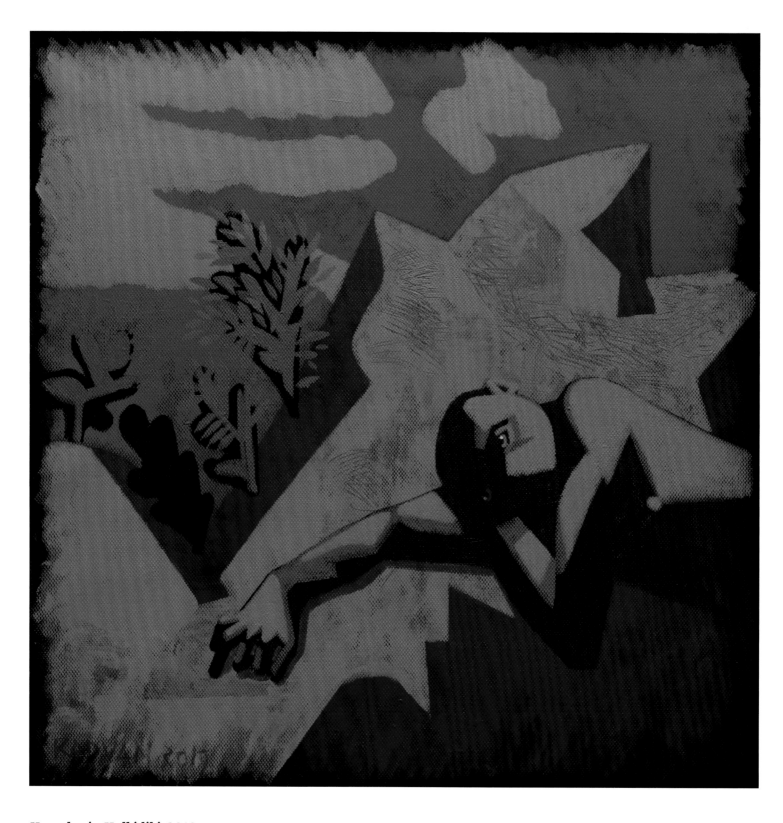

Hercules in Halkidiki, 2019
Acrylic on canvas / Acryl auf Leinwand
141 H x 147 W cm (unstretched / ungedehnt)
(55 33/64 H x 57 7/8 W inches)

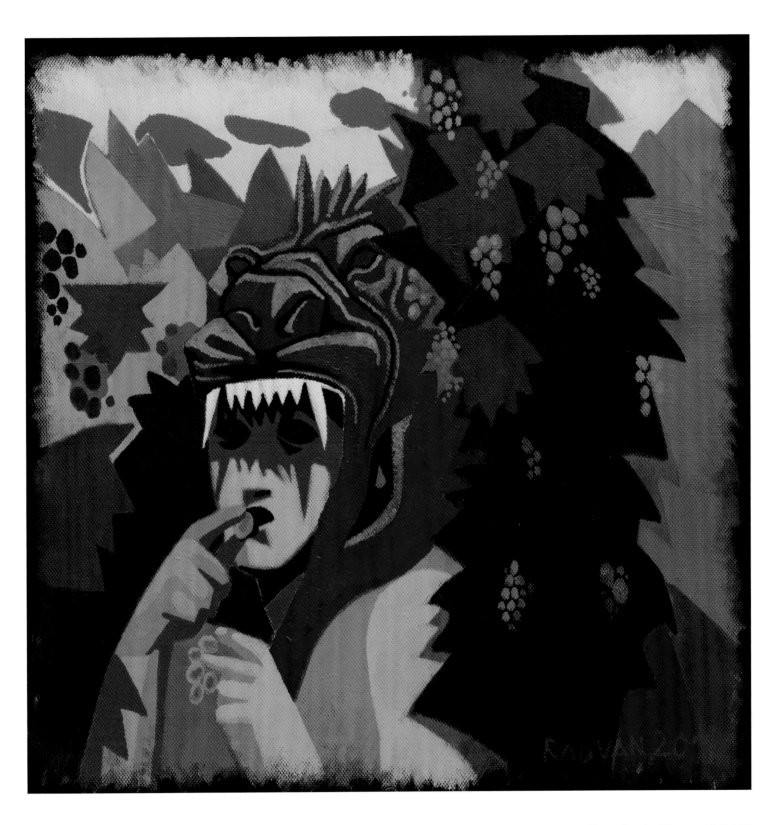

Hercules in Vineyard, 2019
Acrylic on canvas / Acryl auf Leinwand
135 H x 150 W cm
(53 5/32 H x 59 1/16 W inches)

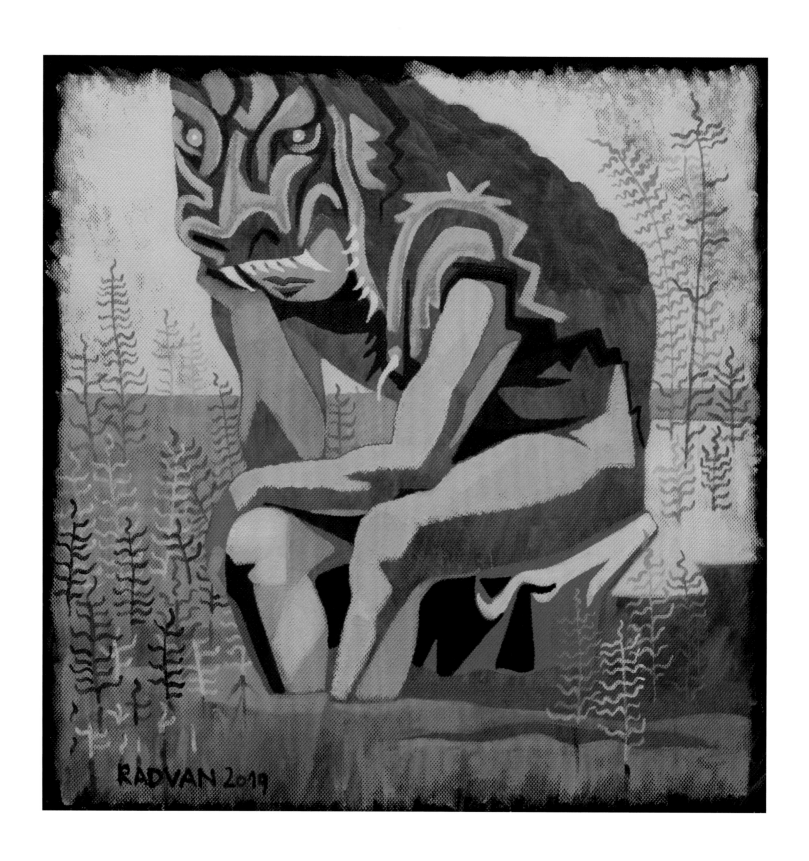

Hercules in the Swamp, 2019
Acrylic on canvas / Acryl auf Leinwand
135 H x 135 W cm
(53 5/32 H x 53 5/32 W inches)

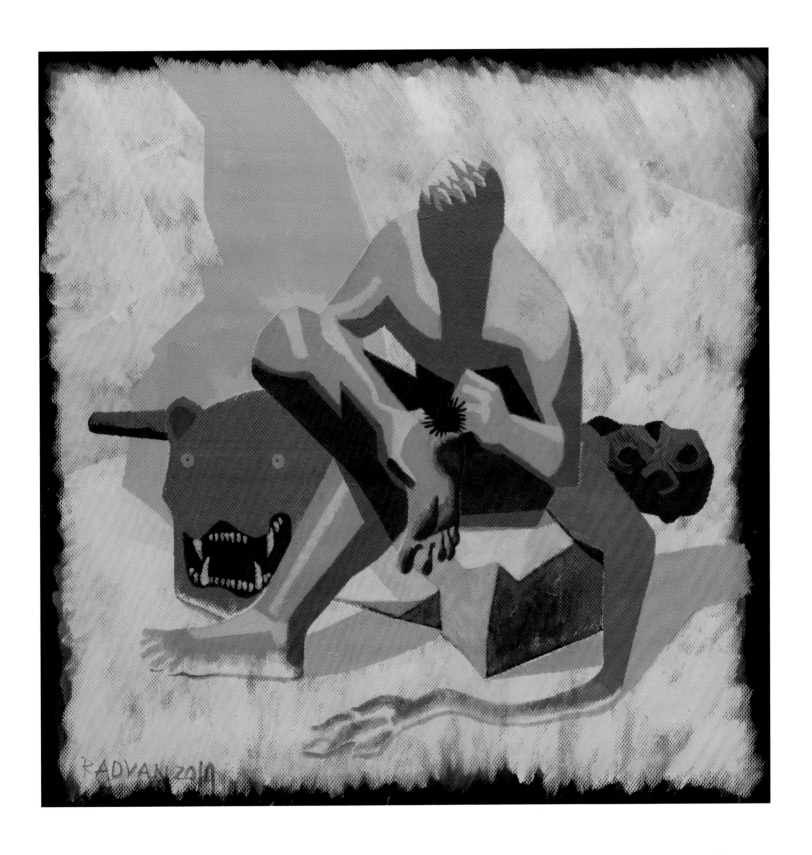

Hercules and Sea Urchin, 2019
Acrylic on canvas / Acryl auf Leinwand
141 H x 145,5 W cm (unstretched / ungedehnt)
(55 33/64 H x 57 9/32 W inches)

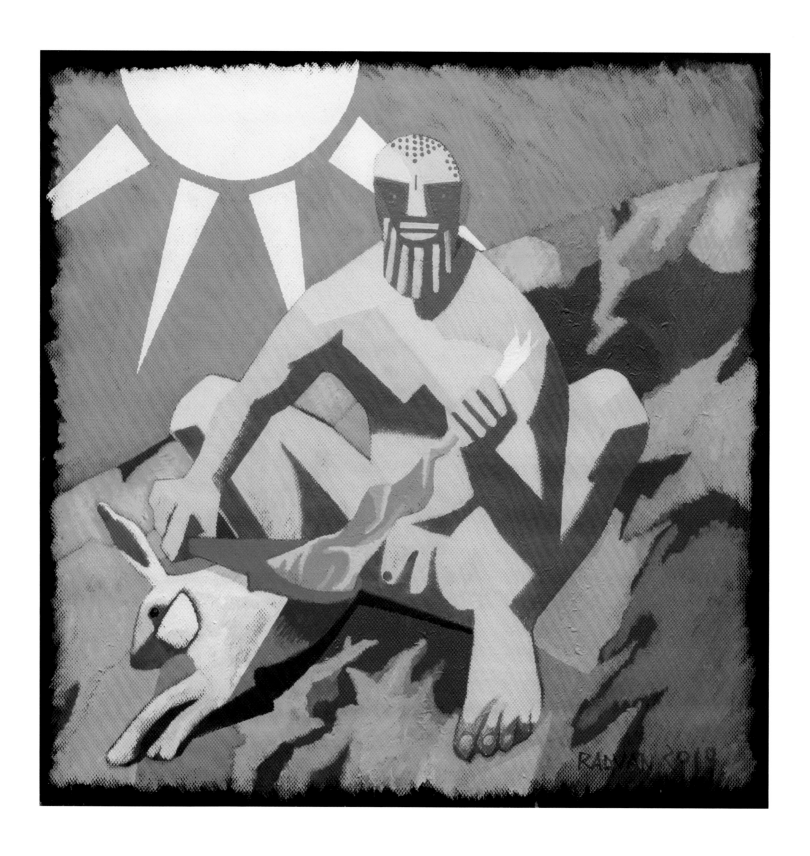

Archaic Hercules Skinning a Rabbit, 2019
Acrylic on canvas / Acryl auf Leinwand
135 H x 140 W cm
(53 5/32 H x 55 1/8 W inches)

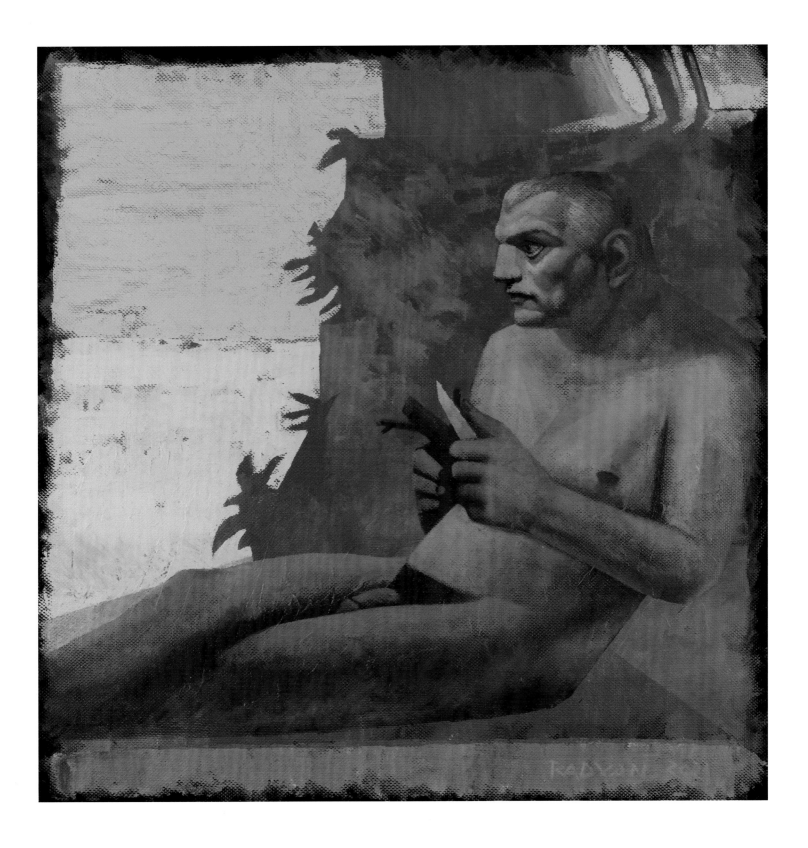

Man Waiting for Something to Happen, 2021
Acrylic on canvas / Acryl auf Leinwand
141,5 H x 147,5 W cm (unstretched / ungedehnt)
(55 45/64 H x 58 5/64 W inches)

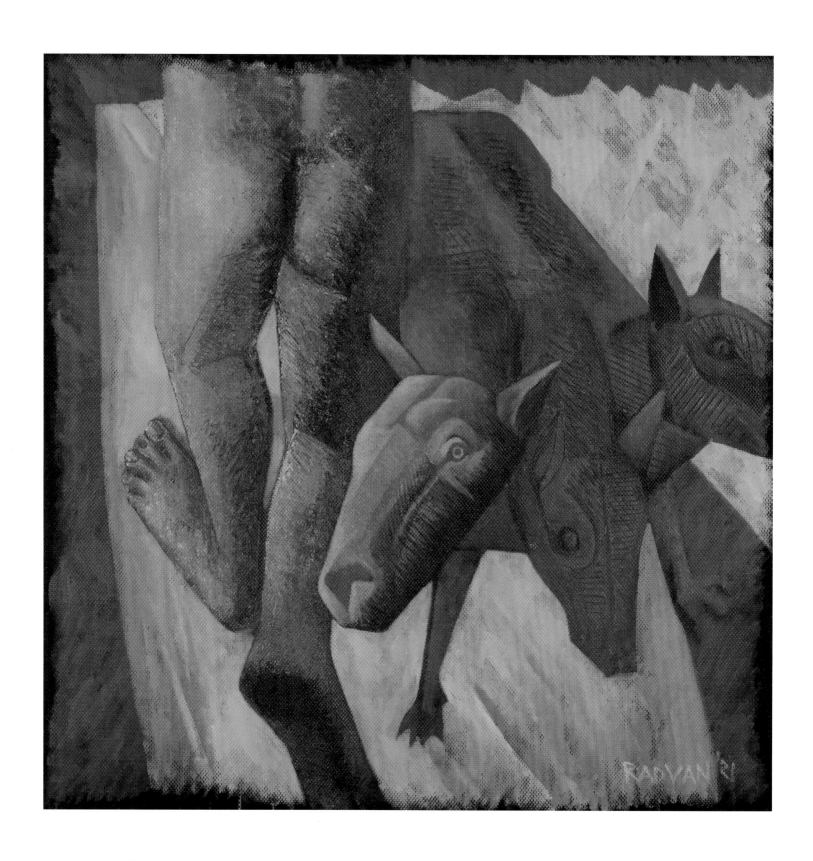

Cerberus 1, 2021
Acrylic on canvas / Acryl auf Leinwand
141 H x 145,5 W cm (unstretched / ungedehnt)
(55 33/64 H x 57 9/32 W inches)

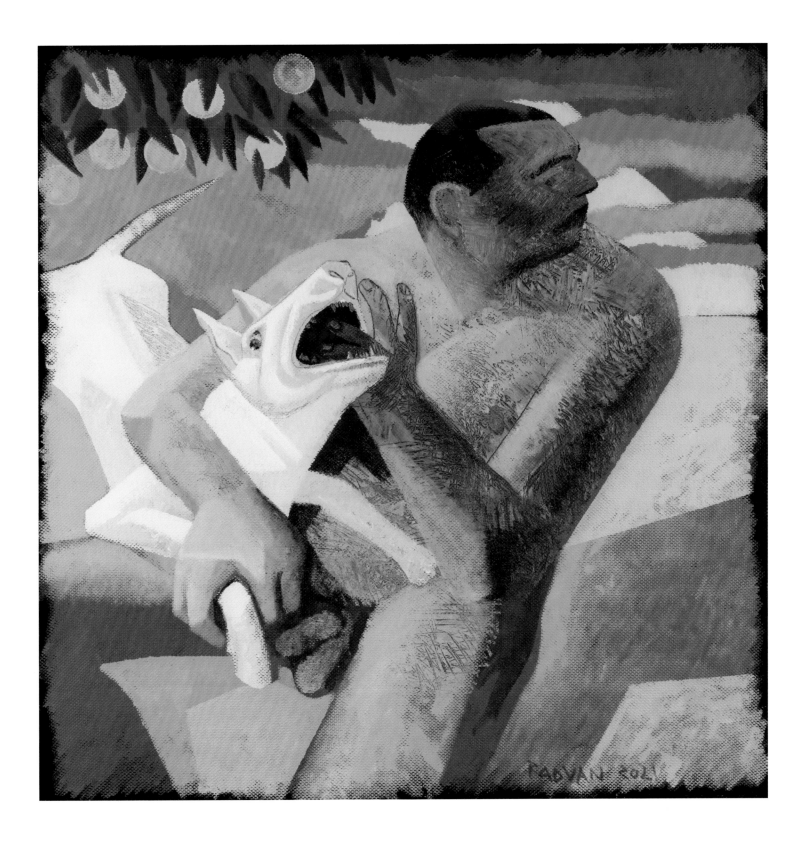

Cerberus 2, 2021
Acrylic on canvas / Acryl auf Leinwand
140,5 H x 148 W cm (unstretched / ungedehnt)
(55 5/16 H x 58 17/64 W inches)

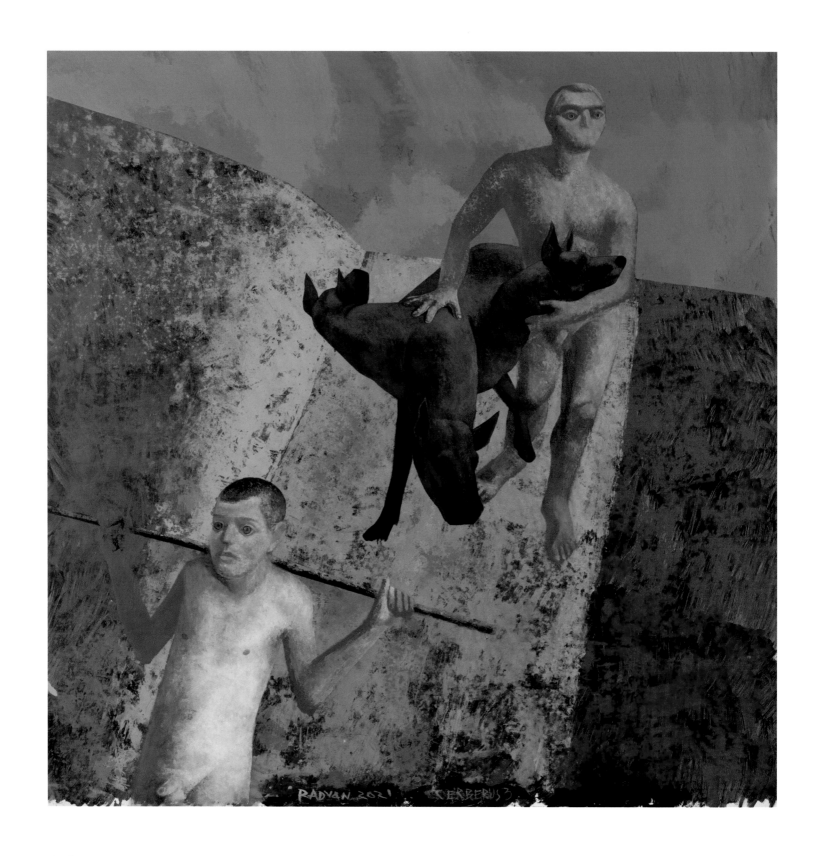

Cerberus 3, 2021
Acrylic on canvas / Acryl auf Leinwand
215 H x 205 W cm
(84 41/64 H x 80 45/64 W inches)

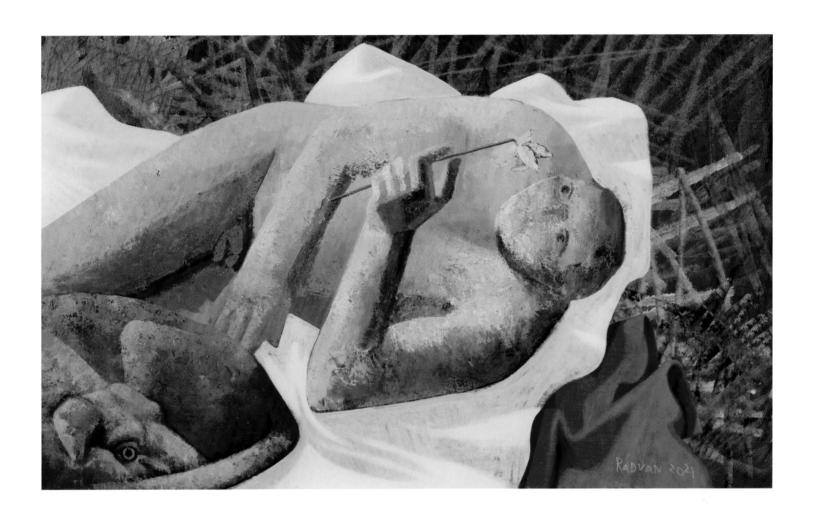

Cerberus 4, 2021
Acrylic on canvas / Acryl auf Leinwand
125 H x 210 W cm
(49 7/32 H x 82 43/64 W inches)

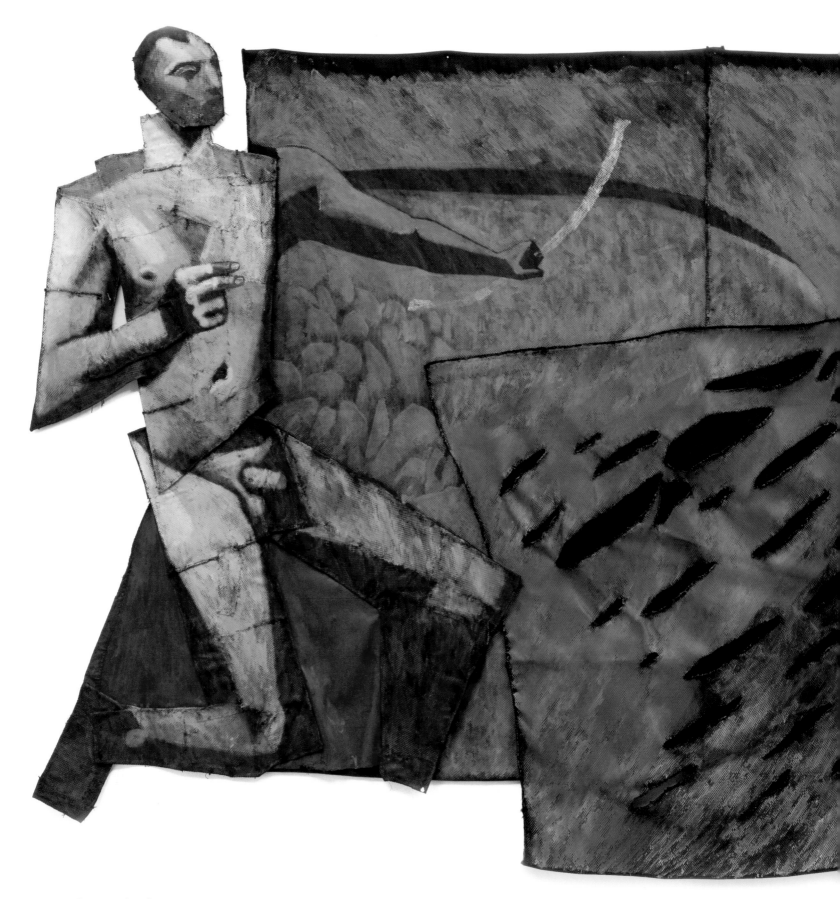

The Death of Nessus, 2019–2020
Textile picto-relief: canvas, fiberglass mesh, wadding, polypropylene, wood, velcro, acrylic /
Textiles Bildrelief: Leinwand, Glasfasergewebe, Watte,Polypropylen, Holz, Klettverschluss, Acryl
237 H x 480 W x 10 D cm
(93 5/16 H x 188 31/32 W x 3 15/16 D inches)

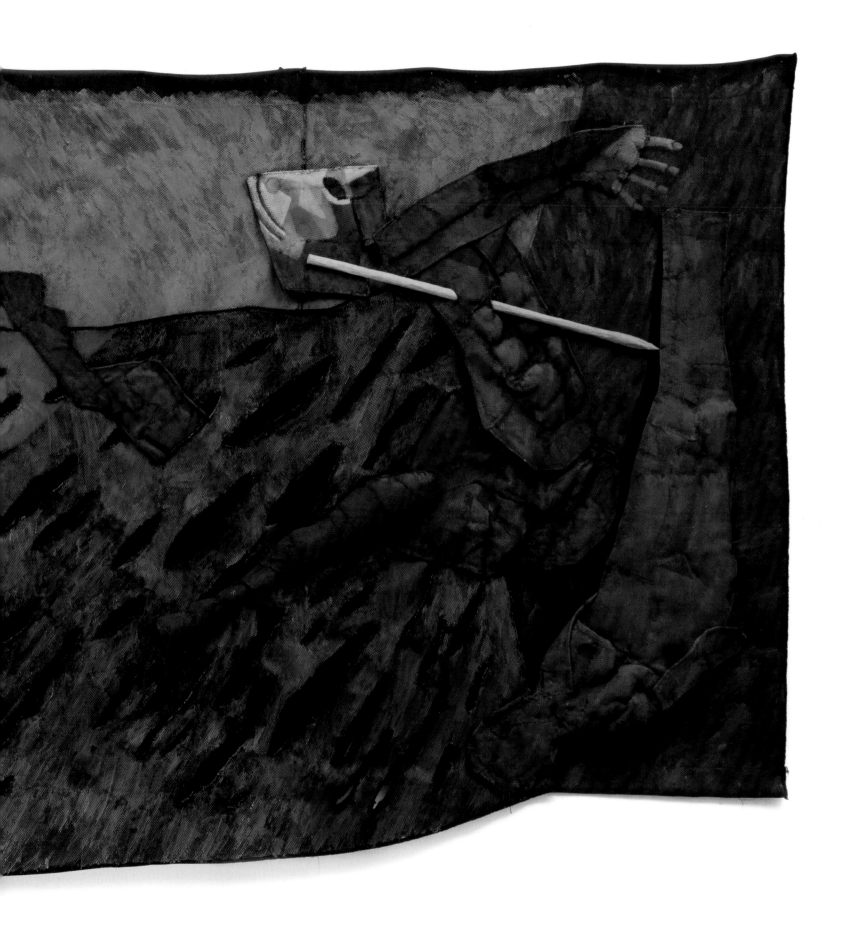

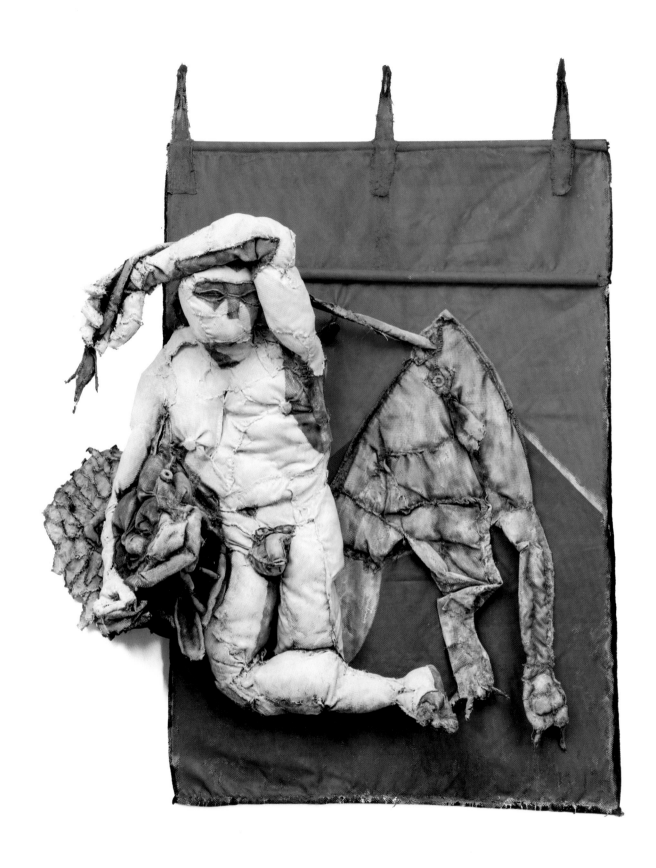

Hercules' Victory Dance, 2019
Textile picto-relief: acrylic, canvas, wadding, polypropylene /
Textiles Bildrelief: Acryl, Leinwand, Wattierung, Polypropylen
223 H x 175 W x 50 D cm
(87 51/64 H x 68 57/64 W x 19 11/16 D inches)

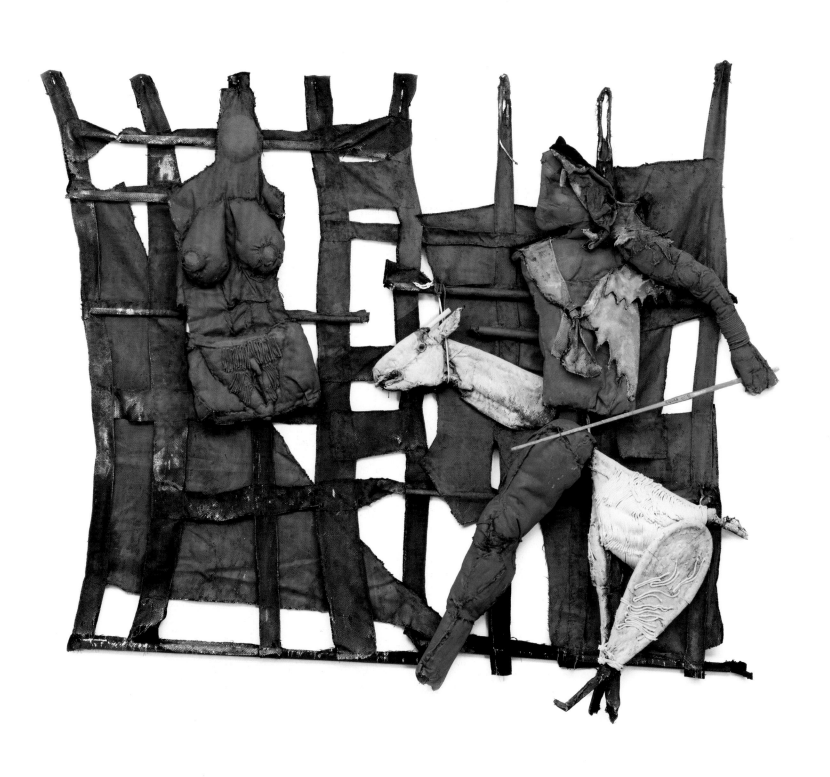

Fragmentary Hercules at the Oracle, 2019
Textile picto-relief: acrylic, canvas, wadding, polypropylene, bamboo /
Textiles Bildrelief: Acryl, Leinwand, Wattierung, Polypropylen, Bambus
250 H x 270 W x 33 D cm
(98 27/64 H x 106 19/64 W x 12 63/64 D inches)

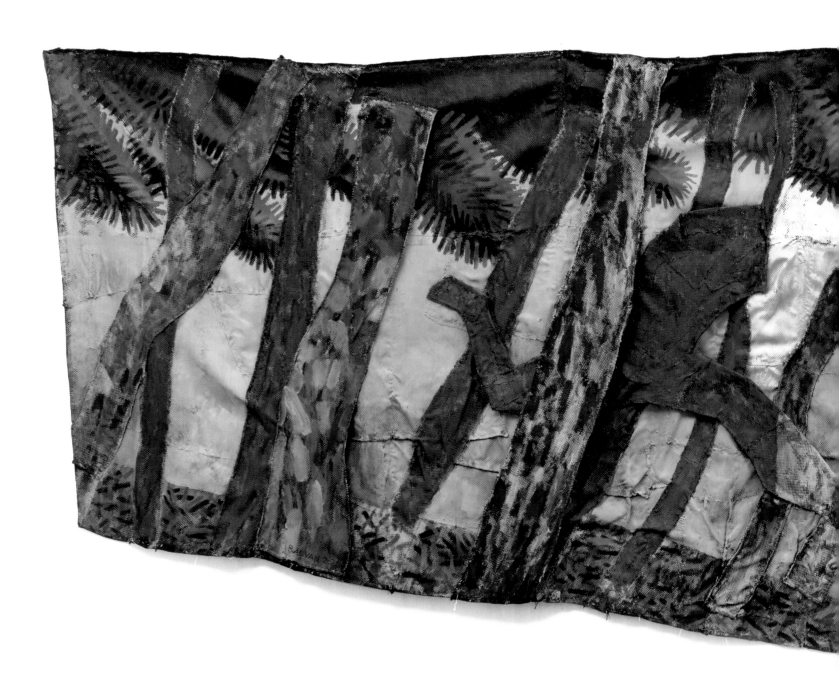

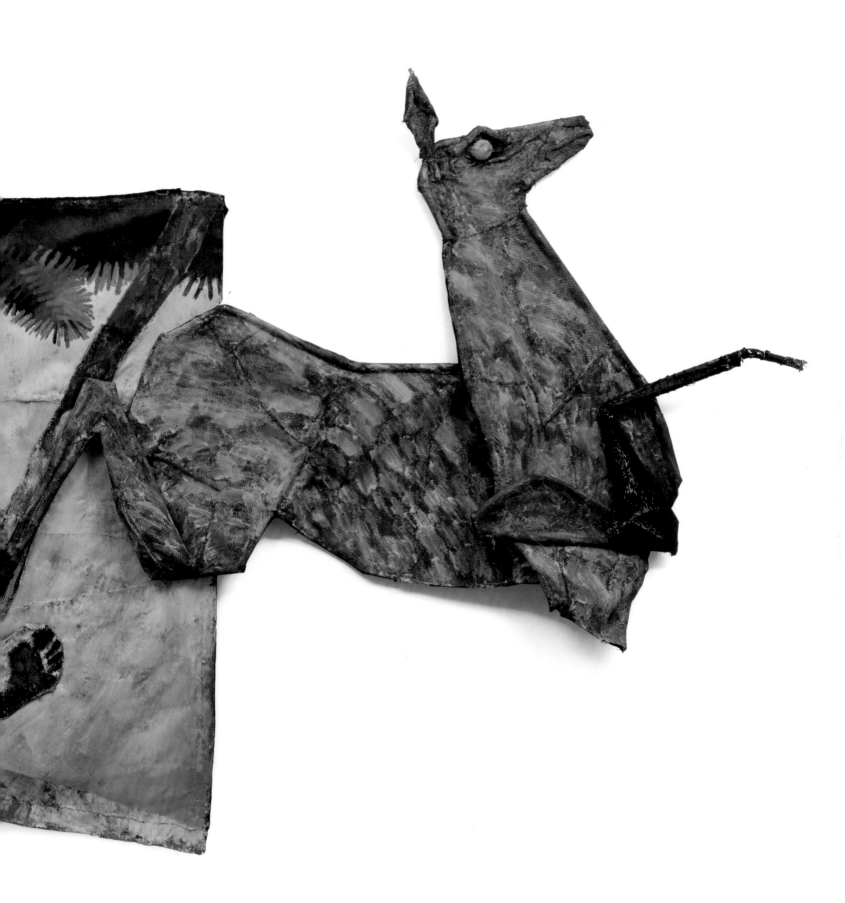

***Diana's Hind**, 2021
Textile picto-relief: canvas, fiberglass mesh, aluminium, wadding, polypropylene, wood, velcro, acrylic
Textiles Bildrelief: Leinwand, Glasfasergewebe, Aluminium, Watte, Polypropylen, Holz, Klettverschluss, Acryl
233 H x 510 W x 10 D cm
(91 47/64 H x 200 25/32 W x 3 15/16 D inches)

Chapter VII: Self-portrait

Kapitel VII: Selbstbildnis

OXYMORONISCHE ANSICHT

„Ich liebe:
die Romantik der brutalen Farben,
die Sinnlichkeit eckiger Formen,
die Weichheit von intensivem Licht,
die Eleganz unbeholfener Körper,
die Zartheit von Riesen,
die Intimität weiter Horizonte,
die Beschaulichkeit der Gefahr,
die Solidität der Himmel.
Ich liebe sie und möchte sie euch zeigen.“

Alexandru Rădvan, Künstler

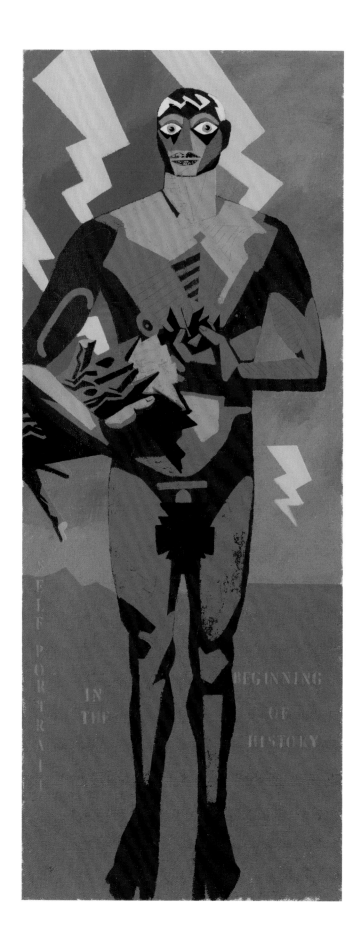

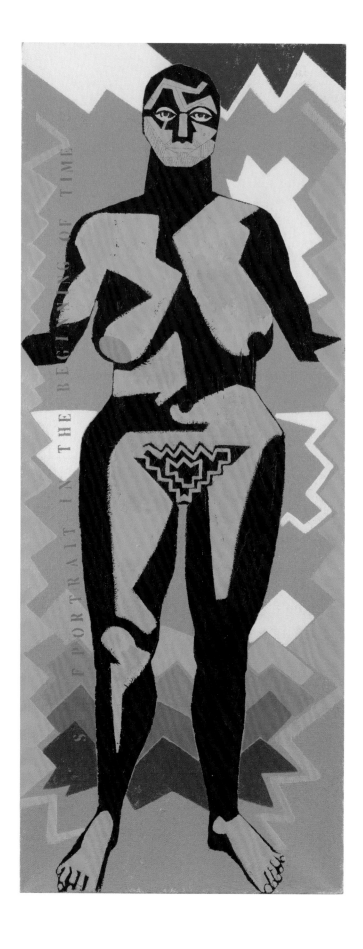

Self-portrait in the Beginning of History, 2019
Acrylic on canvas / Acryl auf Leinwand
226 H x 87,5 W cm
(88 31/32 H x 34 29/64 W inches)

Self-portrait in the Beginning of Time, 2019
Acrylic on canvas / Acryl auf Leinwand
226 H x 87,5 W cm
(88 31/32 H x 34 29/64 W inches)

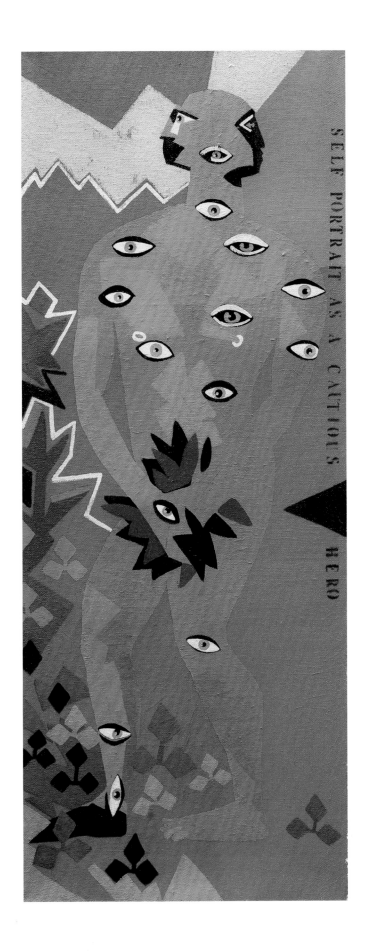

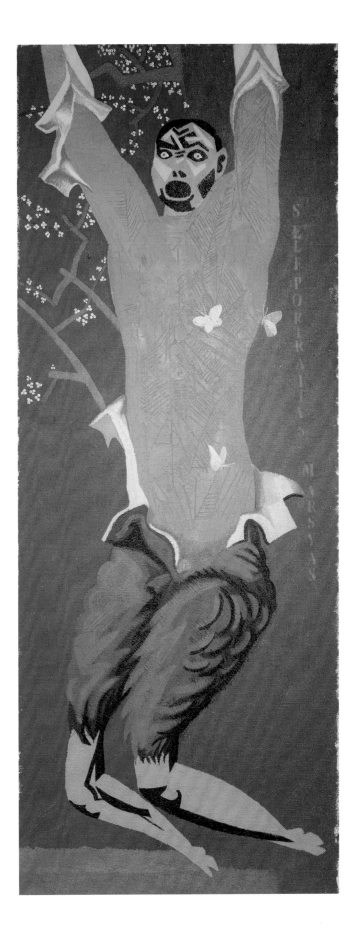

Self-portrait as a Cautious Hero, 2019
Acrylic on canvas / Acryl auf Leinwand
226 H x 87,5 W cm
(88 31/32 H x 34 29/64 W inches)

Self-portrait as Marsyas, 2019
Acrylic on canvas / Acryl auf Leinwand
226 H x 87,5 W cm
(88 31/32 H x 34 29/64 W inches)

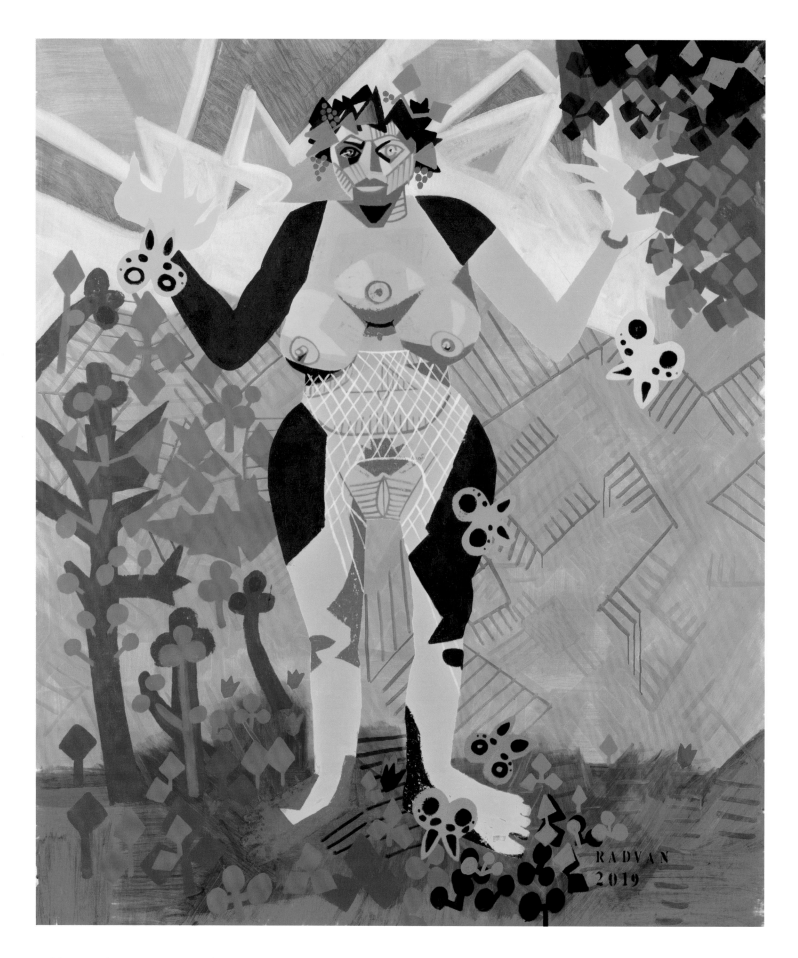

Self-portrait as a Super Ancient Goddess, 2019
Acrylic, acrylic marker on canvas / Acryl, Acrylmarker auf Leinwand
250 H x 210 W cm
(98 27/64 H x 82 43/64 W inches)

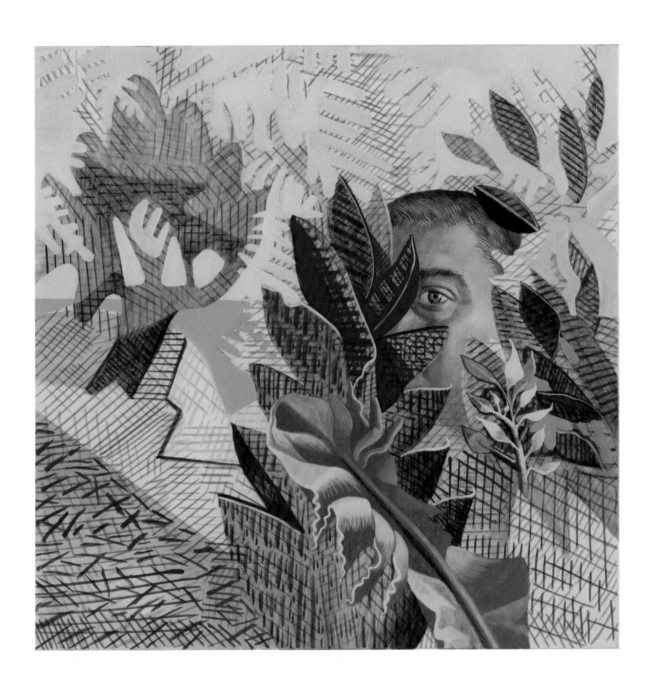

Self-portrait Thinking of the Summers I Have Left, 2020
Acrylic on canvas / Acryl auf Leinwand
70 H x 70 W cm
(27 9/16 H x 27 9/16 W inches)

This publication is released to accompany the exhibition:
Mythical Flesh, Alexandru Rădvan, 2021.

The project Mythical Flesh by Alexandru Rădvan, was supported by Stiftung Kunstfonds thru NeuStart Kultur.

Editor(s)
Diana Dochia
Mark Gisbourne

Editorial staff
Mihai Ziman

Photo Credit
Marcus Schneider
Sorina Andreica

Design
Casandra Elefterescu

Copyediting
Susann Harring
Georg Frederick Takis

Translations
Herwig Engelmann

Production
Jens Bartneck / Kerber Verlag

Project management
Martina Kupiak / Kerber Verlag

Printed and published by
Kerber Verlag
Windelsbleicher Str. 166–170
33659 Bielefeld
Germany
+49 521 950 08 10
+49 521 950 08 88 (F)
info@kerberverlag.com
kerberverlag.com

Kerber publications are distributed worldwide:

ACC Art Books
Sandy Lane
Old Martlesham
Woodbridge, IP12 4SD
UK
+44 1394 38 99 50
+44 1394 38 99 99 (F)
accartbooks.com

Artbook | D.A.P.
75 Broad Street, Suite 630
New York, NY 10004
USA
+1 212 627 19 99
+1 212 627 94 84 (F)
artbook.com

AVA Verlagsauslieferung AG
Centralweg 16
8910 Affoltern am Albis
Switzerland
+41 44 762 42 50
+41 44 762 42 10 (F)
avainfo@ava.ch

Zeitfracht GmbH
Verlagsauslieferung
kerber-verlag@knv-zeitfracht.de

The Deutsche Nationalbibliothek lists this publication in the Deutsche Nationalbibliografie: dnb.de.

ISBN 978-3-7356-0654-9
www.kerberverlag.com

Printed in Germany